RM Stuart

to Jimmy,
X MAS 1971

VISUAL ILLUSIONS

THEIR CAUSES, CHARACTERISTICS
AND APPLICATIONS

by
M. LUCKIESH

With a New Introduction by
WILLIAM H. ITTELSON

Department of Psychology, Brooklyn College

Dover Publications, Inc., New York

Published in Canada by General Publishing Company, Ltd., 30 Lesmill Road, Don Mills, Toronto, Ontario.
Published in the United Kingdom by Constable and Company, Ltd., 10 Orange Street, London W. C. 2.

This Dover edition, first published in 1965, is an unabridged and unaltered republication of the work originally published by D. Van Nostrand Company and Constable & Company, Ltd., in 1922. This edition also contains a new Introduction by William H. Ittelson.

Standard Book Number: 486-21530-X

Library of Congress Catalog Card Number: 65-27432

Manufactured in the United States of America

Dover Publications, Inc.
180 Varick Street
New York, N. Y. 10014

INTRODUCTION TO THE DOVER EDITION

ALTHOUGH most properly described as an illuminating engineer, Luckiesh approached his subject with a broader range of interests than is usually associated with that title. His published works extend from the engineering aspects of lighting and their commercial applications, to the field of applied psychology of vision, to the aesthetics of light, form and color. To an early conviction that good illuminating engineering is essential for good vision, he added the belief that a sound knowledge of the psychology of visual perception is necessary for good illuminating engineering. Always interested in the practical, he found utility where others saw only difficulties to be ignored or overcome. With this background, he was inevitably drawn to the study of visual illusions. "The practical aspects of visual illusions," he wrote, "have been quite generally passed by." He, therefore, set out to write a volume "which treats the subject in a condensed manner but with broad scope [and which] it is hoped . . . will be of interest to the general reader, to painters, decorators, and architects, to lighting experts, and to all interested in light, color, and vision." Today, the accelerating interest of all these groups in visual illusions need scarcely be pointed out.

It is now almost a half-century since Luckiesh wrote this book which he modestly called "ambitious only in scope." In the intervening years those professionally interested in the many facets of visual perception have come to look upon this work as perhaps the classic monograph on the subject of visual illusions. The opportunity to place this volume, so long unavailable, on one's shelf is a welcome and exciting prospect. With this in mind the book is reprinted here in its entirety, as originally published.

Were this book today of only historic interest, appealing primarily to experts in the field who for years have longed to own a copy, this Introduction might well stop at this point. Here is Luckiesh's *Visual Illusions*. To the student of the field it needs no introduction; it speaks for itself.

However, this volume is of more than historic interest. It remains today, as it was when first published, the best available introduction to the field of visual illusions. The reader who, for whatever reason, has newly developed an interest in this subject can do no better than to turn to these pages for an over-view. It is to this reader that this brief Introduction is addressed. He is cautioned, while reading, to bear in mind that, in spite of its great contemporary value, this book was written in the second decade of this century. It necessarily reflects the times in which it was written; it is obviously un-influenced by subsequent work. Some understanding of both is necessary if this book is to be maximally useful.

Visual illusions have been the subject of such intense study throughout the past four or five decades that a complete survey of all the relevant work of that period would, without doubt, require a separate volume. Virtually every page of this book calls to mind at least one, and more frequently a whole series of recent studies. The literature in this area is vast, encompass-ing many hundreds of works.

How then can a volume be up-to-date and at the same time totally innocent of this huge accumulation of knowledge? The resolution of this paradox follows from a consideration of what this book is and what it is not. It is primarily and pre-eminently a description of the phenomena associated with virtually all the visual illusions known at the time of its writing, together with one or a few examples to illustrate each to the reader, and some discussion of practical applications or problems. It is this aspect of the book which gives it its current utility. On the other hand, Luckiesh makes quite clear and explicit what he does not intend the book to be. It is not theoretical; it is not quantitative; and it is not, except occasionally and suggestively, physiological. And yet these three aspects are those to which

the work of the past fifty years has been primarily addressed. Let us examine each aspect briefly.

Luckiesh's approach to theory in this book is stated early in his declared purpose of "subordinating theory . . . to emphasize experimental facts." Nevertheless, he unavoidably wrote in the context of the theoretical presuppositions of his time, and his book necessarily reflects these. They are the theoretical assumptions of the elementaristic associationism which had dominated experimental psychology since its inception. The reader who is familiar with this phase of psychology's history will immediately recognize this era in the first few pages where one finds, to cite but two examples, reference to the "recency, frequency, and vividness of past experience," followed in the next paragraph by a listing of the "elemental visual sensations." To the reader unfamiliar with the vagaries of psychological theorizing over the past century, a simple warning is in order: ignore theory wherever it occurs in this book. It is in no way essential to the value of the work, nor is it representative of contemporary approaches.

Indeed, by the time of its writing the theoretical framework of this book had already been for some time under severe and ultimately overwhelming attack by the forces of Gestalt psychology in Germany and Behaviorism in the United States. Both of these movements had a revolutionary impact on psychological theory in general and, in different ways, on perceptual theory in particular. Today's psychological theory is dominated by an uneasy détente between their contemporary descendants, plus a new functionalist approach which traces its antecedents in part to the earliest days of experimental psychology and in part to a line of thought growing out of work in clinical psychology and psychiatry.

Current perceptual theory, in addition to reflecting these rather general trends in psychological thought, specifically assigns a rather different position to the phenomena of illusions. Long before the emergence of psychology as a separate discipline, it was recognized, as Boring so nicely states, that "strictly speaking, the concept of illusion has no place in psychology

because no experience actually copies 'reality'." That Luckiesh was fully aware of this reasoning is quite clear. Nevertheless for a long period illusions were considered sufficiently different in kind so as to fall outside the realm of normal perceptual theory and to demand separate study and separate explanatory systems. The hope, always implicit, that these systems would eventually tie in with and supplement normal perceptual theory was made quite explicit with the advent of Gestalt psychology. Ever since that time, the study of illusions has been treated as the path along which perceptual theory is to be sought, rather than as a parallel side-road which hopefully might some day converge with the main body of perceptual theory. Concurrently, it has been recognized that the utility of the concept of illusory perception depends upon the ability to define true or veridical perception. The naive appeal to "correspondance with reality," with all its epistemological implications, has given way to a more specifically psychological approach in which various criteria of veridicality, and hence of illusion as well, have been investigated. In general, these criteria can be subsumed under three headings: internal consistency between the perception and information gained through other perceptual channels or cognitive processes; consensual validation; and pragmatic or fuctional significance. While Luckiesh was not principally concerned with the definition of illusion, it is interesting to note that reference to all three of these criteria can be found in this volume.

Perhaps, to summarize the current status of the theory of visual illusions, one can do no better than to quote, forty-five years later, Luckiesh's masterful understatement: "Some theoretical aspects of the subject are still extremely controversial."

In contrast to the sweeping changes in psychological theory over the past half-century, the role of quantification has undergone no such metamorphosis. The absence of quantification in this volume was dictated by the author's specific aims in writing it rather than any attitudes toward quantification which he personally, or the scientific community at large, may have held. Psychology has always been an experimental

science and as such has always and necessarily been interested in quantification. Theory and measurement necessarily go hand in hand, although perhaps from time to time the pendulum of emphasis may swing in one direction or the other. Present-day psychology probably represents an extreme emphasis on quantification. The belief seems to be widely held that out of the careful manipulation and measurement of parameters understanding will emerge. Certainly anyone writing the story of visual illusions today would deal proportionately less with the phenomenology of the illusions and more with their quantification.

To suggest that an all-absorbing interest in measurement may be a transient disease of the current body psychologic is in no way to deny that measurement is a necessary and crucial ingredient of science. The many empirical studies of illusions over the past decades have provided us with an invaluable store of information. We know quite a bit, for example, about the conditions which are necessary for most of the illusions to occur, about which are the relevant and which the irrelevant parameters, about the effects of varying the different parameters, about the magnitude of the various illusions, and, perhaps most dramatically, about the existence of individual differences. We know, for example, that an illusion is not an either-or phenomenon, and that not everybody experiences an illusion to the same degree or even at all. We know that the magnitude of the effect of some illusions is subject to wide individual variations, great cultural differences, and specific individual experiences and attitudes.

Almost any of the illusions throughout the book might be cited as an illustration of these points. Without going into specific detail, the reader's attention will be called to two of the best-known illusions.

Without doubt the most famous of all natural illusions is the moon illusion. Speculation about this phenomenon dates back literally thousands of years. It is virtually the only illusion in the book for which Luckiesh gives some detailed experimental and quantitative results. In the succeeding years experimental

study of the moon illusion has proceeded in several directions. The last word on the moon illusion has certainly yet to be written, but thanks to a number of ingenious, carefully carried-out and meticulously quantified experiments, we know a great deal about the role of many of the parameters about which Luckiesh could only speculate.

If the moon illusion is the most famous natural illusion, certainly the Müller-Lyer is the best-known artificial one, and its experimental study illustrates another aspect of contemporary work. While a number of parametric studies have been conducted, the most interesting findings have to do with individual differences. We know, for example, that the attitude or set of the observer can maximize or virtually eliminate the effect, that an individual can be specifically trained to minimize the illusion, and that there are fairly large cross-cultural differences in the extent to which the illusion is observed.

Luckiesh's lack of quantitative material was dictated by his aims for the book. The same is not true of his treatment of physiology; he calls upon it wherever he can. The relative paucity of physiological material seems to be primarily a reflection of the limitations of that field in general at the time the book was written. It is in the area of the physiology of perception that some of the most significant and exciting work of recent years has taken place. A brief listing of a few areas will suggest the value of a more detailed look into contemporary neurophysiology. At the peripheral level the study of stabilized retinal images, single fiber transmission, and microprocesses in the retina has led to significant findings in such areas as color perception and contour formation, and, in a more general context, has given evidence of complex interactional activity among retinal elements and peripheral nerves. A picture of complex perceptual organization starting to occur at the extreme peripheral receptor organs is gradually emerging. At the same time, studies of more central processes, in particular with regard to the reticular formation and the analysis of sensory feedback mechanisms, shows that central control over the perceptual process also extends all the way out to the

periphery. The picture emerging is of an immensely elaborate sensory control mechanism, influenced by activity in even apparently remote parts of the nervous system, which appears to provide the perceptual process with an active organizing principle including an element of "purpose" which tends to select, modify and organize the sensory input starting at its remotest peripheral origin. The implications of these remarkable findings in neurophysiology for perceptual theory are just beginning to be developed.

This then, in sketchy and fragmentary form, is an outline of some of the theoretical, quantitative, and physiological material so central to present-day psychology and absent from this volume. However, as suggested earlier, to emphasize "what this book is not" is to do a grave injustice to "what it is"; and it is, to repeat, a masterful summary of most of the phenomena observable in conjunction with visual illusions. Since the time it was written, some few visual illusions have been added to the list, and others, then considered perhaps irrelevant or trivial, have assumed a greater significance. A brief listing of the more important of these can provide a starting point for the reader who wishes to proceed further.

Without doubt the largest area of omission is that of illusions involving motion. Luckiesh expressly limited himself to static illusions in the interest of keeping the work manageable. In deference to this decision, no extensive listing of the many visual illusions of motion will be made here. However, Luckiesh did include some illusions at least bordering on the area of motion, and to this list a few may be added. Certainly the Phi phenomenon, and stroboscopic motion in general, has assumed a significance in psychology which would dictate its inclusion in any summary of visual illusions. Similarly, the autokinetic effect, while mentioned very briefly and not by that name, has a current significance which would suggest a more extensive treatment. Both of these phenomena were known at the time of Luckiesh's writing. Since then two quite new illusions involving motion have been added. The kinetic depth effect of Wallach shows the possibility of three-dimensional

effects being produced by continuous motion in a two-dimensional plane, while the rotating trapezoid of Ames produces a wide variety of fascinating illusory phenomena.

The present volume contains a chapter on illusions of depth and distance. However, the reader is struck by the paucity of material compared to that available today. Ames, of whose work the distorted room and the rotating trapezoid are undoubtedly the best known, has produced a large number of illusions of depth and distance involving all of the classical depth cues singly and in various combinations. Gibson has contributed a number of illusions based upon his conception of visual gradients. Closely related are illusions of spatial orientation, the best known examples of which are probably the tilting-room and rod-and-frame experiments of Witkin. In this same general context, probably should be included illusions related to stereoscopic depth effects. Two particularly fascinating recent additions to this area merit special notice. Julesz has demonstrated the production of binocular shapes from separate, randomly generated, shapeless and contourless patterns. Ames' aniseikonic lenses have revealed many intriguing illusory effects that occur when binocular disparity is placed in conflict with monocular depth information. These latter phenomena are theoretically closely related to those observable with the pseudoscope which is mentioned by Luckiesh, although only casually in passing, and totally out of context in his chapter on Mirror Magic (p. 205).

Another illusion mentioned briefly by Luckiesh, but not under that name is that of the Moiré patterns which have received so much recent interest. This is but another of many examples of illusions included in this volume, only given perhaps much less relative importance than would be attributed to them today. Prominent in this list also might be some of the Gestalt phenomena associated with figure-ground and closure, both of which appear in Luckiesh's volume, although not under those names, and certainly with less than contemporary emphasis.

It may be well to close this brief list of possible addenda

with an interesting illusion which was first reported by Gibson more than a decade after the writing of this book. Figural after-effect refers to the apparent distortion of parts of the visual field following prolonged fixation of a particular visual pattern. While the effect is of relatively short duration, it produces illusory distortions of magnitude comparable to many of the other more familiar illusions.

Having concluded a brief but fairly comprehensive look at this volume through contemporary eyes, one is left with a single overwhelming impression: if you want to learn about visual illusions, start with this book. In spite of the large body of subsequent research, this is as true today as it was at the time the book was written.

WILLIAM H. ITTELSON

Department of Psychology
Brooklyn College
August, 1965

PREFACE

EVENTUALLY one of the results of application to the analysis and measurement of the phenomena of light, color, lighting, and vision is a firmly entrenched conviction of the inadequacy of physical measurements as a means for representing what is perceived. Physical measurements have supplied much of the foundation of knowledge and it is not a reflection upon their great usefulness to state that often they differ from the results of intellectual appraisal through the visual sense. In other words, there are numberless so-called visual illusions which must be taken into account. All are of interest; many can be utilized; and some must be suppressed.

Scientific literature yields a great many valuable discussions from theoretical and experimental viewpoints but much of the material is controversial. The practical aspects of visual illusions have been quite generally passed by and, inasmuch as there does not appear to be a volume available which treats the subject in a condensed manner but with a broad scope, this small volume is contributed toward filling the gap.

The extreme complexity of the subject is recognized, but an attempt toward simplicity of treatment has been made by confining the discussion chiefly to static visual illusions, by suppressing minor details, and by

subordinating theory. In other words, the intent has been to emphasize experimental facts. Even these are so numerous that only the merest glimpses of various aspects can be given in order to limit the text to a small volume. Some theoretical aspects of the subject are still extremely controversial, so they are introduced only occasionally and then chiefly for the purpose of illustrating the complexities and the trends of attempted explanations. Space does not even admit many qualifications which may be necessary in order to escape criticism entirely.

The visual illusions discussed are chiefly of the static type, although a few others have been introduced. Some of the latter border upon motion, others upon hallucinations, and still others produced by external optical media are illusions only by extension of the term. These exceptions are included for the purpose of providing glimpses into the border-lands.

It is hoped that this condensed discussion, which is ambitious only in scope, will be of interest to the general reader, to painters, decorators, and architects, to lighting experts, and to all interested in light, color, and vision. It is an essential supplement to certain previous works.

November, 1920. M. LUCKIESH

CONTENTS

LIST OF ILLUSTRATIONS

xix

VISUAL ILLUSIONS

I

INTRODUCTION

S EEING is deceiving. Thus a familiar epigram may be challenged in order to indicate the trend of this book which aims to treat certain phases of visual illusions. In general, we do not see things as they are or as they are related to each other; that is, the intellect does not correctly interpret the deliverances of the visual sense, although sometimes the optical mechanism of the eyes is directly responsible for the illusion. In other words, none of our conceptions and perceptions are quite adequate, but fortunately most of them are satisfactory for practical purposes. Only a part of what is perceived comes through the senses from the object; the remainder always comes from within. In fact, it is the visual sense or the intellect which is responsible for illusions of the various types to be discussed in the following chapters. Our past experiences, associations, desires, demands, imaginings, and other more or less obscure influences create illusions.

An illusion does not generally exist physically but it is difficult in some cases to explain the cause. Certainly there are many cases of errors of judgment. A mistaken estimate of the distance of a mountain

is due to an error of judgment but the perception of a piece of white paper as pink on a green background is an error of sense. It is realized that the foregoing comparison leads directly to one of the most controversial questions in psychology, but there is no intention on the author's part to cling dogmatically to the opinions expressed. In fact, discussions of the psychological judgment involved in the presentations of the visual sense are not introduced with the hope of stating the final word but to give the reader an idea of the inner process of perception. The final word will be left to the psychologists but it appears possible that it may never be formulated.

In general, a tree appears of greater length when standing than when lying upon the ground. Lines, areas, and masses are not perceived in their actual physical relations. The appearance of a colored object varies considerably with its environment. The sky is not perceived as infinite space nor as a hemispherical dome, but as a flattened vault. The moon apparently diminishes in size as it rises toward the zenith. A bright object appears larger than a dark object of the same physical dimensions. Flat areas may appear to have a third dimension of depth. And so on.

Illusions are so numerous and varied that they have long challenged the interest of the scientist. They may be so useful or even so disastrous that they have been utilized or counteracted by the skilled artist or artisan. The architect and painter have used or avoided them. The stage-artist employs them to carry the audience in its imagination to other

environments or to far countries. The magician has employed them in his entertainments and the camoufleur used them to advantage in the practice of deception during the recent war. They are vastly entertaining, useful, deceiving, or disastrous, depending upon the viewpoint.

Incidentally, a few so-called illusions will be discussed which are not due strictly to errors of the visual sense or of the intellect. Examples of these are the mirage and certain optical effects employed by the magician. In such cases neither the visual sense nor the intellect errs. In the case of the mirage rays of light coming from the object to the eye are bent from their usual straight-line course and the object appears to be where it really is not. However, with these few exceptions, which are introduced for their specific interest and for the emphasis they give to the "true" illusion, it will be understood that illusions in general as hereinafter discussed will mean those due to the visual mechanism or to errors of judgment or intellect. For the sake of brevity we might say that they are those due to errors of visual perception. Furthermore, only those of a "static" type will be considered; that is, the vast complexities due to motion are not of interest from the viewpoint of the aims of this book.

There are two well-known types of misleading perceptions, namely illusions and hallucinations. If, for example, two lines appear of equal length and are not, the error in judgment is responsible for what is termed an "illusion." If the perceptual consciousness of an object appears although the object is not present, the

result is termed an "hallucination." For example, if something is seen which does not exist, the essential factors are supplied by the imagination. Shadows are often wrought by the imagination into animals and even human beings bent upon evil purpose. Ghosts are created in this manner. Hallucinations depend largely upon the recency, frequency, and vividness of past experience. A consideration of this type of misleading perception does not advance the aims of this book and therefore will be omitted.

The connection between the material and mental in vision is incomprehensible and apparently must ever remain so. Objects emit or reflect light and the optical mechanism known as the eye focuses images of the objects upon the retina. Messages are then carried to the brain where certain molecular vibrations take place. The physiologist records certain physical and chemical effects in the muscles, nerves, and brain and behold! there appears consciousness, sensations, thoughts, desires, and volitions. How? and, Why? are questions which may never be answered.

It is dangerous to use the word *never*, but the ultimate answers to those questions appear to be so remote that it discourages one from proceeding far over the hazy course which leads toward them. In fact, it does not appreciably further the aims of this book to devote much space to efforts toward explanation. In covering this vast and complex field there are multitudes of facts, many hypotheses, and numerous theories from which to choose. Judgment dictates that of the limited space most of it be given to

the presentation of representative facts. This is the reasoning which led to the formulation of the outline of chapters.

Owing to the vast complex beyond the physical phenomena, physical measurements upon objects and space which have done so much toward building a solid foundation for scientific knowledge fail ultimately to provide an exact mathematical picture of that which is perceived. Much of the author's previous work has been devoted to the physical realities but the ever-present differences between physical and perceptive realities have emphasized the need for considering the latter as well.

Illusions are legion. They greet the careful observer on every hand. They play a prominent part in our appreciation of the physical world. Sometimes they must be avoided, but often they may be put to work in various arts. Their widespread existence and their forcefulness make visual perception the final judge in decoration, in painting, in architecture, in landscaping, in lighting, and in other activities. The ultimate limitation of measurements with physical instruments leaves this responsibility to the intellect. The mental being is impressed with things as perceived, not with things as they are. It is believed that this intellectual or judiciary phase which plays such a part in visual perception will be best brought out by examples of various types of static illusions coupled with certain facts pertaining to the eye and to the visual process as a whole.

In special simple cases it is not difficult to determine when or how nearly a perception is true but in

general, agreement among normal persons is necessary owing to the absence of any definite measuring device which will span the gap between the perception and the objective reality. Illusions are sometimes called " errors of sense " and some of them are such, but often they are errors of the intellect. The senses may deliver correctly but error may arise from imagination, inexperience, false assumptions, and incorrect associations, and the recency, frequency, and vividness of past experience. The gifts of sight are augmented by the mind with judgments based upon experience with these gifts.

The direct data delivered by the visual sense are light, intensity, color, direction. These may be considered as simple or elemental sensations because they cannot be further simplified or analyzed. At this point it is hoped that no controversy with the psychologist will be provoked. In the space available it appears unfruitful to introduce the many qualifications necessary to satisfy the, as yet uncertain or at least conflicting, definitions and theories underlying the science of psychology. If it is necessary to add darkness to the foregoing group of elemental visual sensations, this will gladly be agreed to.

The perceptions of outline-form and surface-contents perhaps rank next in simplicity; however, they may be analyzed into directions. The perception of these is so direct and so certain that it may be considered to be immediate. A ring of points is apparently very simple and it might be considered a direct sense-perception, but it consists of a number of elemental directions.

The perception of solid-form is far more complex than outline-form and therefore more liable to error. It is judged partially by binocular vision or perspective and partly by the distribution of light and shade. Colors may help to mold form and even to give depth to flat surfaces. For example, it is well known that some colors are " advancing " and others are " retiring."

Perhaps of still greater complexity are the judgments of size and of distance. Many comparisons enter such judgments. The unconscious acts of the muscles of the eye and various external conditions such as the clearness of the atmosphere play prominent parts in influencing judgment. Upon these are superposed the numerous psycho-physiological phenomena of color, irradiation, etc.

In vision judgments are quickly made and the process apparently is largely outside of consciousness. Higher and more complex visual judgments pass into still higher and more complex intellectual judgments. All these may appear to be primary, immediate, innate, or instinctive and therefore, certain, but the fruits of studies of the psychology of vision have shown that these visual judgments may be analyzed into simpler elements. Therefore, they are liable to error.

That the ancients sensed the existence or possibility of illusions is evidenced by the fact that they tried to draw and to paint although their inability to observe carefully is indicated by the absence of true shading. The architecture of ancient Greece reveals a knowledge of certain illusions in the efforts to overcome them. However, the study of illusions did not

engage the attention of scientists until a comparatively recent period. Notwithstanding this belated attention there is a vast scientific literature pertaining to the multitudinous phases of the subject; however, most of it is fragmentary and much of it is controversial. Some of it deals with theory for a particular and often a very simple case. In life complex illusions are met but at present it would be futile to attempt to explain them in detail. Furthermore, there have been few attempts to generalize and to group examples of typical phenomena in such a manner as to enable a general reader to see the complex fabric as a whole. Finally, the occurrence and application of illusions in various arts and the prominence of illusions on every hand have not been especially treated. It is the hope that this will be realized in the following chapters in so far as brevity of treatment makes this possible.

Doubtless thoughtful observers ages ago noticed visual illusions, especially those found in nature and in architecture. When it is considered that geometrical figures are very commonly of an illusory character it appears improbable that optical illusions could have escaped the keenness of Euclid. The apparent enlargement of the moon near the horizon and the apparent flattened vault of the sky were noticed at least a thousand years ago and literature yields several hundred memoirs on these subjects. One of the oldest dissertations upon the apparent form of the sky was published by Alhazen, an Arab astronomer of the tenth century. Kepler in 1618 wrote upon the subject.

Philosophers of the past centuries prepared the

way toward an understanding of many complexities of today. They molded thought into correct form and established fundamental concepts and principles. Their chief tool was philosophy, the experimental attack being left to the scientists of the modern age. However, they established philosophically such principles as " space and time are not realities of the phenomenal world but the modes under which we see things apart." As science became organized during the present experimental era, measurements were applied and there began to appear analytical discussions of various subjects including optical illusions. One of the earliest investigations of the modern type was made by Oppel, an account of which appeared in 1854. Since that time scientific literature has received thousands of worthy contributions dealing with visual illusions.

There are many facts affecting vision regarding which no theory is necessary. They speak for themselves. There are many equally obvious facts which are not satisfactorily explained but the lack of explanation does not prevent their recognition. In fact, only the scientist needs to worry over systematic explanations and theoretical generalizations. He needs these in order to invade and to explore the other unknowns where he will add to his storehouse of knowledge. A long step toward understanding is made by becoming acquainted with certain physical, physiological, and psychological facts of light, color, and lighting. Furthermore, acquaintance with the visual process and with the structure of the eye aids materially. For this reason the next two chapters have been added even at the risk of discouraging some readers.

In a broad sense, any visual perception which does not harmonize with physical measurements may be termed an " illusion." Therefore, the term could include those physical illusions obtained by means of prisms, lenses, and mirrors and such illusions as the mirage. It could also include the physiological illusions of light and color such as after-images, irradiation, and contrast, and the psycho-physiological illusions of space and the character of objects. In fact, the scope of the following chapters is arbitrarily extended to include all these aspects, but confines consideration only to " static " illusions.

In a more common sense attention is usually restricted to the last group; that is, to the psycho-physiological illusions attending the perception of space and the character of objects although motion is often included. It should be obvious that no simple or even single theory can cover the vast range of illusions considered in the broad sense because there are so many different kinds of factors involved. For this reason explanations will be presented wherever feasible in connection with specific illusions. However, in closing this chapter it appears of interest to touch upon the more generally exploited theories of illusions of the type considered in the foregoing restricted sense. Hypotheses pertaining to illusions are generally lacking in agreement, but for the special case of what might be more safely termed " geometrical-optical illusions " two different theories, by Lipps and by Wundt respectively, are conspicuous. In fact, most theories are variants of these two systematic " explanations " of illusions (in the restricted sense).

Lipps proposed the principle of mechanical-esthetic unity, according to which we unconsciously give to every space-form a living personality and unconsciously consider certain mechanical forces acting. Our judgments are therefore modified by this anthropomorphic attitude. For example, we regard the circle as being the result of the action of tangential and radial forces in which the latter appear to triumph. According to Lipps' theory the circle has a centripetal character and these radial forces toward the center, which apparently have overcome the tangential forces during the process of creating the circle, lead to underestimation of its size as compared with a square of the same height and breadth. By drawing a circle and square side by side, with the diameter of the former equal to the length of a side of the latter, this illusion is readily demonstrated. Of course, the square has a greater area than the circle and it is difficult to determine the effect of this disparity in area. Figure 60 where the areas of the circle and square are equal and consequently the height of the former is considerably greater than the latter, is of interest in this connection. By experimenting with a series of pairs consisting of a circle and a square, varying in dimensions from equal heights to equal areas, an idea of the " shrinking " character of the circle becomes quite apparent.

Wundt does not attribute the illusion to a deception or error of judgment but to direct perception. According to his explanation, the laws of retinal image (fixation) and eye-movement are responsible. For example, vertical distances appear greater than hori-

zontal ones because the effort or expenditure of energy is greater in raising the eyes than in turning them through an equal angle in a horizontal plane. Unconscious or involuntary eye-movements also appear to play a part in many linear or more accurately, angular illusions, but certainly Wundt's explanation does not suffice for all illusions although it may explain many geometrical illusions. It may be said to be of the " perceptive " class and Lipps' theory to be of the " judgment " or " higher-process " class. As already stated, most of the other proposed explanations of geometrical illusions may be regarded as being related to one of these two theories. There is the " indistinct vision " theory of Einthoven; the " perspective " theory of Hering, Guye, Thiéry, and others; the " contrast " theory of Helmholtz, Loeb, and Heyman; and the " contrast-*confluxion* " theory of Müller-Lyer. In order not to discourage the reader at the outset, theories as such will be passed by with this brief glimpse. However, more or less qualified explanations are presented occasionally in some of the chapters which follow in order to indicate or to suggest a train of thought should the reader desire to attempt to understand some of the numerous interesting illusions.

II

THE EYE

HELMHOLTZ, who contributed so much toward our knowledge of the visual process, in referring to the eye, once stated that he could make a much better optical instrument but not a better eye. In other words, the eye is far from an ideal optical instrument but as an eye it is wonderful. Its range of sensitiveness and its adaptability to the extreme variety of demands upon it are truly marvelous when compared with instruments devised by mankind. Obviously, the eye is the connecting link between objective reality and visual perception and, therefore, it plays an important part in illusions. In fact, sometimes it is solely responsible for the illusion. The process of vision may be divided into several steps such as (1) the lighting, color, character, and disposition of objects; (2) the mechanism by which the image is formed upon the retina; (3) various optical defects of this mechanism; (4) the sensitiveness of the parts of the retina to light and color; (5) the structure of the retina; (6) the parts played by monocular and binocular vision; and (7) the various events which follow the formation of the image upon the retina.

The mechanism of the eye makes it possible to see not only light but objects. Elementary eyes of the

lowest animals perceive light but cannot *see* objects. These eyes are merely specialized nerves. In the human eye the optic nerve spreads to form the retina and the latter is a specialized nerve. Nature has accompanied this evolution by developing an instrument — the eye — for intensifying and defining and the whole is the visual sense-organ. The latter contains the most highly specialized nerve and the most refined physiological mechanism, the result being the highest sense-organ.

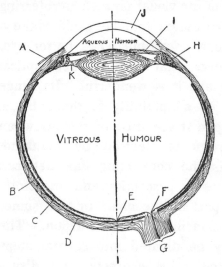

Fig. 1.—Principal parts of the eye.

A, Conjunctiva; B, Retina; C, Choroid; D, Sclera; E, Fovea; F, Blind Spot; G, Optic Nerve; H, Ciliary Muscle; I, Iris; J, Cornea; K, Ligament.

The eye is approximately a spherical shell transparent at the front portion and opaque (or nearly so) over the remaining eighty per cent of its surface. The optical path consists of a series of transparent liquids and solids. The chief details of the structure of the eye are represented in Fig. 1. Beginning with the exterior and proceeding toward the retina we find in succession the cornea, the anterior chamber containing the aqueous humor, the iris, the lens, the large chamber containing the vitreous humor, and finally the retina. Certain muscles alter the position of the eye and consequently the optical axis, and focusing (accommodation) is accomplished by altering

the thickness and shape, and consequently the focal length, of the lens.

The iris is a shutter which automatically controls to some degree the amount of light reaching the retina, thereby tending to protect the latter from too much light. It also has some influence upon the definition of the image; that is, upon what is termed " visual acuity " or the ability to distinguish fine detail. It is interesting to compare the eye with the camera. In the case of the camera and the photographic process, we have (1) an inverted light-image, a facsimile of the object usually diminished in size; (2) an invisible image in the photographic emulsion consisting of molecular changes due to light; and (3) a visible image developed on the plate. In the case of the eye and the visual process we have (1) an inverted light-image, a facsimile of the object diminished in size; (2) the invisible image in the retinal substances probably consisting of molecular changes due to light; and (3) an *external* visible image. It will be noted that in the case of vision the final image is projected outward — it is external. The more we think of this outward projection the more interesting and marvelous vision becomes. For example, it appears certain that if a photographic plate could see or feel, it would see or feel the silver image upon itself but not out in space. However, this point is discussed further in the next chapter.

In the camera and photographic process we trace mechanism, physics, and chemistry throughout. In the eye and visual process we are able to trace these factors only to a certain point, where we encounter

the super-physical and super-chemical. Here molecular change is replaced by sensation, perception, thought, and emotion. Our exploration takes us from the physical world into another, wholly different, where there reigns another order of phenomena. We have passed from the material into the mental world.

The eye as an optical mechanism is reducible to a single lens and therefore the image focused upon the retina is inverted. However, there is no way for the observer to be conscious of this and therefore the inverted image causes no difficulty in seeing. The images of objects in the right half of the field of view are focused upon the left half of the retina. Similarly, the left half of the field of view corresponds to the right half of the retina; the upper half of the former to the lower half of the latter; and so on. When a ray of light from an object strikes the retina the impression is referred back along the ray-line into the original place in space. This is interestingly demonstrated in a simple manner. Punch a pin-hole in a card and hold it about four inches from the eye and at the same time hold a pin-head as close to the cornea as possible. The background for the pin-hole should be the sky or other bright surface. After a brief trial an inverted image of the pin-head is seen *in the hole*. Punch several holes in the card and in each will be seen an inverted image of the pin-head.

The explanation of the foregoing is not difficult. The pin-head is so close to the eye that the image cannot be focused upon the retina; however, it is in a very favorable position to cast a shadow upon the retina, the light-source being the pin-hole with a bright

background. Light streaming through the pin-hole into the eye casts an erect shadow of the pin-head upon the retina, and this erect image is projected into space and inverted in the process by the effect of the lens. The latter is not operative during the casting of the shadow because the pin-head is too close to the lens, as already stated. It is further proved to be outward projection of the retinal image (the shadow) because by multiplying the number of pin-holes (the light-sources) there are also a corresponding number of shadows.

The foregoing not only illustrates the inversion of the image but again emphasizes the fact that we do not see retinal images. Even the " stars " which we see on pressing the eye-lid or on receiving a blow on the eye are projected into space. The " motes " which we see in the visual field while gazing at the sky are defects in the eye-media, and these images are projected into space. We do not see anything in the eye. The retinal image impresses the retina in some definite manner and the impression is carried to the brain by the optic nerve. The intellect then refers or projects this impression outward into space as an external image. The latter would be a facsimile of the physical object if there were no illusions but the fact that there are illusions indicates that errors are introduced somewhere along the path from and to the object.

It is interesting to speculate whether the first visual impression of a new-born babe is "projected outward " or is perceived as in the eye. It is equally futile to conjecture in this manner because there is no in-

dication that the time will come when the baby can answer us immediately upon experiencing its first visual impression. The period of infancy increases with progress up the scale of animal life and this lengthening is doubtless responsible and perhaps necessary for the development of highly specialized sense-organs. Incidentally, suppose a blind person to be absolutely uneducated by transferred experience and that he suddenly became a normal adult and able to see. What would he say about his first visual impression? Apparently such a subject is unobtainable. The nearest that such a case had been approached is the case of a person born blind, whose sight has been restored. This person has acquired much experience with the external world through other senses. It has been recorded that such a person, after sight was restored, appeared to think that external objects "touched" the eyes. Only through visual experience is this error in judgment rectified.

Man studies his kind too much apart from other animals and perhaps either underestimates or over-estimates the amount of inherited, innate, instinctive qualities. A new-born chick in a few minutes will walk straight to an object and seize it. Apparently this im-plies perception of distance and direction and a coördi-nation of muscles for walking and moving the eyes. It appears reasonable to conclude that a certain amount of the wealth of capacities possessed by the individual is partly inherited, and in man the acquired predomi-nates. But all capacities are acquired, for even the in-herited was acquired in ancestral experience. Even instinct (whatever that may be) must involve inherited

experience. These glimpses of the depths to which one must dig if he is to unearth the complete explanations of visual perception — and consequently of illusions — indicate the futility of treating the theories in the available space without encroaching unduly upon the aims of this volume.

Certain defects of the optical system of the eye must contribute toward causing illusions. Any perfect lens of homogeneous material has at least two defects, known as spherical and chromatic aberration. The former manifests itself by the bending of straight lines and is usually demonstrated by forming an image of an object such as a wire mesh or checkerboard; the outer lines of the image are found to be very much bent. This defect in the eye-lens is somewhat counteracted by a variable optical density, increasing from the outer to the central portion. This results in an increase in refractive-index as the center of the lens is approached and tends to diminish its spherical aberration. The eye commonly possesses abnormalities such as astigmatism and eccentricity of the optical elements. All these contribute toward the creation of illusions.

White light consists of rays of light of various colors and these are separated by means of a prism because the refractive-index of the prism differs for lights of different color or wave-length. This causes the blue rays, for example, to be bent more than the red rays when traversing a prism. It is in this manner that the spectrum of light may be obtained. A lens may be considered to be a prism of revolution and it thus becomes evident that the blue rays will be brought

to a focus at a lesser distance than the red rays; that is, the former are bent more from their original path than the latter. This defect of lenses is known as chromatic aberration and is quite obvious in the eye. It may be demonstrated by any simple lens, for the image of the sun, for example, will appear to have a colored fringe. A purple filter which transmits only the violet and red rays is useful for this demonstration. By looking at a lamp-filament or candle-flame some distance away the object will appear to have a violet halo, but the color of the fringe will vary with accommodation. On looking through a pin-hole at the edge of an object silhouetted against the bright sky the edge will appear red if the light from the pin-hole enters the pupil near its periphery. This optical defect of the eye makes objects appear more sharply defined when viewed in monochromatic light. In fact, this is quite obvious when using yellow glasses. The defect is also demonstrated by viewing a line-spectrum focused on a ground glass. The blue and red lines cannot be seen distinctly at the same distance. The blue lines can be focused at a much less distance than the red lines. Chromatic aberration can account for such an illusion as the familiar " advancing " and " retiring " colors and doubtless it plays a part in many illusions.

The structure of the retina plays a very important part in vision and accounts for various illusions and many interesting visual phenomena. The optic nerve spreads out to form the retina which constitutes the inner portion of the spherical shell of the eye with the exception of the front part. Referring again to Fig. 1,

the outer coating of the shell is called the sclerotic. This consists of dense fibrous tissue known as the "white of the eye." Inside this coating is a layer of black pigment cells termed the choroid. Next is the bacillary layer which lines about five-sixths of the interior surface of the eye. This is formed by closely packed "rods" and "cones," which play a dominant role in the visual process. A light-sensitive liquid (visual purple) and cellular and fibrous layers complete the retinal structure.

The place where the optic nerve enters the eye-ball and begins to spread out is blind. Objects whose images fall on this spot are invisible. This blind-spot is not particularly of interest here, but it may be of interest to note its effect. This is easily done by closing one eye and looking directly at one of two small black circles about two inches apart on white paper at a distance of about a foot from the eye. By moving the objects about until the image of the circle not directly looked at falls upon the blind-spot, this circle will disappear. A three-foot circle at a distance of 36 feet will completely disappear if its image falls directly upon the blind-spot. At a distance of 42 inches the invisible area is about 12 inches from the point of sight and about 3 to 4 inches in diameter. At 300 feet the area is about 8 feet in diameter. The actual size of the retinal blind-spot is about 0.05 inch in diameter or nearly 5 degrees. Binocular vision overcomes any annoyance due to the blind-spots because they do not overlap in the visual field. A one-eyed person is really totally blind for this portion of the retina or of the visual field.

The bacillary layer consists of so-called rods and cones. Only the rods function under very low intensities of illumination of the order of moonlight. The cones are sensitive to color and function only at intensities greater than what may be termed twilight intensities. These elements are very small but the fact that they appear to be connecting links between the retinal image and visual perception, acuity or discrimination of fine detail is limited inasmuch as the elements are of finite dimensions. The smallest image which will produce a visual impression is the size of the end of a cone. The smallest distance between two points which is visible at five inches is about 0.001 inch. Two cones must be stimulated in such a case. Fine lines may appear crooked because of the irregular disposition of these elemental light-sensitive points. This apparent crookedness of lines is an illusion which is directly due to the limitations of retinal elements of finite size.

The distribution of rods and cones over the retina is very important. In the fovea centralis — the point of the retina on the optical axis of the eye — is a slight depression much thinner than the remainder of the retina and this is inhabited chiefly by cones. It is this spot which provides visual acuteness. It is easily demonstrated that fine detail cannot be seen well defined outside this central portion of the visual field. When we desire to see an object distinctly we habitually turn the head so that the image of the object falls upon the fovea of each eye. Helmholtz has compared the foveal and lateral images with a finished drawing and a rough sketch respectively.

The fovea also contains a yellow pigmentation which makes this area of the retina selective as to color-vision. On viewing certain colors a difference in color of this central portion of the field is often very evident. In the outlying regions of the retina, rods predominate and in the intermediate zone both rods and cones are found. Inasmuch as rods are not sensitive to color and cones do not function at low intensities of illumination it is obvious that visual impressions should vary, depending upon the area of the retina stimulated. In fact, many interesting illusions are accounted for in this manner, some of which are discussed later.

It is well known that a faint star is seen best by averted vision. It may be quite invisible when the eye is directed toward it, that is, when its image falls upon the rod-free fovea. However, by averting the line of sight slightly, the image is caused to fall on a retinal area containing rods (sensitive to feeble light) and the star may be readily recognized. The fovea is the point of distinct focus. It is necessary for fixed thoughtful attention. It exists in the retina of man and of higher monkeys but it quickly disappears as we pass down the scale of animal life. It may be necessary for the safety of the lower animals that they see equally well over a large field; however, it appears advantageous that man give fixed and undivided attention to the object looked at. Man does not need to trust solely to his senses to protect himself from dangers. He uses his intellect to invent and to construct artificial defenses. Without the highly specialized fovea we might see equally

well over the whole retina but could not look attentively at anything, and therefore could not observe thoughtfully.

When an image of a bright object exists upon the retina for a time there results a partial exhaustion or fatigue of the retinal processes with a result that an after-image is seen. This after-image may be bright for a time owing to the fact that it takes time for the retinal process to die out. Then there comes a reaction which is apparent when the eye is directed toward illuminated surfaces. The part of the retina which has been fatigued does not respond as fully as the fresher areas, with the result that the fatigued area contributes a darker area in the visual field. This is known as an after-image and there are many interesting variations.

The after-image usually undergoes a series of changes in color as well as in brightness as the retinal process readjusts itself. An after-image of a colored object may often appear of a color complementary to the color of the object. This is generally accounted for by fatigue of the retinal process. There are many conflicting theories of color-vision but they are not as conflicting in respect to the aspect of fatigue as in some other aspects. If the eye is directed toward a green surface for a time and then turned toward a white surface, the fatigue to green light diminishes the extent of response to the green rays in the light reflected by the white surface. The result is the perception of a certain area of the white surface (corresponding to the portion of the field fatigued by green light) as of a color equal to white minus

some green —the result of which is pink or purple. This is easily understood by referring to the principles of color-mixture. Red, green, and blue (or violet) mixed in proper proportions will produce any color or tint and even white. Thus these may be considered to be the components of white light. Hence if the retina through fatigue is unable to respond fully to the green component, the result may be expressed mathematically as red plus blue plus reduced green, or synthetically a purplish white or pink. When fatigued to red light the after-image on a white surface is blue-green. When fatigued to blue light it is yellowish.

Further mixtures may be obtained by directing the after-image upon colored surfaces. In this manner many of the interesting visual phenomena and illusions associated with the viewing of colors are accounted for. The influence of a colored environment upon a colored object is really very great. This is known as simultaneous contrast. The influence of the immediately previous history of the retina upon the perception of colored surfaces is also very striking. This is called successive contrast. It is interesting to note that an after-image produced by looking at a bright light-source, for example, is projected into space even with the eyes closed. It is instructive to study after-images and this may be done at any moment. On gazing at the sun for an instant and then looking away, an after-image is seen which passes in color from green, blue, purple, etc., and finally fades. For a time it is brighter than the background which may conveniently be the sky. On

closing the eyes and placing the hands over them the
background now is dark and the appearance of the
after-image changes markedly. There are many
kinds, effects, and variations of after-images, some
of which are discussed in other chapters.

As the intensity of illumination of a landscape,
for example, decreases toward twilight, the retina
diminishes in sensibility to the rays of longer wave-
lengths such as yellow, orange, and red. Therefore,
it becomes relatively more sensitive to the rays of
shorter wave-length such as green, blue, and violet.
The effects of this Purkinje phenomenon (named
after the discoverer) may be added to the class of
illusions treated in this book. It is interesting to
note in this connection that moonlight is represented
on some paintings and especially on the stage as
greenish blue in color, notwithstanding that physical
measurements show it to be approximately the color
of sunlight. In fact, it is sunlight reflected by dead,
frigid, and practically colorless matter.

Some illusions may be directly traced to the
structure of the eye under unusual lighting conditions.
For example, in a dark room hold a lamp obliquely
outward but near one eye (the other being closed
and shielded) and forward sufficiently for the retina
to be strongly illuminated. Move the lamp gently
while gazing at a plain dark surface such as the wall.
Finally the visual field appears dark, due to the in-
tense illumination of the retina and there will appear,
apparently projected upon the wall, an image re-
sembling a branching leafless tree. These are really
shadows of the blood vessels in the retina. The

experiment is more successful if an image of a bright light-source is focused on the sclerotic near the cornea. If this image of the light-source is moved, the tree-like image seen in the visual field will also move.

The rate of growth and decay of various color-sensations varies considerably. By taking advantage of this fact many illusions can be produced. In fact, the careful observer will encounter many illusions which may be readily accounted for in this manner.

It may be said that in general the eyes are never at rest. Involuntary eye-movements are taking place all the time, at least during consciousness. Some have given this restlessness a major part in the process of vision but aside from the correctness of theories involving eye-movements, it is a fact that they are responsible for certain illusions. On a star-lit night if one lies down and looks up at a star the latter will be seen to appear to be swimming about more or less jerkily. On viewing a rapidly revolving wheel of an automobile as it proceeds down the street, occasionally it will be seen to cease revolving momentarily. These apparently are accounted for by involuntary eye-movements which take place regardless of the effort made to fixate vision.

If the eyelids are almost closed, streamers appear to radiate in various directions from a light-source. Movements of the eyelids when nearly closed sometimes cause objects to appear to move. These may be accounted for perhaps by the distortion of the moist film which covers the cornea.

The foregoing are only a few of the many visual phenomena due largely to the structure of the eye. The effects of these and many others enter into visual illusions, as will be seen here and there throughout the chapters which follow.

III

VISION

A DESCRIPTION of the eye by no means suffices to clarify the visual process. Even the descriptions of various phenomena in the preceding chapter accomplish little more than to acquaint the reader with the operation of a mechanism, although they suggest the trend of the explanations of many illusions. At best only monocular vision has been treated, and it does not exist normally for human beings. A person capable only of monocular vision would be like Cyclops Polyphemus. We might have two eyes, or even, like Argus, possess a hundred eyes and still not experience the wonderful advantages of binocular vision, for each eye might see independently. The phenomena of binocular vision are far less physical than those of monocular vision. They are much more obscure, illusory, and perplexing because they are more complexly interwoven with or allied to psychological phenomena.

The sense of sight differs considerably from the other senses. The sense of touch requires solid contact (usually); taste involves liquid contact; smell, gaseous contact; and hearing depends upon a relay of vibrations from an object through another medium (usually air), resulting finally in contact. However, we perceive things at a distance through vibration

(electromagnetic waves called light) conveyed by a subtle, intangible, universal medium which is unrecognizable excepting as a hypothetically necessary bearer of light-waves or, more generally, radiant energy.

It also is interesting to compare the subjectiveness and objectiveness of sensations. The sensation of taste is subjective; it is in us, not in the body tasted. In smell we perceive the sensation in the nose and by experience refer it to an object at a distance. The sensation of hearing is objective; that is, we refer the cause to an object so completely that there is practically no consciousness of sensation in the ear. In sight the impression is so completely projected outward into space and there is so little consciousness of any occurrence in the eye that it is extremely difficult to convince ourselves that it is essentially a subjective sensation. The foregoing order represents the sense-organs in increasing specialization and refinement. In the two higher senses — sight and hearing — there is no direct contact with the object and an intricate mechanism is placed in front of the specialized nerve to define and to intensify the impression. In the case of vision this highly developed instrument makes it possible to see not only *light* but *objects*.

As we go up the scale of vertebrate animals we find that there is a gradual change of the position of the eyes from the sides to the front of the head and a change of the inclination of the optical axes of the two eyes from 180 degrees to parallel. There is also evident a gradual increase in the fineness of the

bacillary layer of the retina from the margins toward the center, and, therefore, an increasing accuracy in the perception of form. This finally results in a highly organized central spot or fovea which is possessed only by man and the higher monkeys. Proceeding up the scale we also find an increasing ability to converge the optic axes on a near point so that the images of the point may coincide with the central spots of both retinas. These changes and others are closely associated with each other and especially with the development of the higher faculties of the mind.

Binocular vision in man and in the higher animals is the last result of the gradual improvement of the most refined sense-organ, adapting it to meet the requirements of highly complex organisms. It cannot exist in some animals, such as birds and fishes, because they cannot converge their two optical axes upon a near point. When a chicken wishes to look intently at an object it turns its head and looks with one eye. Such an animal sees with two eyes independently and possibly moves them independently. The normal position of the axes of human eyes is convergent or parallel but it is possible to diverge the axes. In fact, with practice it is possible to diverge the axes sufficiently to look at a point near the back of the head, although, of course, we do not see the point.

The movement of the eyes is rather complex. When they move together to one side or the other or up and down in a vertical plane there is no rotation of the optical axes; that is, no torsion. When the visual plane is elevated and the eyes move to the

right they rotate to the right; when they move to the left they rotate to the left. When the visual plane is depressed and the eyes move to the right they rotate to the left; when they move to the left they rotate to the right. Through experience we unconsciously evaluate the muscular stresses, efforts, and movements accompanying the motion of the eyes and thereby interpret much through visual perception in regard to such aspects of the external world as size, shape, and distance of objects. Even this brief glimpse of the principal movements of the eyes indicates a complexity which suggests the intricacy of the explanations of certain visual phenomena.

At this point it appears advantageous to set down the principal modes by which we perceive the third dimension of space and of objects and other aspects of the external world. They are as follows: (1) extent; (2) clearness of brightness and color as affected by distance; (3) interference of near objects with those more distant; (4) elevation of objects; (5) variation of light and shade on objects; (6) cast shadows; (7) perspective; (8) variation of the visor angle in proportion to distance; (9) muscular effort attending accommodation of the eye; (10) stereoscopic vision; (11) muscular effort attending convergence of the axes of the eyes. It will be recognized that only the last two are necessarily concerned with binocular vision. These varieties of experiences may be combined in almost an infinite variety of proportions.

Wundt in his attempt to explain visual perception considered chiefly three factors: (1) the retinal

image of the eye at rest; (2) the influence of the movements of one eye; and, (3) the additional data furnished by the two eyes functioning together. There are three fields of vision corresponding to the foregoing. These are the retinal field of vision, the monocular field, and the binocular field. The retinal field of vision is that of an eye at rest as compared with the monocular field, which is all that can be seen with one eye in its entire range of movement and therefore of experience. The retinal field has no clearly defined boundaries because it finally fades at its indefinite periphery into a region where sensation ceases.

It might be tiresome to follow detailed analyses of the many modes by which visual perception is attained, so only a few generalizations will be presented. For every voluntary act of sight there are two adjustments of the eyes, namely, focal and axial. In the former case the ciliary muscle adjusts the lens in order to produce a defined image upon the retina. In axial adjustments the two eyes are turned by certain muscles so that their axes meet on the object looked at and the images of the object fall on the central-spots of the retina. These take place together without distinct volition for each but by the single voluntary act of *looking*. Through experience the intellect has acquired a wonderful capacity to interpret such factors as size, form, and distance in terms of the muscular movements in general without the observer being conscious of such interpretations.

Binocular vision is easily recognized by holding a finger before the eyes and looking at a point beyond

it. The result is two apparently transparent fingers. An object is seen single when the two retinal images fall on corresponding points. Direction is a primary datum of sense. The property of corresponding points of the two retinas (binocular vision) and consequently of identical spatial points in the two visual fields is not so simple. It is still a question whether corresponding points (that is, the existence of a corresponding point in one retina for each point in the other retina) are innate, instinctive, and are antecedent of experience or are " paired " as the result of experience. The one view results in the *nativistic,* the other in the *empiristic* theory. Inasmuch as some scientists are arrayed on one side and some on the other, it appears futile to dwell further upon this aspect. It must suffice to state that binocular vision, which consists of two retinas and consequently two fields of view absolutely coördinated in some manner in the brain, yields extensive information concerning space and its contents.

After noting after-images, motes floating in the field of view (caused by defects in the eye-media) and various other things, it is evident that what we call the field of view is the external projection into space of retinal states. All the variations of the latter, such as images and shadows which are produced in the external field of one eye, are faithfully reproduced in the external field of the other eye. This sense of an external visual field is ineradicable. Even when the eyes are closed the external field is still there; the imagination or intellect projects it outward. Objects at different distances cannot be

seen distinctly at the same time but by interpreting the eye-movements as the point of sight is run backward and forward (varying convergence of the axes) the intellect practically automatically appraises the size, form, and distance of each object. Obviously, experience is a prominent factor. The perception of the third dimension, depth or relative distance, whether in a single object or a group of objects, is the result of the successive combination of the different parts of two dissimilar images of the object or group.

As already stated, the perception of distance, size, and form is based partly upon monocular and partly upon binocular vision, and the simple elements upon which judgments of these are based are light, shade, color, intensity, and direction. Although the interpretation of muscular adjustments plays a prominent part in the formation of judgments, the influences of mathematical perspective, light, shade, color, and intensity are more direct. Judgments based upon focal adjustment (monocular) are fairly accurate at distances from five inches to several yards. Those founded upon axial adjustment (convergence of the two axes in binocular vision) are less in error than the preceding ones. They are reliable to a distance of about 1000 feet. Judgments involving mathematical perspective are of relatively great accuracy without limits. Those arrived at by interpreting aerial perspective (haziness of atmosphere, reduction in color due to atmospheric absorption, etc.) are merely estimates liable to large errors, the accuracy depending largely upon experience with local conditions.

The measuring power of the eye is more liable

to error when the distances or the objects compared
lie in different directions. A special case is the com-
parison of a vertical distance with a horizontal one.
It is not uncommon to estimate a vertical distance
as much as 25 per cent greater than an actually equal
horizontal distance. In general, estimates of direction
and distance are comparatively inaccurate when only
one eye is used although a one-eyed person acquires
unusual ability through a keener experience whetted
by necessity. A vertical line drawn perpendicular to
a horizontal one is likely to appear bent when viewed
with one eye. Its apparent inclination is variable but
has been found to vary from one to three degrees.
Monocular vision is likely to cause straight lines to
appear crooked, although the " crookedness " may
seem to be more or less unstable.

The error in the estimate of size is in reality an
error in the estimation of distance except in those
cases where the estimate is based directly upon a com-
parison with an object of supposedly known size.
An amusing incident is told of an old negro who was
hunting for squirrels. He shot several times at what
he supposed to be a squirrel upon a tree-trunk and his
failure to make a kill was beginning to weaken his
rather ample opinion of his skill as a marksman. A
complete shattering of his faith in his skill was only
escaped by the discovery that the " squirrel " was a
louse upon his eyebrow. Similarly, a gnat in the air
might appear to be an airplane under certain favorable
circumstances. It is interesting to note that the
estimated size of the disk of the sun or moon varies
from the size of a saucer to that of the end of a barrel,

although a pine tree at the horizon-line may be estimated as 25 feet across despite the fact that it may be entirely included in the disk of the sun setting behind it.

Double images play an important part in the comparison of distances of objects. The " doubling " of objects is only equal to the interocular distance. Suppose two horizontal wires or clotheslines about fifty feet away and one a few feet beyond the other. On looking at these no double images are visible and it is difficult or even impossible to see which is the nearer when the points of attachment of the ends are screened from view. However, if the head is turned to one side and downward (90 degrees) so that the interocular line is now at right angles (vertical) to the horizontal lines, the relative distances of the latter are brought out distinctly. Double images become visible in the latter case.

According to Brücke's theory the eyes are continuously in motion and the observer by alternately increasing or decreasing the convergence of the axes of the eyes, combines successively the different parts of the two scenes as seen by the two eyes and by running the point of sight back and forth by trial obtains a distinct perception of binocular perspective or relief or depth of space. It may be assumed that experience has made the observer proficient in this appraisal which he arrives at almost unconsciously, although it may be just as easy to accept Wheatstone's explanation. In fact, some experiences with the stereoscope appear to support the latter theory.

Wheatstone discovered that the dissimilar pictures

of an object or scene, when united by means of optical systems, produce a visual effect similar to that produced by the actual solid object or scene provided the dissimilarity is the same as that between two retinal images of the solid object or scene. This is the principle upon which the familiar stereoscope is founded. Wheatstone formulated a theory which may be briefly stated as follows: In viewing a solid object or a scene two slightly dissimilar retinal images are formed in the two eyes respectively, but the mind completely fuses them into one "mental" image. When this mental fusion of the two really dissimilar retinal images is complete in this way, it is obvious that there cannot exist a mathematical coincidence. The result is a perception of depth of space, of solidity, of relief. In fact the third dimension is perceived. A stereoscope accomplishes this in essentially the same manner, for two pictures, taken from two different positions respectively corresponding to the positions of the eyes, are combined by means of optical systems into one image.

Lack of correct size and position of the individual elements of stereoscopic pictures are easily detected on combining them. That is, their dissimilarity must exactly correspond to that between two views of an object or scene from the positions of the two eyes respectively (Fig. 2). This fact has been made use of in detecting counterfeit notes. If two notes made from the same plate are viewed in a stereoscope and the identical figures are combined, the combination is perfect and the plane of the combined images is perfectly flat. If the notes are not made from the

same plate but one of them is counterfeit, slight variations in the latter are unavoidable. Such variations will show themselves in a wavy surface.

The unwillingness of the visual sense to combine the two retinal images, if they are dissimilar to the extent of belonging to two different objects, is emphasized by means of colors. For example, if a green glass is placed over one eye and a red glass over the other, the colors are not mixed by the visual sense. The addition of these two colors results normally in yellow, with little or no suggestion of the components— red and green. But in the foregoing case the visual field does not appear of a uniform yellow. It appears alternately red and green, as though the colors were rivaling each other for complete mastery. In fact, this phenomenon has been termed "retinal rivalry."

The lenses of the stereoscope supplement eye-lenses and project on the retina two perfect images of a near object, although the eyes are looking at a distant object and are therefore not accommodated for the near one (the photographs). The lenses enlarge the images similar to the action of a perspective glass. This completes the illusion of an object or of a scene. There is a remarkable distinctness of the perception of depth of space and therefore a wonderful resemblance to the actual object or scene. It is interesting to note the effect of taking the two original photographs from distances separated by several feet. The effect is apparently to magnify depth. It is noteworthy that two pictures taken from an airplane at points fifty feet or so apart, when combined in the

stereoscope, so magnify the depth that certain enemy-works can be more advantageously detected than from ordinary photographs.

Stereoscopic images such as represented in Fig. 2 may be combined without the aid of the stereoscope if the optical axes of the eye can be sufficiently converged or diverged. Such images or pictures are usually upon a card and are intended to be combined beyond the plane of the card, for it is in this position that the object or scene can be perceived in natural perspective, of natural size, of natural form, and at natural distance. But in combining them the eyes are looking at a distant object and the axes are parallel or nearly so. Therefore, the eyes are focally adjusted for a distant object but the light comes from a very near object — the pictures on the card. Myopic eyes do not experience this difficulty and it appears that normal vision may be trained to overcome it. Normal eyes are aided by using slightly convex lenses. Such glasses supplement the lenses of the eye, making possible a clear vision of a near object while the eyes are really looking far away or, in other words, making possible a clear image of a near object upon the retina of the unadjusted eye. Stereoscopic pictures are usually so mounted that " identical points " on the two pictures are farther apart than the interocular distance and therefore the two images cannot be combined when the optical axes of the eyes are parallel or nearly so, which is the condition when looking at a distant object. In such a case the two pictures must be brought closer together.

In Figs. 2 and 3 are found " dissimilar " drawings

of the correct dissimilarity of stereoscopic pictures. It is interesting and instructive to practice combining these with the unaided eyes. If Fig. 2 is held at an arm's length and the eyes are focused upon a point several inches distant, the axes will be sufficiently

Fig. 2. — Stereoscopic pictures for combining by converging or diverging the optical axes.

converged so that the two images are superposed. It may help to focus the eyes upon the tip of a finger until the stereoscopic images are combined. In this case of converging axes the final combined result will be the appearance of a hollow tube or of a shell of a truncated cone, apparently possessing the third dimension and being perceived as apparently smaller than the actual pictures in the background at arm's

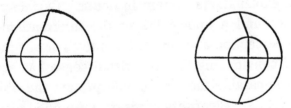

Fig. 3. — Stereoscopic pictures.

length. If the two stereoscopic pictures are combined by looking at a point far beyond the actual position of Fig. 2, the combined effect is a solid truncated cone but perceived as of about the same size and at about the same distance from the eye as the actual

diagrams. In the latter case the smaller end of the apparent solid appears to be nearer than the larger end, but in the former case the reverse is true, that is, the smaller end appears to be at a greater distance. The same experiments may be performed for Fig. 3 with similar results excepting that this appears to be a shell under the same circumstances that Fig. 2 appears to be a solid and vice versa. A few patient trials should be rewarded by success, and if so the reader can gain much more understanding from the actual experiences than from description.

The foregoing discussion of vision should indicate the complexity of the visual and mental activities involved in the discrimination, association, and interpretation of the data obtained through the eye. The psychology of visual perception is still a much controverted domain but it is believed that the glimpses of the process of vision which have been afforded are sufficient to enable the reader to understand many illusions and at least to appreciate more fully those whose explanations remain in doubt. Certainly these glimpses and a knowledge of the information which visual perception actually supplies to us at any moment should convince us that the visual sense has acquired an incomparable facility for interpreting the objective world for us. Clearness of vision is confined to a small area about the point of sight, and it rapidly diminishes away from this point, images becoming dim and double. We sweep this point of sight backward and forward and over an extensive field of view, gathering all the distinct impressions into one mental image. In doing this the unconscious interpretation of the

muscular activity attending accommodation and con-
vergence of the eyes aids in giving to this mental
picture the appearance of depth by establishing relative
distances of various objects. Certainly the acquired
facility is remarkable.

IV

SOME TYPES OF GEOMETRICAL ILLUSIONS

NO simple classification of illusions is ample or satisfactory, for there are many factors interwoven. For this reason no claims are made for the various divisions of the subject represented by and in these chapters excepting that of convenience. Obviously, some divisions are necessary in order that the variegated subject may be presentable. The classification used appears to be logical but very evidently it cannot be perfectly so when the " logic " is not wholly available, owing to the disagreement found among the explanations offered by psychologists. It may be argued that the " geometrical " type of illusion should include many illusions which are discussed in other chapters. Indeed, this is perhaps true. However, it appears to suit the present purpose to introduce this phase of this book by a group of illusions which involve plane geometrical figures. If some of the latter appear in other chapters, it is because they seem to border upon or to include other factors beyond those apparently involved in the simple geometrical type. The presentation which follows begins (for the sake of clearness) with a few representative geometrical illusions of various types.

The Effect of the Location in the Visual Field.— One of the most common illusions is found in the

letter "S" or figure "8." Ordinarily we are not strongly conscious of a difference in the size of the upper and lower parts of these characters; however, if we invert them (8888 SSSS) the difference is seen to be large. The question arises, Is the difference due fundamentally to the locations of the two parts in the visual field? It scarcely seems credible that visual perception innately appraises the upper part larger than the lower, or the lower smaller than the upper part when these small characters are seen in their accustomed position. It appears to be possible that here we have examples of the effect of learning or experience and that our adaptive visual sense has become accustomed to overlook the actual difference. That is, for some reason through being confronted with this difference so many times, the intellect has become adapted to it and, therefore, has grown to ignore it. Regardless of the explanation, the illusion exists and this is the point of chief interest. For the same reason the curvature of the retina does not appear to account for illusion through distortion of the image, because the training due to experience has caused greater difficulties than this to disappear. We must not overlook the tremendous " corrective " influence of experience upon which visual perception for the adult is founded. If we have learned to " correct " in some cases, why not in all cases which we have encountered quite generally?

This type of illusion persists in geometrical figures and may be found on every hand. A perfect square when viewed vertically appears too high, although the illusion does not appear to exist in the circle. In

Fig. 4 the vertical line appears longer than the horizontal line of the same length. This may be readily demonstrated by the reader by means of a variety of figures. A striking case is found in Fig. 5, where the height and the width of the diagram of a silk hat are equal. Despite the actual equality the height appears

Fig. 4. — The vertical line appears longer than
the equal horizontal line in each case.

to be much greater than the width. A pole or a tree is generally appraised as of greater length when it is standing than when it lies on the ground. This illusion may be demonstrated by placing a black dot an inch or so above another on a white paper. Now, at right angles to the original dot place another at a horizontal distance which appears equal to the vertical distance of the first dot above the original. On turning the paper through ninety degrees or by actual measurement, the extent of the illusion will become apparent. By doing this several times, using various distances, this type of illusion becomes convincing.

The explanation accepted by some is that more effort is required to raise the eyes, or point of sight, through a certain vertical distance than through an equal horizontal distance. Perhaps we unconsciously appraise effort of this sort in terms of distance, but is it not logical to inquire why we have not through

Fig. 5. — The vertical dimension is equal to the horizontal one, but the former appears greater.

experience learned to sense the difference between the relation of effort to horizontal distance and that of effort to vertical distance through which the point of sight is moved? We are doing this continuously, so why do we not learn to distinguish; furthermore, we have overcome other great obstacles in developing our visual sense. In this complex field of physiological psychology questions are not only annoying, but often disruptive.

As has been pointed out in Chapter II, images of objects lying near the periphery of the visual field are more or less distorted, owing to the structure and to certain defects of parts of the eye. For example, a checkerboard viewed at a proper distance with respect to its size appears quite distorted in its outer regions. Cheap cameras are likely to cause similar errors in the images fixed upon the photographic plate. Photographs are interesting in connection with visual illusions, because of certain distortions and of the magnification of such aspects as perspective. Incidentally in looking for illusions, difficulty is sometimes experienced in seeing them when the actual physical truths are known; that is, in distinguishing between what is actually seen and what actually exists. The ability to make this separation grows with practice but where the difficulty is obstinate, it is well for the reader to try observers who do not suspect the truth.

Illusions of Interrupted Extent. — Distance and area appear to vary in extent, depending upon whether they are filled or empty or are only partially filled. For example, a series of dots will generally appear longer overall than an equal distance between two points. This may be easily demonstrated by arranging three dots in a straight line on paper, the two intervening spaces being of equal extent, say about one or two inches long. If in one of the spaces a series of a dozen dots is placed, this space will appear longer than the empty space. However, if only one dot is placed in the middle of one of the empty spaces, this space now is likely to appear of less extent than the

mpty space. (See Fig. 7.) A specific example of this
ype of illusion is shown in Fig. 6. The filled or di-
ided space generally appears greater than the empty
r undivided space, but certain qualifications of this
tatement are necessary. In *a* the divided space
nquestionably appears greater than the empty space.
Apparently the filled or empty space is more important

a

b

c

ig. 6. — The divided or filled space on the left appears longer than the equal
space on the right.

han the amount of light which is received from the
lear spaces, for a black line on white paper appears
onger than a white space between two points sep-
rated a distance equal to the length of the black line.
Furthermore, apparently the spacing which is the
nost obtrusive is most influential in causing the
livided space to appear greater for *a* than for *b*. The
llusion still persists in *c*.

An idea of the magnitude may be gained from
ertain experiments by Aubert. He used a figure
imilar to *a* Fig. 6 containing a total of five short lines.

Four of them were equally spaced over a distance
of 100 mm. corresponding to the left half of *a*, Fig. 6.
The remaining line was placed at the extreme right
and defined the limit of an empty space also 100 mm.
long. In all cases, the length of the empty space ap-
peared about ten per cent less than that of the space

a *b* *c*

Fig. 7. — The three lines are of equal length.

occupied by the four lines equally spaced. Various
experimenters obtain different results, and it seems
reasonable that the differences may be accounted
for, partially at least, by different degrees of uncon-
scious correction of the illusion. This emphasizes the
desirability of using subjects for such experiments
who have no knowledge pertaining to the illusion.

As already stated there are apparent exceptions
to any simple rule, for, as in the case of dots cited in a
preceding paragraph, the illusion depends upon the

Fig. 8. — The distance between the two circles on the left is equal to the
distance between the outside edges of the two circles on the right.

manner in which the division is made. For example,
in Fig. 7, *a* and *c* are as likely to appear shorter than
b as equal to it. It has been concluded by certain
investigators that when subdivision of a line causes
it to appear longer, the parts into which it is divided
or some of them are likely to appear shorter than
isolated lines of the same length. The reverse of
this statement also appears to hold. For example in

Fig. 7, *a* appears shorter than *b* and the central part appears lengthened, although the total line appears shortened. This illusion is intensified by leaving the central section blank. A figure of this sort can be readily drawn by the reader by using short straight lines in place of the circles in Fig. 8. In this figure the space between the inside edges of the two circles on the left appears larger than the overall distance between the outside edges of the two circles on the right, despite the fact that these distances are equal. It appears that mere intensity of retinal stimulation does not account for these illusions, but rather the figures which we see.

In Fig. 9 the three squares are equal in dimensions but the different characters of the divisions cause them to appear not only unequal, but no longer squares. In Fig. 10

c

b

a

Fig. 9. — Three squares of equal dimensions which appear different in area and dimension.

the distance between the outside edges of the three circles arranged horizontally appears greater than the empty space between the upper circle and the left-hand circle of the group.

Illusions of Contour. — The illusions of this type, or exhibiting this influence, are quite numerous. In

Fig. 10. — The vertical distance between the upper circle and the left-hand one of the group is equal to the overall length of the group of three circles.

Fig. 11 there are two semicircles, one closed by a diameter, the other unclosed. The latter appears somewhat flatter and of slightly greater radius than the closed one. Similarly in Fig. 12 the shorter portion of the interrupted circumference of a circle appears flatter and of greater radius of curvature than the greater portions. In Fig. 13 the length of the

middle space and of the open-sided squares are equal. In fact there are two uncompleted squares and an empty " square " between, the three of which are of equal dimensions. However the middle space ap-

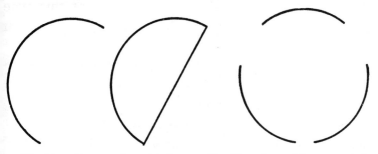

Fig. 11. — Two equal semicircles. Fig. 12. — Arcs of the same circle

pears slightly too high and narrow; the other two appear slightly too low and broad. These figures are related to the well-known Müller-Lyer illusion illustrated in Fig. 56. Some of the illusions presented later will be seen to involve the influence of contour.

Fig. 13. — Three incomplete but equal squares.

Examples of these are Figs. 55 and 60. In the former, the horizontal base line appears to sag; in the latter, the areas appear unequal, but they are equal.

Illusions of Contrast. — Those illusions due to brightness contrast are not included in this group,

for " contrast " here refers to lines, angles and areas of different sizes. In general, parts adjacent to large extents appear smaller and those adjacent to small extents appear larger. A simple case is shown in

Fig. 14. — Middle sections of the two lines are equal.

Fig. 14, where the middle sections of the two lines are equal, but that of the shorter line appears longer than that of the longer line. In Fig. 15 the two parts of the connecting line are equal, but they do not appear so. This illusion is not as positive as the preceding one and, in fact, the position of the short vertical dividing line may appear to fluctuate considerably.

Fig. 15. — An effect of contrasting areas (Baldwin's figure).

Fig. 16 might be considered to be an illusion of contour, but the length of the top horizontal line of the lower figure being apparently less than that of the top line of the upper figure is due largely to contrasting the two figures. Incidentally, it is difficult to believe that the maximum horizontal width of the lower figure is as great as the maximum height of the figure. At this point it is of interest to refer to other contrast illusions such as Figs. 20, 57, and 59.

A striking illusion of contrast is shown in Fig. 17, where the central circles of the two figures are equal, although the one surrounded by the large circles appears much smaller than the other. Similarly, in Fig. 18 the inner circles of *b* and *c* are equal but that of *b* appears the larger. The inner circle of *a* appears

Fig. 16. — An illusion of contrast.

larger than the outer circle of *b*, despite their actual equality.

In Fig. 19 the circle nearer the apex of the angle appears larger than the other. This has been presented as one reason why the sun and moon appear larger at the horizon than when at higher altitudes. This explanation must be based upon the assumption that we interpret the "vault" of the sky to meet

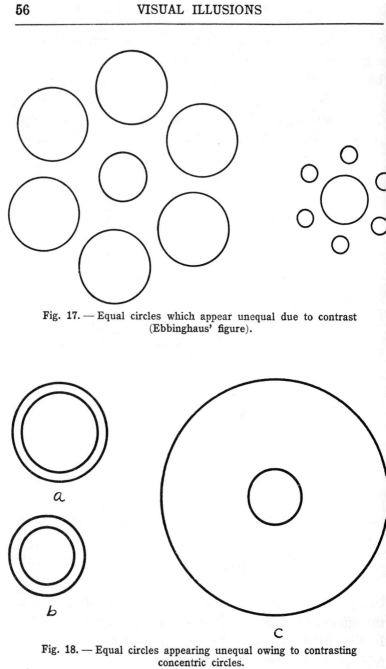

Fig. 17. — Equal circles which appear unequal due to contrast (Ebbinghaus' figure).

Fig. 18. — Equal circles appearing unequal owing to contrasting concentric circles.

at the horizon in a manner somewhat similar to the angle but it is difficult to imagine such an angle made by the vault of the sky and the earth's horizon. If

Fig. 19. — Circles influenced by position within an angle.

there were one in reality, it would not be seen in profile.

If two angles of equal size are bounded by small and large angles respectively, the apex in each case

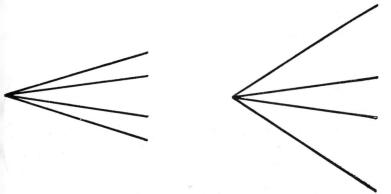

Fig. 20. — Contrasting angles.

being common to the inner and two bounding angles, the effect of contrast is very apparent, as seen in Fig. 20. In Fig. 57 are found examples of effects of lines contrasted as to length.

The reader may readily construct an extensive variety of illusions of contrast; in fact, contrast plays a part in most geometrical-optical illusions. The

Fig. 21. — Owing to perspective the right angles appear oblique and vice versa.

contrasts may be between existing lines, areas, etc., or the imagination may supply some of them.

Illusions of Perspective. — As the complexity of figures is increased the number of possible illusions

Fig. 22. — Two equal diagonals which appear unequal.

is multiplied. In perspective we have the influences of various factors such as lines, angles, and sometimes contour and contrast. In Fig. 21 the sug-

gestion due to the perspective of the cube causes right angles to appear oblique and oblique angles to appear to be right angles. This figure is particularly illusive. It is interesting to note that even an after-image of a right-angle cross when projected upon a wall drawn in perspective in a painting will appear oblique.

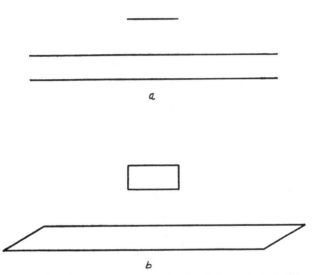

Fig. 23. — Apparent variations in the distance between two parallel lines.

A striking illusion involving perspective, or at least the influence of angles, is shown in Fig. 22. Here the diagonals of the two parallelograms are of equal length but the one on the right appears much smaller. That AX is equal in length to AY is readily demonstrated by describing a circle from the center A and with a radius equal to AX. It will be found to pass through the point Y. Obviously, geometry abounds in geometrical-optical illusions.

The effect of contrast is seen in *a* in Fig. 23; that is, the short parallel lines appear further apart than the pair of long ones. By adding the oblique lines at the ends of the lower pair in *b*, these parallel lines

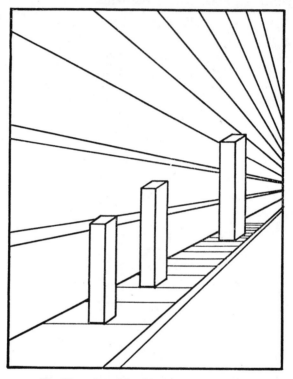

Fig. 24. — A striking illusion of perspective.

now appear further apart than the horizontal parallel lines of the small rectangle.

The influence of perspective is particularly apparent in Fig. 24, where natural perspective lines are drawn to suggest a scene. The square columns are of the same size but the further one, for example, being apparently the most distant and of the same

physical dimensions, actually appears much larger.
Here is a case where experience, allowing for a di-
minution of size with increasing distance, actually
causes the column on the right to appear larger than
it really is. The artist will find this illusion even more

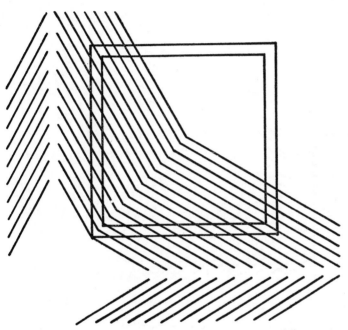

Fig. 25. — Distortion of a square due to superposed lines.

striking if he draws three human figures of the same
size but similarly disposed in respect to perspective
lines. Apparently converging lines influence these
equal figures in proportion as they suggest perspective.

Although they are not necessarily illusions of
perspective, Figs. 25 and 26 are presented here be-
cause they involve similar influences. In Fig. 25 the
hollow square is superposed upon groups of oblique
lines so arranged as to apparently distort the square.

In Fig. 26 distortions of the circumference of a circle are obtained in a similar manner.

It is interesting to note that we are not particularly conscious of perspective, but it is seen that it

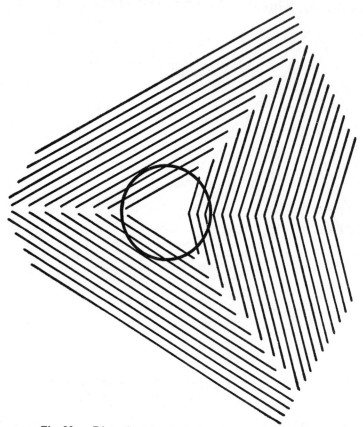

Fig. 26. — Distortion of a circle due to superposed lines.

has been a factor in the development of our visual perception. In proof of this we might recall the first time as children we were asked to draw a railroad track trailing off in the distance. Doubtless, most of us drew two parallel lines instead of converging ones.

A person approaching us is not sensibly perceived to grow. He is more likely to be perceived all the time as of normal size. The finger held at some distance may more than cover the object such as a distant person, but the finger is not ordinarily perceived as larger than the person. Of course, when we think of it we are conscious of perspective and of the increase in size of an approaching object. When a locomotive or automobile approaches very rapidly, this "growth" is likely to be so striking as to be generally noticeable. The reader may find it of interest at this point to turn to illustrations in other chapters.

The foregoing are a few geometrical illusions of representative types. These are not all the types of illusions by any means and they are only a few of an almost numberless host. These have been presented in a brief classification in order that the reader might not be overwhelmed by the apparent chaos. Various special and miscellaneous geometrical illusions are presented in later chapters.

V

EQUIVOCAL FIGURES

MANY figures apparently change in appearance owing to fluctuations in attention and in associations. A human profile in intaglio (Figs. 72 and 73) may appear as a bas-relief. Crease a card in the middle to form an angle and hold it at an arm's length. When viewed with one eye it can be made to appear open in one way or the other; that is, the angle may be made to appear pointing toward the observer or away from him. The more distant part of an object may be made to appear nearer than the remaining part. Plane diagrams may seem to be solids. Deception of this character is quite easy if the light-source and other extraneous factors are concealed from the observer. It is very interesting to study these fluctuating figures and to note the various extraneous data which lead us to judge correctly. Furthermore, it becomes obvious that often we see what we expect to see. For example, we more commonly encounter relief than intaglio; therefore, we are likely to think that we are looking at the former.

Proper consideration of the position of the dominant light-source and of the shadows will usually provide the data for a correct conclusion. However, habit and probability are factors whose influence is difficult to overcome. Our perception is strongly

associated with accustomed ways of seeing objects and when the object is once suggested it grasps our mind completely in its stereotyped form. Stairs, glasses, rings, cubes, and intaglios are among the objects commonly used to illustrate this type of illusion. In connection with this type, it is well to

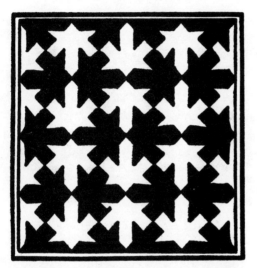

Fig. 27. — Illustrating fluctuation of attention.

realize how tenaciously we cling to our perception of the real shapes of objects. For example, a cube thrown into the air in such a manner that it presents many aspects toward us is throughout its course a cube.

The figures which exhibit these illusions are obviously those which are capable of two or more spatial relations. The double interpretation is more readily accomplished by monocular than by binocular vision. Fig. 27 consists of identical patterns in black and white. By gazing upon this steadily it will appear

to fluctuate in appearance from a white pattern upon a black background to a black pattern upon a white background. Sometimes fluctuation of attention apparently accounts for the change and, in fact, this can be tested by willfully altering the attention from a white pattern to a black one. Incidentally one in-

Fig. 28. — The grouping of the circles fluctuates.

vestigator found that the maximum rate of fluctuation was approximately equal to the pulse rate, although no connection between the two was claimed. It has also been found that inversion is accompanied by a change in refraction of the eye.

Another example is shown in Fig. 28. This may appear to be white circles upon a black background or a black mesh upon a white background. However, the more striking phenomenon is the change in the grouping of the circles as attention fluctuates. We may be conscious of hollow diamonds of circles, one inside the other, and then suddenly the pattern may change to groups of diamonds consisting of four

circles each. Perhaps we may be momentarily conscious of individual circles; then the pattern may change to a hexagonal one, each "hexagon" consisting of seven circles — six surrounding a central one. The pattern also changes into parallel strings of circles, triangles, etc.

Fig. 29. — Crossed lines which may be interpreted in two ways.

The crossed lines in Fig. 29 can be seen as right angles in perspective with two different spatial arrangements of one or both lines. In fact there is quite a tendency to see such crossed lines as right angles in perspective. The two groups on the right represent a simplified Zöllner's illusion (Fig. 37). The reader may find it interesting to spend some time viewing these figures and in exercising his ability to fluctuate his attention. In fact, he must call upon his imagination in these cases. Sometimes the

changes are rapid and easy to bring about. At other moments he will encounter an aggravating stubbornness. Occasionally there may appear a conflict of two appearances simultaneously in the same figure. The latter may be observed occasionally in Fig. 30.

Fig. 30. — Reversible cubes.

Eye-movements are brought forward by some to aid in explaining the changes.

In Fig. 30 a reversal of the aspect of the individual cubes or of their perspective is very apparent. At rare moments the effect of perspective may be completely vanquished and the figure be made to appear as a plane crossed by strings of white diamonds and zigzag black strips.

The illusion of the bent card or partially open book is seen in Fig. 31. The tetrahedron in Fig. 32 may appear either as erect on its base or as leaning backward with its base seen from underneath.

The series of rings in Fig. 33 may be imagined

Fig. 31. — The reversible " open book " (after Mach).

Fig. 32. — A reversible tetrahedron.

to form a tube such as a sheet-metal pipe with its axis lying in either of two directions. Sometimes by closing one eye the two changes in this type of illusion are more readily brought about. It is also interesting to close and open each eye alternately, at the same time trying to note just where the attention is fixed.

The familiar staircase is represented in Fig. 34. It is likely to appear in its usual position and then

suddenly to invert. It may aid in bringing about the reversal to insist that one end of a step is first nearer than the other and then farther away. By focusing

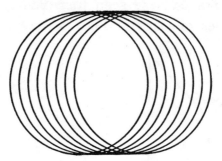

Fig. 33. — Reversible perspective of a group of rings or of a tube.

the attention in this manner the fluctuation becomes an easy matter to obtain.

In Fig. 35 is a similar example. First one part

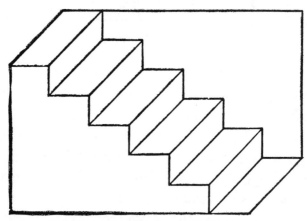

Fig. 34. — Schröder's reversible staircase.

will appear solid and the other an empty corner, then suddenly both are reversed. However, it is striking to note one half changes while the other remains un-

changed, thus producing momentarily a rather peculiar figure consisting of two solids, for example, attached by necessarily warped surfaces.

Perhaps the reader has often witnessed the striking illusion of some portraits which were made of sub-

Fig. 35. — Thiéry's figure.

jects looking directly at the camera or painter. Regardless of the position of the observer the eyes of the portrait appear to be directed toward him. In fact, as the observer moves, the eyes in the picture follow him so relentlessly as to provoke even a feeling of uncanniness. This fact is accounted for by the absence of a third dimension, for a sculptured model of a head does not exhibit this feature. Perspective plays a part in some manner, but no attempt toward explanation will be made.

In Fig. 36 are two sketches of a face. One appears to be looking at the observer, but the other does not. If the reader will cover the lower parts of the two figures, leaving only the two pairs of eyes showing, both pairs will eventually appear to be looking at the observer. Perhaps the reader will be conscious of mental effort and the lapse of a few moments before the eyes on the left are made to appear to be looking directly at him. Although it is not claimed that this illusion is caused by the same conditions as those immediately preceding, it involves attention. At least, it is fluctuating in appearance and therefore is equivocal. It is interesting to note the influence of the other features (below the eyes). The perspective of these is a powerful influence in " directing " the eyes of the sketch.

In the foregoing only definite illusions have been presented which are universally witnessed by normal persons. There are no hallucinatory phases in the conditions or causes. It is difficult to divide these with definiteness from certain illusions of depth as discussed in Chapter VII. The latter undoubtedly are sometimes entwined to some extent with hallucinatory phases; in fact, it is doubtful if they are not always hallucinations to some degree. Hallucinations are not of interest from the viewpoint of this book, but illusions of depth are treated because they are of interest. They are either hallucinations or are on the border-line between hallucinations and those illusions which are almost universally experienced by normal persons under similar conditions. The latter statement does not hold for illusions of depth in

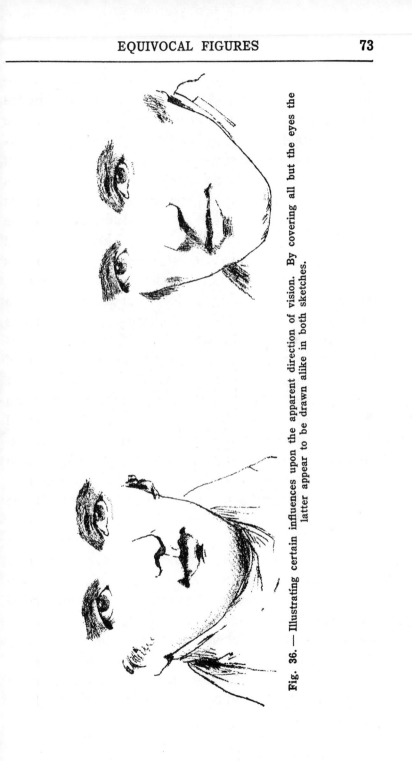

Fig. 36. — Illustrating certain influences upon the apparent direction of vision. By covering all but the eyes the latter appear to be drawn alike in both sketches.

which objects may be seen alternately near and far, large and small, etc., although they are not necessarily pure hallucinations as distinguished from the types of illusions regarding which there is general perceptual agreement.

In explanation of the illusory phenomena pertaining to such geometrical figures as are discussed in the foregoing paragraphs, chiefly two different kinds of hypotheses have been offered. They are respectively psychological and physiological, although there is more or less of a mixture of the two in most attempts toward explanation. The psychological hypotheses introduce such factors as attention, imagination, judgment, and will. Hering and also Helmholtz claim that the kind of inversion which occurs is largely a matter of chance or of volition. The latter holds that the perception of perspective figures is influenced by imagination or the images of memory. That is, if one form of the figure is vividly imagined the perception of it is imminent. Helmholtz has stated that, "Glancing at a figure we observe spontaneously one or the other form of perspective and usually the one that is associated in our memory with the greatest number of images."

The physiological hypotheses depend largely upon such factors as accommodation and eye-movement. Necker held to the former as the chief cause. He has stated that the part of the figure whose image lies near the fovea is estimated as nearer than those portions in the peripheral regions of the visual field. This hypothesis is open to serious objections. Wundt contends that the inversion is caused by changes in the points and lines of fixation. He says, " The image

of the retina ought to have a determined position if a perspective illusion is to appear; but the form of this illusion is entirely dependent on motion and direction." Some hypotheses interweave the known facts of the nervous system with psychological facts but some of these are examples of a common anomaly in theorization, for facts plus facts do not necessarily result in a correct theory. That is, two sets of facts interwoven do not necessarily yield an explanation which is correct.

VI

THE INFLUENCE OF ANGLES

A S previously stated, no satisfactory classification of visual illusions exists, but in order to cover the subject, divisions are necessary. For this reason the reader is introduced in this chapter to the effects attending the presence of angles. By no means does it follow that this group represents another type, for it really includes many illusions of several types. The reason for this grouping is that angles play an important part, directly or indirectly, in the production of illusions. For a long time many geometrical illusions were accounted for by "over-estimation" or "underestimation" of angles, but this view has often been found to be inadequate. However, it cannot be denied that many illusions are due at least to the presence of angles.

Apparently Zöllner was the first to describe an illusion which is illustrated in simple form in Fig. 29 and more elaborately in Figs. 37 to 40. The two figures at the right of Fig. 29 were drawn for another purpose and are not designed favorably for the effect, although it may be detected when the figure is held at a distance. Zöllner accidentally noticed the illusion on a pattern designed for a print for dress-goods. The illusion is but slightly noticeable in Fig. 29, but by multiplying the number of lines (and angles) the long parallel lines appear to diverge in

76

the direction that the crossing lines converge. Zöllner studied the case thoroughly and established various facts. He found that the illusion is greatest when the long parallel lines are inclined about 45 degrees to the horizontal. This may be accomplished for Fig. 37, by turning the page (held in a vertical plane) through

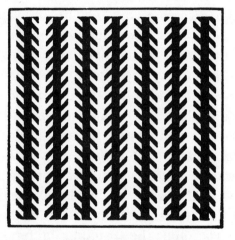

Fig. 37. — Zöllner's illusion of direction.

an angle of 45 degrees from normal. The illusion vanishes when held too far from the eye to distinguish the short crossing lines, and its strength varies with the inclination of the oblique lines to the main parallels. The most effective angle between the short crossing lines and the main parallels appears to be approximately 30 degrees. In Fig. 37 there are two illusions of direction. The parallel vertical strips appear unparallel and the right and left portions of the oblique cross-lines appear to be shifted vertically. It is interesting to note that steady fixation diminishes and even destroys the illusion.

The maximum effectiveness of the illusion, when the figure is held so that the main parallel lines are at an inclination of about 45 degrees to the horizontal was accounted for by Zöllner as the result of less visual experience in oblique directions. He insisted that it takes less time and is easier to infer divergence or convergence than parallelism. This explanation appears to be disproved by a figure in which slightly divergent lines are used instead of parallel ones. Owing to the effect of the oblique crossing lines, the diverging lines may be made to appear parallel. Furthermore it is difficult to attach much importance to Zöllner's explanation because the illusion is visible under the extremely brief illumination provided by one electric spark. Of course, the duration of the physiological reaction is doubtless greater than that of the spark, but at best the time is very short. Hering explained the Zöllner illusion as due to the curvature of the retina, and the resulting difference in the retinal images, and held that acute angles appear relatively too large and obtuse ones too small. The latter has been found to have limitations in the explanation of certain illusions.

This Zöllner illusion is very striking and may be constructed in a variety of forms. In Fig. 37 the effect is quite apparent and it is interesting to view the figure at various angles. For example, hold the figure so that the broad parallel lines are vertical. The illusion is very pronounced in this position; however, on tilting the page backward the illusion finally disappears. In Fig. 38 the short oblique lines do not cross the long parallel lines and to make the

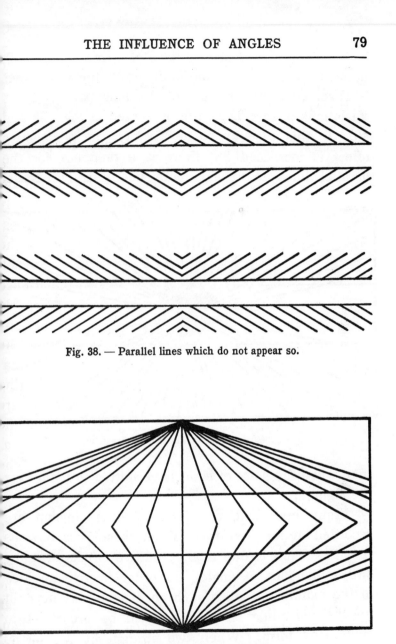

Fig. 38. — Parallel lines which do not appear so.

Fig. 39. — Wundt's illusion of direction.

illusion more striking, the obliquity of the short lines is reversed at the middle of the long parallel lines. Variations of this figure are presented in Figs. 39 and 40. In this case by steady fixation the perspective effect is increased but there is a tendency for the parallel lines to appear more nearly truly parallel

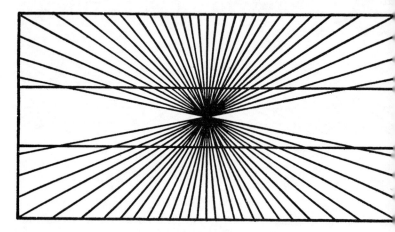

Fig. 40. — Hering's illusion of direction.

than when the point of sight is permitted to roam over the figures.

Many investigations of the Zöllner illusion are recorded in the literature. From these it is obvious that the result is due to the additive effects of many simple illusions of angle. In order to give an idea of the manner in which such an illusion may be built up the reasoning of Jastrow [1] will be presented in condensed form. When two straight lines such as A and B in Fig. 41 are separated by a space it is usually possible to connect the two mentally and to determine whether or not, if connected, they would lie

on a straight line. However, if another line is connected to one, thus forming an angle as *C* does with *A*, the lines which appeared to be continuous (as *A* and *B* originally) no longer appear so. The converse is also true, for lines which are not in the same straight line may be made to appear to be by the addition of another line forming a proper angle. All these vari-

Fig. 41. — Simple effect of angles.

ations cannot be shown in a single figure, but the reader will find it interesting to draw them. Furthermore, the letters used on the diagram in order to make the description clearer may be confusing and these can be eliminated by redrawing the figure. In Fig. 41 the obtuse angle *AC* tends to tilt *A* downward, so apparently if *A* were prolonged it would fall below *B*. Similarly, *C* appears to fall to the right of *D*.

This illusion apparently is due to the presence of

the angle and the effect is produced by the presence of right and acute angles to a less degree. The illusion decreases or increases in general as the angle decreases or increases respectively.

Although it is not safe to present simple statements in a field so complex as that of visual illusion where explanations are still controversial, it is perhaps possible to generalize as Jastrow did in the foregoing case as follows: If the direction of an angle is that of the line bisecting it and pointing toward the apex, the direction of the sides of an angle will apparently be deviated toward the direction of the angle. The deviation apparently is greater with obtuse than with acute angles, and when obtuse and acute angles are so placed in a figure as to give rise to opposite deviations, the greater angle will be the dominant influence.

Although the illusion in such simple cases as Fig. 41 is slight, it is quite noticeable. The effect of the addition of many of these slight individual influences is obvious in accompanying figures of greater complexity. These individual effects can be so multiplied and combined that many illusory figures may be devised.

In Fig. 42 the oblique lines are added to both horizontal lines in such a manner that *A* is tilted downward at the angle and *B* is tilted upward at the angle (the letters corresponding to similar lines in Fig. 41). In this manner they appear to be deviated considerably out of their true straight line. If the reader will draw a straight line nearly parallel to *D* in Fig. 41 and to the right, he will find it helpful.

This line should be drawn to appear to be a continuation of *C* when the page is held so *D* is approximately horizontal. This is a simple and effective means of testing the magnitude of the illusion, for it

Fig. 42. The effect of two angles in tilting the horizontal lines.

is measured by the degree of apparent deviation between *D* and the line drawn adjacent to it, which the eye will tolerate. Another method of obtaining such a measurement is to begin with only the angle and to draw the apparent continuation of one of its

Fig. 43. The effect of crossed lines upon their respective apparent directions.

lines with a space intervening. This deviation from the true continuation may then be readily determined.

A more complex case is found in Fig. 43 where the effect of an obtuse angle *ACD* is to make the continu-

ation of *AB* apparently fall below *FG* and the effect
of the acute angle is the reverse. However, the net
result is that due to the preponderance of the effect
of the larger angle over that of the smaller. The line
EC adds nothing, for it merely introduces two angles
which reinforce those above *AB*. The line *BC* may
be omitted or covered without appreciably affecting
the illusion.

In Fig. 44 two obtuse angles are arranged so that
their effects are additive, with the result that the

Fig. 44. — Another step toward the Zöllner illusion.

horizontal lines apparently deviate maximally for such
a simple case. Thus it is seen that the tendency of
the sides of an angle to be apparently deviated toward
the direction of the angle may result in an apparent
divergence from parallelism as well as in making
continuous lines appear discontinuous. The illusion
in Fig. 44 may be strengthened by adding more lines
parallel to the oblique lines. This is demonstrated
in Fig. 38 and in other illustrations. In this manner
striking illusions are built up.

If oblique lines are extended across vertical ones,
as in Figs. 45 and 46, the illusion is seen to be very
striking. In Fig. 45 the oblique line on the right is

extended would meet the upper end of the oblique line on the left; however, the apparent point of intersection is somewhat lower than it is in reality. In Fig. 46 the oblique line on the left is in the same straight line with the lower oblique line on the right. The line drawn parallel to the latter furnishes an idea of the extent of the illusion. This is the well-known Poggendorff illusion. The upper oblique line on the

Fig. 45. — The two diagonals would meet on the left vertical line.

Fig. 46. — Poggendorff's illusion. Which oblique line on the right is the prolongation of the oblique line on the left?

right actually appears to be approximately the continuation of the upper oblique line on the right. The explanation of this illusion on the simple basis of underestimation or overestimation of angles is open to criticism. If Fig. 46 is held so that the intercepted line is horizontal or vertical, the illusion disappears or at least is greatly reduced. It is difficult to reconcile this disappearance of the illusion for certain positions of the figure with the theory that the illusion is due to an incorrect appraisal of the angles.

According to Judd,[2] those portions of the parallels lying on the obtuse-angle side of the intercepted line will be overestimated when horizontal or vertical distances along the parallel lines are the subjects of attention, as they are in the usual positions of the Poggendorff figure. He holds further that the over-estimation of this distance along the parallels (the two vertical lines) and the underestimation of the oblique distance across the interval are sufficient to provide a full explanation of the illusion. The disappearance and appearance of the illusion, as the position of the figure is varied appears to demonstrate the fact that lines produce illusions only when they have a direct influence on the direction in which the attention is turned. That is, when this Poggendorff figure is in such a position that the intercepted line is horizontal, the incorrect estimation of distance along the parallels has no direct bearing on the distance to which the attention is directed. In this case Judd holds that the entire influence of the parallels is absorbed in aiding the intercepted line in carrying the

Fig. 47. — A straight line appears to sag.

eye across the interval. For a detailed account the reader is referred to the original paper.

Some other illusions are now presented to demonstrate further the effect of the presence of angles. Doubtless, in some of these, other causes contribute

more or less to the total result. In Fig. 47 a series of concentric arcs of circles end in a straight line. The result is that the straight line appears to sag perceptibly. Incidentally, it may be interesting for the reader to ascertain whether or not there is any doubt in his mind as to the arcs appearing to belong to

Fig. 48. — Distortions of contour due to contact with other contours.

circles. To the author the arcs appear distorted from those of true circles.

In Fig. 48 the bounding figure is a true circle but it appears to be distorted or dented inward where the angles of the hexagon meet it. Similarly, the sides of the hexagon appear to sag inward where the corners of the rectangle meet them.

The influences which have been emphasized apparently are responsible for the illusions in Figs. 49, 50 and 51. It is interesting to note the disappearance of the illusion, as the plane of Fig. 49 is varied from

vertical toward the horizontal. That is, it is very apparent when viewed perpendicularly to the plane of the page, the latter being held vertically, but as the page is tilted backward the illusion decreases and finally disappears.

The illusions in Figs. 50 and 51 are commonly

Fig. 49. — An illusion of direction.

termed " twisted cord " effects. A cord may be made by twisting two strands which are white and black (or any dark color) respectively. This may be super-posed upon various backgrounds with striking results. In Fig. 50 the straight " cords " appear bent in the middle, owing to a reversal of the " twist." Such a

figure may be easily made by using cord and a
checkered cloth. In Fig. 51 it is difficult to convince

Fig. 50. — " Twisted-cord " illusion. These are straight cords.

the intellect that the " cords " are arranged in
the form of concentric circles, but this becomes evi-
dent when one of them is traced out. The influence

Fig. 51. — " Twisted-cord " illusion. These are concentric circles.

of the illusion is so powerful that it is even difficult to follow one of the circles with the point of a pencil around its entire circumference. The cord appears to form a spiral or a helix seen in perspective.

A striking illusion is obtained by revolving the spiral shown in Fig. 52 about its center. This may be considered as an effect of angles because the curva-

Fig. 52. — A spiral when rotated appears to expand or contract, depending upon direction of rotation.

ture and consequently the angle of the spiral is continually changing. There is a peculiar movement or progression toward the center when revolved in one direction. When the direction of rotation is reversed the movement is toward the exterior of the figure; that is, there is a seeming expansion.

Angles appear to modify our judgments of the length of lines as well as of their direction. Of course, it must be admitted that some of these illusions might be classified under those of "contrast" and others. In fact, it has been stated that classification is difficult but it appears logical to discuss the effect of angles

in this chapter apart from the divisions presented in the preceding chapters. This decision was reached because the effect of angles could be seen in many of the illusions which would more logically be grouped under the classification presented in the preceding chapters.

In Fig. 53 the three horizontal lines are of equal length but they appear unequal. This must be due primarily to the size of the angles made by the lines

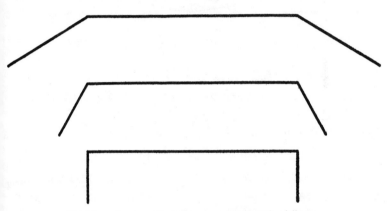

Fig. 53. — Angles affect the apparent length of lines.

at the ends. Within certain limits, the greater the angle the greater is the apparent elongation of the central horizontal portion. This generalization appears to apply even when the angle is less than a right angle, although there appears to be less strength to the illusions with these smaller angles than with the larger angles. Other factors which contribute to the extent of the illusion are the positions of the figures, the distance between them, and the juxta-position of certain lines. The illusion still exists if the horizontal lines are removed and also if the figures

are cut out of paper after joining the lower ends of the short lines in each case.

In Fig. **54** the horizontal straight line appears to consist of two lines tilting slightly upward toward the center. This will be seen to be in agreement with the general proposition that the sides of an angle are deviated in the direction of the angle. In this case

Fig. 54. — The horizontal line appears to tilt downward toward the ends.

it should be noted that one of the obtuse angles to be considered is *ABC* and that the effect of this is to tilt the line *BD* downward from the center. In Fig. **55** the horizontal line appears to tilt upward toward its extremities or to sag in the middle. The explanation in order to harmonize with the foregoing must be based upon the assumption that our judgments may be influenced by things not present but

Fig. 55. — The horizontal line appears to sag in the middle.

imagined. In this case only one side of each obtuse angle is present, the other side being formed by continuing the horizontal line both ways by means of the imagination. That we do this unconsciously is attested to by many experiences. For example, we often find ourselves imagining a horizontal, a vertical, or a center upon which to base a pending judgment.

A discussion of the influence of angles must include a reference to the well-known Müller-Lyer illusion presented in Fig. 56. It is obvious in *a* that the horizontal part on the left appears considerably longer than that part in the right half of the diagram. The influence of angles in this illusion can be easily tested by varying the direction of the lines at the ends of the two portions.

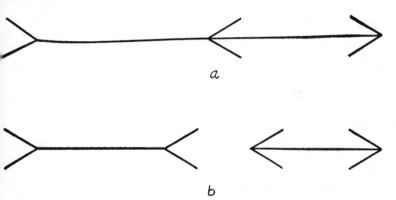

Fig. 56. — The Müller-Lyer illusion.

In all these figures the influence of angles is obvious. This does not mean that they are always solely or even primarily responsible for the illusion. In fact, the illusion of Poggendorff (Fig. 46) may be due to the incorrect estimation of certain linear distances, but the angles make this erroneous judgment possible, or at least contribute toward it. Many discussions of the theories or explanations of these figures are available in scientific literature of which one by Judd [2] may be taken as representative. He holds that the false estimation of angles in the Poggendorff figure is merely a secondary effect, not always

present, and in no case the source of the illusion; furthermore, that the illusion may be explained as due to the incorrect linear distances, and may be reduced to the type of illusion found in the Müller-Lyer figure. Certainly there are grave dangers in explaining an illusion on the basis of an apparently simple operation.

In Fig. 56, *b* is made up of the two parts of the Müller-Lyer illusion. A small dot may be placed equally distant from the inside extremities of the horizontal lines. It is interesting to note that overestimation of distance within the figure is accompanied with underestimation outside the figure and, conversely, overestimation within the figure is accompanied by underestimation in the neighboring space. If the small dot is objected to as providing an additional Müller-Lyer figure of the empty space, this dot may be omitted. As a substitute an observer may try to locate a point midway between the inside extremities of the horizontal lines. The error in locating this point will show that the illusion is present in this empty space.

In this connection it is interesting to note some other illusions. In Fig. 57 the influence of several factors are evident. Two obviously important ones are (1) the angles made by the short lines at the extremities of the exterior lines parallel to the sides of the large triangle, and (2) the influence of contrast of the pairs of adjacent parallel lines. The effect shown in Fig. 53 is seen to be augmented by the addition of contrast of adjacent lines of unequal length.

An interesting variation of the effect of the presence

of angles is seen in Fig. 58. The two lines forming
angles with the horizontal are of equal length but due
to their relative positions, they do not appear so. It
would be quite misleading to say that this illusion is

Fig. 57. — Combined influence of angles and contrasting lengths.

merely due to angles. Obviously, it is due to the
presence of the two oblique lines. It is of interest
to turn to Figs. 25, 26 and various illusions of per-
spective.

Fig. 58. — Two equal oblique lines appear unequal
because of their different positions.

At this point a digression appears to be necessary
and, therefore, Fig. 59 is introduced. Here the areas
of the two figures are equal. The judgment of area is
likely to be influenced by juxtaposed lines and there-
fore, as in this case, the lower appears larger than the

upper one. Similarly two trapezoids of equal dimensions and areas may be constructed. If each is constructed so that it rests upon its longer parallel and one figure is above the other and only slightly separated, the mind is tempted to be influenced by

Fig. 59. — An illusion of area.

comparing the juxtaposed base of the upper with the top of the lower trapezoid. The former dimension being greater than the latter, the lower figure appears smaller than the upper one. Angles must necessarily play a part in these illusions, although it is admitted that other factors may be prominent or even dominant.

This appears to be a convenient place to insert an illusion of area based, doubtless, upon form, but angles must play a part in the illusions; at least they

are responsible for the form. In Fig. 60 the five figures are constructed so as to be approximately equal in area. However, they appear unequal in this respect. In comparing areas, we cannot escape the influence of the length and directions of lines which bound these areas, and also, the effect of contrasts in lengths and directions. Angles play a part in all these, although very indirectly in some cases.

Fig. 60. — Five equal areas showing the influence of angles and contrasting lengths.

To some extent the foregoing is a digression from the main intent of this chapter, but it appears worth while to introduce these indirect effects of the presence of angles (real or imaginary) in order to emphasize the complexity of influences and their subtleness. Direction is in the last analysis an effect of angle; that is, the direction of a line is measured by the angle it makes with some reference line, the latter being real or imaginary. In Fig. 61, the effect of diverting or directing attention by some subtle force, such as suggestion, is demonstrated. This "force" appears to contract or expand an area. The circle on the left appears smaller than the other. Of course there is the effect of empty space compared with partially filled space, but this cannot be avoided in

this case. However, it can be shown that the suggestions produced by the arrows tend to produce apparent reduction or expansion of areas. Note the use of arrows in advertisements.

Although theory is subordinated to facts in this book, a glimpse here and there should be interesting and helpful. After having been introduced to various types and influences, perhaps the reader may better

Fig. 61. — Showing the effect of directing the attention.

grasp the trend of theories. The perspective theory assumes, and correctly so, that simple diagrams often suggest objects in three dimensions, and that the introduction of an imaginary third dimension effects changes in the appearance of lines and angles. That is, lengths and directions of lines are apparently altered by the influence of lines and angles, which do not actually exist. That this is true may be proved in various cases. In fact the reader has doubtless

been convinced of this in connection with some of the illusions already discussed. Vertical lines often represent lines extending away from the observer, who sees them foreshortened and therefore they may seem longer than horizontal lines of equal length, which are not subject to foreshortening. This could explain such illusions as seen in Figs. 4 and 5. However this theory is not as easily applied to many illusions.

According to Thiéry's perspective theory a line that appears nearer is seen as smaller and a line that seems to be further away is perceived as longer. If the left portion of b, Fig. 56, be reproduced with longer oblique lines at the ends but with the same length of horizontal lines, it will appear closer and the horizontal lines will be judged as shorter. The reader will find it interesting to draw a number of these portions of the Müller-Lyer figure with the horizontal line in each case of the same length but with longer and longer obliques at the ends.

The dynamic theory of Lipps gives an important role to the inner activity of the observer, which is not necessarily separated from the objects viewed, but may be felt as being in the objects. That is, in viewing a figure the observer unconsciously separates it from surrounding space and therefore creates something definite in the latter, as a limiting activity. These two things, one real (the object) and one imaginary, are balanced against each other. A vertical line may suggest a necessary resistance against gravitational force, with the result that the line appears longer than a horizontal one resting in peace.

The difficulty with this theory is that it allows too much opportunity for purely philosophical explanations, which are likely to run to the fanciful. It has the doubtful advantage of being able to explain illusions equally well if they are actually reversed from what they are. For example, gravity could either contract or elongate the vertical line, depending upon the choice of viewpoint.

The confusion theory depends upon attention and begins with the difficulty of isolating from illusory figures the portions to be judged. Amid the complexity of the figure the attention cannot easily be fixed on the portions to be judged. This results in confusion. For example, if areas of different shapes such as those in Fig. 60 are to be compared, it is difficult to become oblivious of form or of compactness. In trying to see the two chief parallel lines in Fig. 38, in their true parallelism the attention is being subjected to diversion, by the short oblique parallels with a compromising result. Surely this theory explains some illusions successfully, but it is not so successful with some of the illusions of contrast. The fact that practice in making judgments in such cases as Figs. 45 and 56 reduces the illusion even to ultimate disappearance, argues in favor of the confusion theory. Perhaps the observer devotes himself more or less consciously to isolating the particular feature to be judged and finally attains the ability to do so. According to Auerbach's indirect-vision theory the eyes in judging the two halves of the horizontal line in *a*, Fig. 56, involuntarily draw imaginary lines parallel to this line but above or below it. Obviously

the two parts of such lines are unequal in the same manner as the horizontal line in the Müller-Lyer figure appears divided into two unequal parts.

Somewhat analogous to this in some cases is Brunot's mean-distance theory. According to this we establish " centers of gravity " in figures and these influence our judgments.

These are glimpses of certain trends of theories. None is a complete success or failure. Each explains some illusions satisfactorily, but not necessarily exclusively. For the present, we will be content with these glimpses of the purely theoretical aspects of visual illusions.

ILLUSIONS OF DEPTH AND OF DISTANCE

B ESIDES the so-called geometrical illusions discussed in the preceding chapters, there is an interesting group in which the perception of the third dimension is in error. When any of the ordinary criteria of relief or of distance are apparently modified, illusions of this kind are possible. There are many illusions of this sort, such as the looming of objects in a fog; the apparent enlargement of the sun and moon near the horizon; the flattening of the " vault " of the sky; the intaglio seen as relief; the alteration of relief with lighting; and various changes in the landscape when regarded with the head inverted.

Although some of the criteria for the perception of depth or of distance have already been pointed out, especially in Chapter III, these will be mentioned again. Distance or depth is indicated by the distribution of light and shade, and an unusual object like an intaglio is likely to be mistaken for relief which is more common. An analysis of the lighting will usually reveal the real form of the object. (See Figs. 70, 71, 72, 73, 76 and 77.) In this connection it is interesting to compare photographic negatives with their corresponding positive prints.

Distance is often estimated by the definition and color of objects seen through great depths of

air (aerial perspective). These distant objects are "blurred" by the irregular refraction of the light-rays through non-homogeneous atmosphere. They are obscured to some degree by the veil of brightness due to the illuminated dust, smoke, etc., in the atmosphere. They are also tinted (apparently) by the superposition of a tinted atmosphere. Thus we have "dim distance," "blue peaks," "azure depths of sky," etc., represented in photographs, paintings, and writings. Incidentally, the sky above is blue for the same general reasons that the atmosphere, intervening between the observer and a distant horizon, is bluish. The ludicrous errors made in estimating distances in such regions as the Rockies is usually accounted for by the rare clearness and homogeneity of the atmosphere. However, is the latter a full explanation? To some extent we judge unknown size by estimated distance, and unknown distance by estimated size. When a person is viewing a great mountain peak for the first time, is he not likely to assume it to be comparable in size to the hills with which he has been familiar? Even by allowing considerable, is he not likely to greatly underestimate the size of the mountain and, as a direct consequence, to underestimate the distance proportionately? This incorrect judgment would naturally be facilitated by the absence of "dimness" and "blueness" due to the atmospheric haze.

Angular perspective, which apparently varies the forms of angles and produces the divergence of lines, contributes much information in regard to relative and absolute distances from the eye of the various

objects or the parts of an object. For example, a rectangle may appear as a rhomboid. It is obvious that certain data pertaining to the objects viewed must be assumed, and if the assumptions are incorrect, illusions will result. These judgments also involve, as most judgments do, other data external to the objects viewed. Perhaps these incorrect judgments are delusions rather than illusions, because visual perception has been deluded by misinformation supplied by the intellect.

Size or linear perspective is a factor in the perception of depth or of distance. As has been stated, if we know the size experience determines the distance; and conversely, if we know the distance we may estimate the size. Obviously estimates are involved and these when incorrect lead to false perception or interpretation.

As an object approaches, the axes of the eyes converge more and more and the eye-lens must be thickened more and more to keep the object in focus. As stated in Chapter III, we have learned to interpret these accompanying sensations of muscular adjustment. This may be demonstrated by holding an object at an arm's length and then bringing it rapidly toward the eyes, keeping it in focus all the time. The sensations of convergence and accommodation are quite intense.

The two eyes look at a scene from two different points of view respectively and their images do not perfectly agree, as has been shown in Figs. 2 and 3. This binocular disparity is responsible to some degree for the perception of depth, as the stereoscope has

demonstrated. If two spheres of the same size are suspended on invisible strings, one at six feet, the other at seven feet away, one eye sees the two balls in the same plane, but one appears larger than the other. With binocular vision the balls appear at different distances, but judgment appraises them as of approximately equal size. At that distance the focal adjustment is not much different for both balls, so that the muscular movement, due to focusing the eye, plays a small part in the estimation of the relative distance. Binocular disparity and convergence are the primary factors.

Some have held that the perception of depth, that is, of a relative distance, arises from the process of unconsciously running the point of sight back and forth. However, this view, unmodified, appears untenable when it is considered that a scene illuminated by a lightning flash (of the order of magnitude of a thousandth of a second) is seen even in this brief moment to have depth. Objects are seen in relief, in actual relation as to distance and in normal perspective, even under the extremely brief illumination of an electric spark (of the order of magnitude of one twenty-thousandth of a second). This can also be demonstrated by viewing stereoscopic pictures with a stereoscope, the illumination being furnished by an electric spark. Under these circumstances relief and perspective are quite satisfactory. Surely in these brief intervals the point of sight cannot do much surveying of a scene.

Parallax aids in the perception of depth or distance. If the head be moved laterally the view or

scene changes slightly. Objects or portions of objects previously hidden by others may now become visible. Objects at various distances appear to move nearer or further apart. We have come to interpret these apparent movements of objects in a scene in terms of relative distances; that is, the relative amount of parallactic displacement is a measure of the relative distances of the objects.

The relative distances or depth locations of different parts of an object can be perceived as fluctuating or even reversing. This is due to fluctuations in attention, and illusions of reversible perspective are of this class. It is quite impossible for one to fix his attention in perfect continuity upon any object. There are many involuntary eye-movements which cannot be overcome and under normal conditions certain details are likely to occupy the focus of attention alternately or successively. This applies equally well to the auditory sense and perhaps to the other senses. Emotional coloring has much to do with the fixation of attention; that which we admire, desire, love, hate, etc., is likely to dwell more in the focus of attention than that which stirs our emotions less.

A slight suggestion of forward and backward movements can be produced by successively intercepting the vision of one eye by an opaque card or other convenient object. It has been suggested that the illusion is due to the consequent variations in the tension of convergence. Third dimensional movements may be produced for binocular or monocular vision during eye-closure. They are also produced by opening the eyes as widely as possible, by pressure on

the eye-balls, and by stressing the eyelids. However, these are not important and are merely mentioned in passing.

An increase in the brightness of an object is accompanied by an apparent movement toward the observer, and conversely a decrease in brightness produces an apparent movement in the opposite direction. These effects may be witnessed upon viewing the glowing end of a cigar which is being smoked by some one a few yards away in the darkness. Rapidly moving thin clouds may produce such an effect by varying the brightness of the moon. Some peculiar impressions of this nature may be felt while watching the flashing light of some light-houses or of other signaling stations. It has been suggested that we naturally appraise brighter objects as nearer than objects less bright. However, is it not interesting to attribute the apparent movement to irradiation? (See Chapter VIII.) A bright object appears larger than a dark object of the same size and at the same distance. When the same object varies in brightness it remains in consciousness the same object and therefore of constant size; however, the apparent increase in size as it becomes brighter must be accounted for in some manner and there is only one way open. It must be attributed a lesser distance than formerly and therefore the sudden increase in brightness mediates a consciousness of a movement forward, that is, toward the observer.

If two similar objects, such as the points of a compass, are viewed binocularly and their lateral distance apart is altered. the observer is conscious of

a third dimensional movement. Inasmuch as the accommodation is unaltered but convergence must be varied as the lateral distance between the two, the explanation of the illusion must consider the latter. The pair of compass-points are very convenient for making a demonstration of this pronounced illusion. The relation of size and distance easily accounts for the illusion.

Obviously this type of illusion cannot be illustrated effectively by means of diagrams, so the reader must be content to watch for them himself. Some persons are able voluntarily to produce illusory movements in the third dimension, but such persons are rare. Many persons have experienced involuntary illusions of depth. Carr found, in a series of classes comprising 350 students, 58 persons who had experienced involuntary depth illusions at some time in their lives. Five of these also possessed complete voluntary control over the phenomenon. The circumstances attending visual illusions of depth are not the same for various cases, and the illusions vary widely in their features.

Like other phases of the subject, this has been treated in many papers, but of these only one will be specifically mentioned, for it will suffice. Carr [3] has studied this type of illusion comparatively recently and apparently quite generally, and his work will be drawn upon for examples of this type. Apparently they may be divided into four classes: (1) Those of pure distance; that is, an object may appear to be located at varying distances from the observer, but no movement is perceived. For example, a person

might be seen first at the true distance; he might be seen next very close in front of the eyes; then he might suddenly appear to be quite remote; (2) illusions of pure motion; that is, objects are perceived as moving in a certain direction without any apparent change in location. In other words, they appear to move, but they do not appear to traverse space; (3) illusions of movement which include a change in location. This appears to be the most common illusion of depth; (4) those including a combination of the first and third classes. For example, the object might first appear to move away from its true location and is perceived at some remote place. Shortly it may appear in its true original position, but this change in location does not involve any sense of motion.

These peculiar illusions of depth are not as generally experienced as those described in preceding chapters. A geometrical illusion, especially if it is pronounced, is likely to be perceived quite universally, but these illusions of depth are either more difficult to notice or more dependent upon psychological peculiarities far from universal among people. It is interesting to note the percentages computed from Carr's statistics obtained upon interrogating 350 students. Of these, 17 per cent had experienced depth-illusions and between one and two per cent had voluntary control of the phenomenon. Of the 48 who had experienced illusions of this type and were able to submit detailed descriptions, 25 per cent belonged to class (1) of those described in the preceding paragraph; 4 per cent to class (2); 52 per cent to class (3); and 17 per cent to class (4).

Usually the illusion involves all objects in the visual field but with some subjects the field is contracted or the objects in the periphery of the field are unaffected. For most persons these illusions involve normal perceptual objects, although it appears that they are phases of hallucinatory origin.

Inasmuch as these illusions cannot be illustrated diagrammatically we can do no better than to condense some of the descriptions obtained and reported by Carr.[3]

A case in which the peripheral objects remain visible and stationary at their true positions while the central portion of the field participates in the illusion is as follows:

The observer on a clear day was gazing down a street which ended a block away, a row of houses forming the background at the end of the street. The observer was talking to and looking directly at a companion only a short distance away. Soon this person (apparently) began to move down the street, until she reached the background of houses at the end, and then slowly came back to her original position. The movement in both directions was distinctly perceived. During the illusory movement there was no vagueness of outline or contour, no blurring or confusion of features; the person observed, seemed distinct and substantial in character during the illusion. The perceived object moved in relation to surrounding objects; there was no movement of the visual field as a whole. The person decreased in size during the backward movement and increased in size during the forward return movement.

With many persons who experience illusions of depth, the objects appear to move to, or appear at, some definite position and remain there until the illusion is voluntarily overcome, or until it disappears without voluntary action. A condensation of a typical

description of this general type presented by Carr is
as follows:

All visual objects suddenly recede to the apparent distance
of the horizon and remain in that position several minutes, re-
turning at the end of this period to their original positions. This
return movement is very slow at the beginning, but the latter
phase of the movement is quite rapid. If the subject closes
her eyes while the objects appear at their distant position she
cannot even *imagine* those objects located anywhere except at
their apparent distant position.

In all cases (encountered by Carr) the motion in both di-
rections is an actual experience reality and the subject was
helpless as to initiating, stopping, or modifying the course of the
illusion in any way. Objects and even visual images (which
are subject to the same illusions) decrease in size in proportion
to the amount of backward movement and grow larger again on
their return movement. The objects are always clearly defined
as if in good focus. In this particular case the illusion occurred
about twice a year, under a variety of conditions of illumination,
at various times of the day, but apparently under conditions of
a rather pronounced fatigue.

In regard to the variation in the size of objects,
many who have experienced these illusions of depth
testify that the size seems to change in proportion to
the apparent distance, according to the law of per-
spective. Some persons appear in doubt as to this
change and a few have experienced the peculiar
anomaly of decreasing size as the objects apparently
approached.

Many persons who have experienced these pe-
culiar illusions report no change in the distinctness of
objects; almost as many are uncertain regarding this
point; and as many report a change in distinctness.
Apparently there are phases of hallucinatory origin

so that there is a wide variety of experiences among those subject to this type of illusion.

According to Carr's investigation internal conditions alone are responsible for the illusion with more persons than those due to external conditions alone. With some persons a combination of internal and external conditions seem to be a necessity. Fixation of vision appears to be an essential objective condition for many observers. That is, the illusion appeared while fixating a speaker or singer in a church or a theater. With others the illusion occurs while reading. Some reported that fixation upon checkered or other regularly patterned objects was an essential condition. Among the subjective conditions reported as essential are steady fixation, concentration of attention, complete mental absorption, dreamy mental abstraction, and fatigue.

Ocular defects do not appear to be essential, for the illusions have been experienced by many whose eyes were known to be free from any abnormalities.

Period of life does not appear to have any primary influence, for those who are subject to these peculiar illusions often have experienced them throughout many years. In some cases it is evident that the illusions occur during a constrained eye position, while lying down, immediately upon arising from bed in the morning, and upon opening the eyes after having had them closed for some time. However, the necessity for these conditions are exceptional.

The control of these illusions of depth, that is, the ability to create or to destroy them, appears to be totally lacking for most of those who have ex-

perienced them. Some can influence them, a few can destroy them, a few can indirectly initiate them, but those who can both create and destroy them appear to be rare.

It may seem to the reader that the latter part of this chapter departs from the main trend of this book, for most of these illusions of depth are to a degree of hallucinatory origin. Furthermore it has been the intention to discuss only those types of illusions which are experienced quite uniformly and universally. The digression of this chapter is excused on the basis of affording a glimpse along the borderland of those groups of illusions which are nearly universally experienced. Many other phases of depth illusions have been recorded in scientific literature. The excellent records presented by Carr could be drawn upon for further glimpses, but it appears that no more space should be given to this exceptional type. The reader should be sufficiently forewarned of this type and should be able to take it into account if peculiarities in other types appear to be explainable in this manner. However, in closing it is well to emphasize the fact that the hallucinatory aspect of depth illusions is practically absent in types of illusions to which attention is confined in other chapters.

IRRADIATION AND BRIGHTNESS–CONTRAST

MANY interesting and striking illusions owe their existence to contrasts in brightness. The visual phenomenon of irradiation does not strictly belong to this group, but it is so closely related to it and so dependent upon brightness-contrast that it is included. A dark line or spot will appear darker in general as the brightness of its environment is increased; or conversely, a white spot surrounded by a dark environment will appear brighter as the latter is darkened. In other words, black and white, when juxtaposed, mutually reinforce each other. Black print on a white page appears much darker than it really is. This may be proved by punching a hole in a black velvet cloth and laying this hole over a " black " portion of a large letter. The ink which appeared so black in the print, when the latter was surrounded by the white paper, now appears only a dark gray. Incidentally a hole in a box lined with black velvet is much darker than a piece of the black velvet surrounding the hole.

The effects of brightness-contrast are particularly striking when demonstrated by means of lighting, a simple apparatus being illustrated diagrammatically in Fig. 62. For example, if a hole H is cut in an opaque white blotting paper and a large piece of the white

blotting paper is placed at *C*, the eye when placed before the opening at the right will see the opening at *H* filled with the background *C*. The hole *H* may be cut in thin metal, painted a dull white, and may be of the shape of a star. This shape provides an intimacy between the hole and its environment which tends to augment the effects of contrasts. *R* and *F* are respectively the rear and front lamps.

Fig. 62. — Simple apparatus for demonstrating the remarkable effects of contrasts in brightness and color.

That is, the lamps *R* illuminate *C*, which " fills " the hole and apparently *is* the hole; and the lamps *F* illuminate the diffusing white environment *E*. The two sets of lamps may be controlled by separate rheostats, but if the latter are unavailable the lamps (several in each set) may be arranged so that by turning each one off or on, a range of contrasts in brightness between *E* and *H* (in reality *C*) may be obtained. (By using colored lamps and colored papers as discussed in Chapter IX the marvelous effects of color-contrast may be superposed upon those of brightness-contrast.)

If, for example, C is very feebly illuminated and E is very bright, C will be pronounced black; but when the lamps F are extinguished and no light is permitted to reach E, the contrast is reversed, and C may actually appear " white." Of course, it is obvious that white and black are relative terms as encountered in such a case. In fact in brightness-contrasts relative and not absolute values of brightness are usually the more important. In order to minimize the stray light which emerges from H, it is well to paint the inside of both compartments black with the exception of sufficiently large areas of C and E. The use of black velvet instead of black paint is sometimes advisable. It is also well to screen the lamps as suggested in the diagram. This simple apparatus will demonstrate some very striking effects of contrasts in brightness and will serve, also, to demonstrate even more interesting effects of contrasts in color.

Two opposite contrasts obtainable by means of a simple apparatus illustrated in Fig. 62 may be shown simultaneously by means of white, black, and gray papers arranged as in Fig. 63. In this figure the gray is represented by the partially black Vs, each of which contains equal amounts of black and of white. When held at some distance this serves as a gray and the same effect is apparent as is described for the case of actually gray Vs. An excellent demonstration may be made by the reader by using two Vs, cut from the same sheet of gray paper, and pasted respectively upon white and black backgrounds, as in Fig. 63. It will be apparent that the one amid the black environment

appears much brighter than the one (same gray) amid the white environment. This can be demonstrated easily to an audience by means of a figure two feet long. It is interesting to carry the experiment further and place a *V* of much darker gray on the black background than the *V* on the white background. The persistency of the illusion is found to be remarkable, for it will exist even when the one *V*

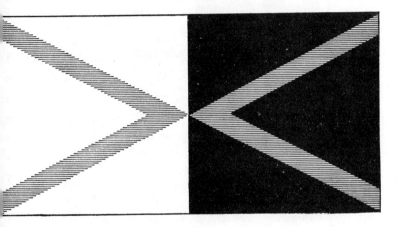

Fig. 63. — Illustrating brightness-contrast.

is actually a much darker gray than the other. To become convinced that the two grays are of the same brightness in Fig. 63, it is only necessary to punch two holes in a white or gray card at such a distance apart that they will lie respectively over portions of the two *V*s when the card is laid upon Fig. 63. The grays in the holes should now appear alike because their environments are similar.

The importance of contrasts in brightness and in color cannot be overemphasized, and it appears certain

that no one can fully realize their effectiveness without witnessing it in a manner similar to that suggested in Fig. 62.

Many illusions of brightness-contrast are visible on every hand. For example, the point at which the

Fig. 64. — An effect of brightness-contrast. Note the darkening of the intersections of the white strips.

mullions of a window cross will be seen to appear brighter than the remaining portions of them when viewed against a bright sky. Conversely, in Fig. 64, dark spots appear where the white bars cross. This is purely an illusion and the same type may be witnessed by the observant many times a day. In Fig. 64 it is of interest to note that the illusion is weak for the crossing upon which the point of sight rests, but by averted vision the illusion is prominent for the

other crossings. This is one of the effects which depends upon the location in the visual field.

No brightness-contrasts are seen correctly and often the illusions are very striking. If a series of gray papers is arranged from black to white, with the successive pieces overlapped or otherwise juxtaposed, a series of steps of uniform brightness is not seen. An instrument would determine the brightness of each as uniform, but to the eye the series would appear somewhat "fluted." That is, where a light gray joined a darker gray the edge of the former would appear lighter than its actual brightness, and the edge of the darker gray would appear darker than it should. This may also be demonstrated by laying a dozen pieces of white tissue paper in a pile in such a manner that a series of 1, 2, 3, 4, etc., thickness would be produced. On viewing this by transmitted light a series of grays is seen, and the effect of contrast is quite apparent. Such a pattern can be made photographically by rotating before a photographic plate a disk with openings arranged properly in steps.

Many demonstrations of the chief illusion of brightness-contrast are visible at night under glaring lighting conditions. It is difficult or impossible to see objects beyond automobile headlights, and adjacent to them, in the visual field. Objects similarly located in respect to any surface sufficiently bright are more or less obscured. Characters written upon a blackboard, placed between two windows, may be invisible if the surfaces seen through the window are quite bright, unless a sufficient quantity of light reaches the blackboard from other sources. Stage-settings have

been changed in perfect obscurity before an audience by turning on a row of bright lights at the edge of the stage-opening. The term " blinding light " owes its origin to this effect of brightness-contrast.

The line of juncture between a bright and a dark surface may not be seen as a sharp line, but as a narrow band of gray. When this is true it is possible that an undue amount of area is credited to the white. In preceding paragraphs we have seen the peculiar effect at the border-lines of a series of grays. This may have something to do with the estimate; however, irradiation may be due to excitation of retinal rods and cones adjacent to, but not actually within the bright image.

A remarkable effect which may be partially attributable to irradiation can be produced by crossing a grating of parallel black lines with an oblique black line. At the actual crossings the black appears to run up the narrow angle somewhat like ink would under the influence of surface tension. This is particularly striking when two gratings or even two ordinary fly-screens are superposed. The effect is visible when passing two picket-fences, one beyond the other. If a dark object is held so that a straight edge appears to cross a candle-flame or other light-source, at this portion the straight edge will appear to have a notch in it.

Irradiation in general has been defined as the lateral diffusion of nervous stimuli beyond the actual stimulus. It is not confined to the visual sense but irradiation for this sense is a term applied to the apparent enlargement of bright surfaces at the ex-

pense of adjacent darker surfaces. The crescent of
the new moon appears larger in radius than the faint
outline of the darker portion which is feebly illumi-
nated chiefly by light reflected from the earth's surface.
A filament of a lamp appears to grow in size as the
current through it is slowly increased from a zero
value; that is, as it increases in brightness. In Fig. 65

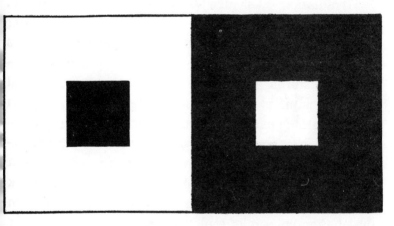

Fig. 65. — The phenomenon of irradiation.

the small inner squares are of the same size but the
white square appears larger than the black one. It
seems that this apparent increase is made at the ex-
pense of the adjacent dark area. This phenomenon
or illusion is strongest when the brightness is most
intense, and is said to be greatest when the accommo-
dation is imperfect. A very intense light-source may
appear many times larger than its actual physical
size.

Doubtless a number of factors may play a part in
this phenomenon. It appears possible that there is a
rapid spreading of the excitation over the retina ex-

tending quite beyond the border of the more intensely stimulated region, but this must be practically instantaneous in order to satisfy results of experiments. Eye-movements may play some part for, despite the most serious efforts to fixate the point of sight, a fringe will appear on the borders of images which is certainly due to involuntary eye-movements.

Irradiation has also been ascribed to spherical aberration in the eye-lens and to diffraction of light at the pupil. Printed type appears considerably reduced in size when the pupil is dilated with atropin and is restored to normal appearance when a small artificial pupil is placed before the dilated pupil. It has been suggested that chromatic aberration in the eye-lens is a contributory cause, but this cannot be very important, for the illusion is visible with monochromatic light which eliminates chromatic aberration. The experimental evidence appears to indicate that the phenomenon is of a physical nature.

There are variations in the effects attributable to radiation, and it is difficult to reduce them to simple terms. Perhaps it may aid the reader to have before him the classification presented by Boswell.[4] He describes the varieties of irradiation as follows:

1. Very rapid spreading of the excitation over the retina extending far beyond the border of the stimulated region and occurring immediately upon impact of the stimulating light.

2. Irradiation within the stimulated portion of the retina after the form of a figure becomes distinctly perceptible.

3. Emanations of decreasing intensity extend themselves outward and backward from a moving image until lost in the darkness of the background.

4. A well known form of irradiation which occurs when a

surface of greater intensity enlarges itself at the expense of one of less intensity.

5. A form having many of the characteristics of the first type, but occurring only after long periods of stimulation, of the magnitude of 30 to 60 seconds or more.

IX

COLOR

IN order to simplify the presentation of the general subject, discussions of color have been omitted in so far as possible from the preceding chapters. There are almost numberless phenomena involving color, many of which are illusions, or seemingly so. It will be obvious that many are errors of sense; some are errors of judgment; others are errors due to defects of the optical system of the eye; and many may be ascribed to certain characteristics of the visual process. It is not the intention to cover the entire field in detail; indeed, this could not be done within the confines of a large volume. However, substantial glimpses of the more important phases of color as related to illusions are presented in this chapter. In the early chapters pertaining to the eye and to vision some of the following points were necessarily touched upon, but the repetition in the paragraphs which follow is avoided as much as possible.

Simultaneous Contrast — That the life of color is due to contrast is demonstrable in many ways. If a room is illuminated by deep red light, at first this color is very vivid in consciousness; however, gradually it becomes less saturated. After a half hour the color is apparently a much faded red but upon emerging from the room into one normally lighted, the

latter appears very markedly greenish in tint. The reason that the pure red light does not appear as strongly colored as it really is, is due to the lack of contrast. In a similar manner at night we see white objects as white even under the yellowish artificial light. The latter appears very yellow in color when it is first turned on as daylight wanes but as darkness falls and time elapses it gradually assumes a colorless appearance.

An apparatus constructed after the plan of Fig. 62 is very effective for demonstrating the remarkable effects of color-contrast but some additions will add considerably to its convenience. If the lamps F are divided into three circuits, each emitting, respectively, red, green, and blue primary colors, it is possible by means of controlling rheostats to illuminate E, the environment, with light of any hue (including purple), of any saturation, and of a wide range of intensities or resulting brightnesses. Thus we have a very simple apparatus for quickly providing almost number-less environments for H. The same scheme can be applied to lamps R, with the result that a vast array of colors may be seen through the hole H. If the hole is the shape of the star in Fig. 66 it will be found very effective. The observer will actually see a star of any desired color amid an environment of any desired color. Care should be taken to have the star cut in very thin material in order to eliminate conspicuous boundary lines. It is quite satisfactory to use a series of colored papers on a slide at C and ordinary clear lamps at R. By means of this apparatus both contrasts — hue and brightness — may be dem-

onstrated. Of course, for black and white only brightness-contrast is present; but in general where there is color-contrast there is also brightness-contrast. The latter may be reduced or even eliminated if the brightness of the star and of its surroundings are made equal, but it is difficult to make a satisfactory balance in this respect. Assuming, however, that brightness-contrast is eliminated, we have left only

Fig. 66. — An excellent pattern for demonstrating color-contrast.

hue and saturation contrast, or what will be termed (rather loosely, it is admitted) color-contrast.

If the surroundings are dark and, for example, an orange star is seen alone, it does not appear very colorful. However, if the surroundings are now made bright with white light, the star appears quite saturated. With blue or green light the orange star appears even more intensely orange, but when the color-contrast is reduced, as in the case of yellow or red surroundings, the vividness of the orange star again decreases. This may be summarized by stating that

two widely different colors viewed in this manner will mutually affect each other so that they appear still more different in hue. If their hues are close together spectrally this effect is not as apparent. For example, if orange and green are contrasted, the orange will appear reddish in hue and the green will appear bluish.

Let us now assume the star to be white, and that the surroundings are of any color of approximately the same brightness. The star which is really white will now appear decidedly tinted and of a hue approximately complementary to that of the surroundings. When the latter are of a green color the white star will assume a purplish tinge; when red the white star will appear of a blue-green tint; when yellow the white star will appear bluish. This is an illusion in any sense of the term.

The strength of this illusion caused by simultaneous contrast is very remarkable. For example, if a grayish purple star is viewed amid intense green surroundings it will appear richly purple, but when the surroundings are changed to a rich purple the grayish purple star will even appear greenish. The apparent change of a color to its complementary by merely altering its environment is really a remarkable illusion.

The importance of simultaneous contrast is easily demonstrated upon a painting by isolating any colored object from its surroundings by means of a hole in a gray card. For example, an orange flower-pot amid the green foliage of its surroundings will appear decidedly different in color and brightness than when

viewed through a hole in a white, black, or gray cardboard. By means of colored papers the same color may be placed in many different environments and the various contrasts may be viewed simultaneously. The extent of the illusion is very evident when revealed in this simple manner. However, too much emphasis cannot be given to Figs. 62 and 66 as a powerful means for realizing the greatest effects.

After-images. — After looking at bright objects we see after-images of the same size and form which vary more or less in color. These after-images are due to persistence or fatigue of the visual process, depending upon conditions. After looking at the sun for a moment a very bright after-image is seen. Undoubtedly this at first is due to a persistence of the visual process, but as it decays it continuously changes color and finally its presence is due to fatigue.

After-images may be seen after looking intently at any object and then directing the eyes toward a blank surface such as a wall. A picture-frame will be seen as a rectangular after-image; a checkered pattern will be seen as a checkered after-image. When these after-images are projected upon other objects it is obvious that the appearance of the latter is apparently altered especially when the observer is not conscious of the after-image. The effects are seen in paintings and many peculiar phenomena in the various arts are directly traceable to after-imgaes.

It appears unnecessary to detail the many effects for the explanations or at least the general principles of after-images are so simple that the reader should easily render an analysis of any given case.

Let us assume that vision is fixed upon a green square upon a gray or white background. Despite the utmost effort on the part of the observer to gaze fixedly upon this green square, the latter will begin to appear fringed with a pinkish border. This is due to the after-image of the green square and it is displaced slightly due to involuntary eye-movements. After gazing as steadily as possible for a half minute, or even less, if the point of sight is turned to the white paper a pink square is seen upon it. Furthermore, this pink square moves over the field with the point of sight. This is the type most generally noticed.

After-images have been classified as positive and negative. The former are those in which the distribution of light and shade is the same as in the original object. Those in which this distribution is reversed, as in the photographic negative, are termed " negative." After-images undergo a variety of changes in color but in general there are two important states. In one the color is the same as in the original object and in the other it is approximately complementary to the original color. In general the negative after-image is approximately complementary in color to the color of the original object.

After-images are best observed when the eyes are well rested, as in the morning upon awakening. With a little practice in giving attention to them, they can be seen floating in the air, in the indefinite field of the closed eyes, upon a wall, or elsewhere, and the changes in the brightness and color can be readily followed. Negative after-images are sometimes very persistent

and therefore are more commonly noticed than positive ones. The positive after-image is due to retinal inertia, that is, to the persistency of the visual process after the actual stimulus has been removed. It is of relatively brief duration. If an after-image of a window is projected on a white area it is likely to appear as a " negative " when projected upon a white background, and as a " positive " upon a dark background, such as is readily provided by closing the eyes. It may be of interest for the reader to obtain an after-image of a bright surface of a light-source and study its color changes with the eye closed. Upon repeating the experiment the progression of colors will be found to be always the same for the same conditions. The duration of the after-image will be found to vary with the brightness and period of fixation of [the object.

It is interesting to note that an after-image is seen with difficulty when the eyes are in motion, but it becomes quite conspicuous when the eyes are brought to rest.

An after-image due to the stimulation of only one eye sometimes seems to be seen by the other eye. Naturally this has given rise to the suggestion that the seat of after-images is central rather than peripheral; that is, in the brain rather than at the retina. However, this is not generally the case and the experimental evidence weighs heavily against this conclusion.

If Fig. 52 is revolved about its center and fixated for some time striking effects are obtained upon looking away suddenly upon any object. The latter will

appear to shrink if the spiral has seemed to run outward, or to expand if the spiral has seemed to run inward. These are clearly after-images of motion.

As stated elsewhere, we may have illusions of after-images as well as of the original images. For example, if a clearly defined plane geometrical figure such as a cross or square is bright enough to produce a strong after-image, the latter when projected upon a perspective drawing will appear distorted; that is, it is likely to appear in perspective.

A simple way of demonstrating after-images and their duration is to move the object producing them. For example, extinguish a match and move the glowing end. If observed carefully without moving the eye a bluish after-image will be seen to follow the glowing end of the match. In this case the eyes should be directed straight ahead while the stimulus is moving and the observation must be made by averted or indirect vision.

Growth and Decay of Sensation. — Although many after-images may not be considered to be illusions in the sense in which the term is used here, there are many illusions in which they at least play a part. Furthermore, it is the intention throughout these chapters to adhere to a discussion of "static" illusions, it is difficult to avoid touching occasionally upon motion. The eyes are in motion most of the time, hence, certain effects of an illusory nature may be superposed upon stationary objects.

The persistence of vision has been demonstrated by every small boy as he waved a glowing stick seized

from a bonfire. Fireworks owe much of their beauty to this phenomenon. A rapidly revolving spoked wheel may appear to be a more or less transparent disk, but occasionally when a rapid eye-movement moves the point of sight with sufficient speed in the direction of motion, the spokes reappear momentarily. Motion-pictures owe their success to this visual property — the persistence of vision. If a lantern-slide picture be focused upon black velvet or upon a dark doorway, the projected image will not be seen. However, if a white rod be moved rapidly enough in the plane of the image, the latter may be seen in its entirety. The mixture of colors, by rotating them on disks, owes its possibility to the persistence of the color-sensations beyond the period of actual stimulation. The fact that it takes time for sensations of light to grow and decay is not as important here as the fact that the rates of growth, and also of decay, vary for different colors. In general, the growth and the decay are not of similar or uniform rates. Furthermore, the sensation often initially " overshoots " its final steady value, the amount of " overshooting " depending upon the intensity and color of the stimulus. These effects may be witnessed in their extensive variety by rotating disks so constructed that black and various colors stimulate the retina in definite orders.

An interesting case of this kind may be demonstrated by rotating the disk shown in Fig. 67. Notwithstanding the fact that these are only black and white stimuli, a series of colored rings is seen varying from a reddish chocolate to a blue-green. Experiment

will determine the best speed, which is rather slow under a moderate intensity of illumination. The reddish rings will be outermost and the blue-green rings innermost when the disk is rotated in one direction. Upon reversing the direction of rotation the positions of these colored rings will be reversed. By

Fig. 67. — By rotating this Mason (black and white) disk color-sensations are produced.

using various colors, such as red and green for the white and black respectively, other colors will be produced, some of which are very striking. The complete explanation of the phenomenon is not clear, owing to the doubt which exists concerning many of the phenomena of color-vision, but it appears certain that the difference in the rates of growth and decay of the various color-sensations (the white stimulus includes all the spectral hues of the illuminant) is at least partially, if not wholly, responsible.

An interesting effect, perhaps due wholly or in part to the differences in the rates of growth and decay of color-sensations, may be observed when a colored pattern is moved under a low intensity of illumination, the eyes remaining focused upon a point in space at about the same distance as the object. A square of red paper pasted in the center of a larger piece of blue-green paper is a satisfactory object. On moving this object gently, keeping the point of sight fixed in its plane of movement, the central red square will appear to shake like jelly and a decided trail of color will appear to cling to the lagging edge of the central square. Perhaps chromatic aberration plays some part in making this effect so conspicuous.

A similar case will be noted in a photographic dark-room illuminated by red light upon observing the self-luminous dial of a watch or clock. When the latter is moved in the plane of the dial, the greenish luminous figures appear separated from the red dial and seem to lag behind during the movement. For such demonstrations it is well to experiment somewhat by varying the intensity of the illumination and the speed of movement. Relatively low values of each appear to be best.

Although the various color-sensations grow and decay at different rates, the latter depend upon conditions. It appears that blue-sensation rises very rapidly and greatly overshoots its final steady value for a given stimulus. Red ranks next and green third in this respect. The overshooting appears to be greater for the greater intensity of the stimulus. The time required for the sensation to reach a steady value

depends both upon the spectral character and the brightness of the color but is usually less than a second.

Chromatic Aberration. — It is well known that the eye focuses different spectral colors at different points. This is true of any simple lens and the defect is overcome in the manufacture of optical instruments by combining two lenses consisting respectively of glasses differing considerably in refractive index. If a white object is viewed by the eye, it should appear with a purplish fringe; however, the effect is observed more readily by viewing a light-source through a purple filter which transmits only violet and red light. The light-source will have a red or a violet fringe, depending upon the accommodation or focus of the eye.

This effect is perhaps best witnessed on viewing a line spectrum such as that of the mercury arc, focused upon a ground glass. The violet and blue lines are not seen in good focus when the eyes are focused upon the green and yellow lines. Furthermore, the former can be seen in excellent focus at a distance too short for accommodating the eyes to the green and the yellow lines. This experiment shows that the focal length of the optical system of the eye is considerably shorter for the spectral hues of shorter wave-length (violet, blue) than for those of longer wave-length (such as yellow). Narrow slits covered with diffusing glass and illuminated respectively by fairly pure blue, green, yellow, and red lights may be substituted.

The effect may be demonstrated by trying to focus fine detail such as print when two adjacent areas are

illuminated by blue and red lights respectively. It is also observed when fine detail such as black lines are held close to the eye for colored fringes are seen. This optical defect is responsible for certain visual illusions.

An excellent demonstration of chromatic aberration in the eye is found by viewing fine detail through a purple filter. Now if a red filter be superposed on the purple one only the red light is transmitted. Notwithstanding the decrease in illumination or rather of light reaching the eye, measurement shows that finer detail can be discriminated than in the first case. A similar result is found on superposing a blue filter upon the purple one.

Retiring and Advancing Colors. — For years the artist and the decorator have felt that certain colors seem to advance nearer than others or that the latter seem to retire more than the former. The author obtained actual measurements of this phenomenon, but the evidence also indicated that the effects were not the same for all persons. The phenomenon is very noticeable in the case of the image of a colored lantern-slide projected upon a screen and is readily observed when the image consists of letters of various colors. In the case of red and green letters, for example, the former appear (to most persons) to be considerably nearer the observer than the green letters. It has appeared to the writer that the illusion is apparent even for white letters upon a dark background. In general, the colors whose dominant hue are of the shorter wave-lengths (violet, blue, bluegreen, green) are retiring and those whose dominant

ues are of the longer wave-lengths (yellow, orange,
ed) are advancing.

In order to obtain experimental measurements
wo light-tight boxes, each containing a light-source,
were arranged to run independently upon tracks.
Over the front end of each a diaphragm was placed
so that the observer saw two characters as in Fig. 68.
A saturated red filter was placed over one and a
saturated blue filter over the other. In a dark room

Fig. 68. — For demonstrating retiring and advancing colors.

he observer saw a blue *E* and a red *H* standing out
in the darkness. One of these boxes was fastened so
as to be immovable and the observer moved the other
o and fro by means of a cord over pulleys until the
two characters appeared equi-distant from him. This
was done for a series of distances of the stationary
box from the observer's eye. Nearly all the observers
(without being acquainted with the positions) were
obliged to set the red *H* further behind the blue *E*
in order that both appeared at the same distance.
This added distance for the red *H* was as much as
.4 feet when the blue *E* was at a distance of 24 feet.
In other words the difference in the positions of the

two was as much as 10 per cent of the total distance in this case.

Many other interesting data were obtained but most of these are not particularly of interest here. Some of the experiments tended to show the effect of certain optical defects in the eye and the variations and even reversal of the effect for some persons were accounted for by differences in the curvatures, etc., of certain eye-media for the observers. These details are not of interest here but it may be of interest to know that the phenomenon may be accounted for by the chromatic aberration in the eye. This may not be the true explanation, or it may be only partially correct. Perhaps some of the illusion is purely psychological in origin. Certainly the illusion is very apparent to most careful observers.

Color-sensibility of the Retina. This aspect was touched upon in Chapter III, but the differences in the sensibility of various areas of the retina to various colors are of sufficient importance to be discussed further. The ability to distinguish light and color gradually fades or decreases at the periphery of the visual field, but the actual areas of the fields of perception vary considerably, depending upon the hue or spectral character of the light reaching the retina. The extreme peripheral region of the visual field is " color-blind "; that is, color ceases to be perceived before brightness-perception vanishes in the outskirts of the visual field. These fields for various colors depend in size and contour not only upon the hue or spectral character of the light-stimuli but also upon the intensity and perhaps upon the size of the

stimuli. There is some disagreement as to the relative sizes of these fields but it appears that they increase in size in the following order: green, red, blue, white (colorless). The performances of after-images, and the rates of growth and decay of sensation vary for different colors and for different areas of the retina, but it would be tedious to peruse the many details of these aspects of vision. They are mentioned in order that the reader may take them into account in any specific case.

As already stated, the central part of the visual field — the fovea upon which we depend for acute vision — contains a yellowish pigmentation, which is responsible for the term " yellow spot." This operates as a yellow filter for this central area and modifies the appearance of visual fields quite the same as if a similar yellow filter was placed in the central position of the field of vision. The effect of the selectivity of the " yellow spot " is noticeable in viewing certain colors.

Purkinje Effect. — The relative sensibility of the retina varies for different colors with a change in brightness; or it may be better to state that the relative sensations for various colors alters as the brightness values are reduced to a low intensity. For example, if a reddish purple (consisting of red and blue or violet rays) be illuminated in such a manner that the intensity of illumination, and consequently its brightness, may be reduced from normal to a low value (approximating moonlight conditions), it will be seen to vary from reddish purple to violet. In doing this its appearance changes through the range of

purples from reddish to violet. This can be accomplished by orientation of the purple surface throughout various angles with respect to the direction of light or by reducing the illumination by means of screens.

In general the Purkinje effect may be described as an increasing sensibility of the retina for light of shorter wave-lengths (violet, blue, green) as the brightness decreases, or a corresponding decreasing sensibility for light of longer wave-lengths (yellow, orange, red). The effect may be seen on any colored surfaces at twilight illumination. A blue and a red flower, which appear of the same brightness before sunset will begin to appear unequal in this respect as twilight deepens. The red will become darker more rapidly than the blue if there are no appreciable changes in the color of the daylight. Finally all color disappears. It is better to perform this experiment under artificial light, in order that the spectral character of the illuminant may be certain to remain constant. In this case rheostats must not be used for dimming the light because of the attendant changes in color or quality of the light.

The Purkinje effect may be noticed by the careful observer and it is responsible for certain illusions. Apparently it cannot operate over one portion of the retina, while the remainder is stimulated by normal intensities of light.

Retinal Rivalry. — Many curious effects may be obtained by stimulating the two retinas with lights respectively different in color. For example, it is interesting to place a blue glass before one eye and a

yellow or red one before the other. The two independent monocular fields strive for supremacy and this rivalry is quite impressive. For a moment the whole field may appear of one color and then suddenly it will appear of the other color. Apparently the fluctuation of attention is a factor. Usually it does not seem to be possible to reach a quiescent state or a perfect mixture of the two colors in this manner. The dependence of one monocular field upon the

Fig. 69. — By combining these stereoscopically the effect of metallic lustre (similar to graphite in this case) is obtained.

other, and also their independence, are emphasized by this experiment. It is of interest to consider the illusions of reversible perspective and others in Chapter V in this connection.

One of the interesting results of retinal rivalry is found in combining two stereoscopic pictures in black and white with the black and white reversed in one of them. The apparently solid object will appear to possess lustre. The experiment may be tried with Fig. 69 by combining the two stereoscopic pictures by converging or diverging the axes of the eyes as described in connection with Figs. 2 and 3.

It will be noted that in order for two stereoscopic pictures, when combined, to produce a perfect effect

of three dimensions their dissimilarity must be no
more than that existing between the two views from
the two eyes respectively. The dissimilarity in Fig. 65
is correct as to perspective, but the reversal of white
and black in one of them produces an effect beyond
that of true third dimension. When the colors are so
arranged in such pictures as to be quite different in
the two the effects are striking. There is, in such
cases, an effect beyond that of perfect binocular
combination.

By means of the stereoscope it is possible to attain
binocular mixture of colors but this is usually difficult
to accomplish. The difficulty decreases as the bright-
ness and saturation of the colors decrease and is less
for colors which do not differ much in hue and in
brightness. These effects may be studied at any
moment, for it is only necessary to throw the eye
out of focus for any object and to note the results.
Many simple experiments may be arranged for
stereoscope, using black and white, and various
combinations of colors. For example, Fig. 65 may be
combined by means of double images (produced by
converging or diverging the optical axes) so that the
two inner squares are coincident. Actual observation
is much more satisfactory than a detailed description.

Miscellaneous. — There are many interesting ef-
fects due to diffraction of light by edges of objects,
by meshes such as a wire screen or a handkerchief,
by the eye-media, etc. On looking at a very bright
small light-source it may be seen to be surrounded
by many colors.

Streamers of light appear to radiate from brilliant

sources and all bright areas colored or colorless, when viewed amid dark surroundings, appear to be surrounded by diffuse brushes of light. These brushes are likely to be of a bluish tint.

Many of these phenomena are readily explained, but this cannot be done safely without knowing or recognizing all conditions. Many are not easily explained, especially when reported by others, who may not recognize certain important conditions. For example, authentic observers have reported that black letters on white paper appeared vivid red on a white background, under certain conditions. Of the latter, the apparently important one was " sun's rays falling aslant the forehead." When the eyes were shaded with the hand the letters immediately appeared black as they should.

The influence of the color of an object upon its apparent weight is relatively slight, but there is evidence of a tendency to judge a red or black object to be slightly heavier than a yellow or blue object of the same weight. It appears that hue is a minor factor in influencing the judgment and that there is no correlation between the affective quality of a color and its influence upon apparent weight. Although the scanty evidence available attributes but a slight influence to color in this respect, it is of interest in passing as a reminder of the many subtle factors which are at work modifying our judgments.

X

LIGHTING

IT should be obvious by this time that the lighting of objects or of a scene can alone produce an illusion, and that it can in still more cases contribute toward an illusion. Furthermore, there are many cases of illusions in lighting due to brightness and color. Many effects of lighting have been described elsewhere with detailed analyses of the underlying principles, but a condensed survey applying particularly to illusions will be presented here.

The comparison of intaglio with low relief has been mentioned several times in preceding chapters. Examples of these as related to lighting are found in Figs. 70 to 73. Fig. 70 represents a bas-relief lighted from above and Fig. 71 would ordinarily be taken to represent a bas-relief lighted from below. However, the latter was made from a photograph of the mold (intaglio) from which the bas-relief was made and Fig. 71 really represents an intaglio lighted from above.

Similarly Fig. 72 represents the bas-relief lighted from the left and Fig. 73 ordinarily would be taken to be a bas-relief lighted from the right. However, Fig. 73 was made from a photograph of an intaglio lighted from the left. These amply demonstrate the effect of lighting as an influence upon the appearance

of objects and they indicate the importance of correct assumptions in arriving at a correct judgment. In these cases the concealment of the light-source and the commonness of bas-relief as compared with

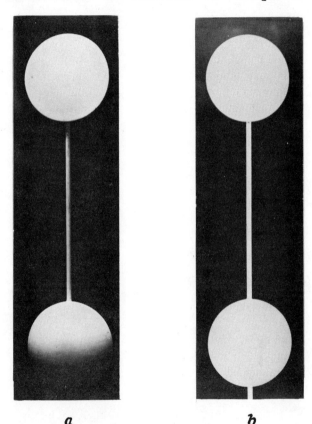

Fig. 74. — *a.* A disk (above) and a sphere (below) lighted from overhead. *b.* A disk and a sphere lighted by perfectly diffused light.

intaglio are the causes for the illusion or the error in judgment. Certainly in these cases the visual sense delivers its data correctly.

In Fig. 74 the upper object is a disk and the lower is a sphere. In *a* Fig. 74 the lighting is due

Fig. 70. — A bas-relief lighted from above.

Fig. 71. — An intaglio lighted from above.

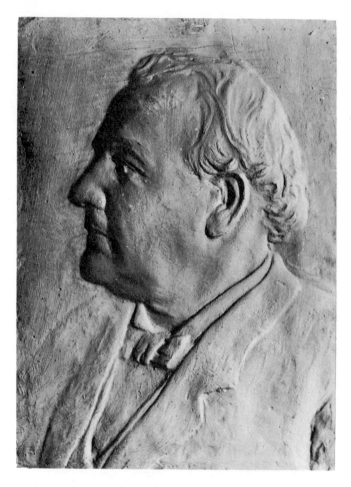

Fig. 72.— A bas-relief lighted from the left.

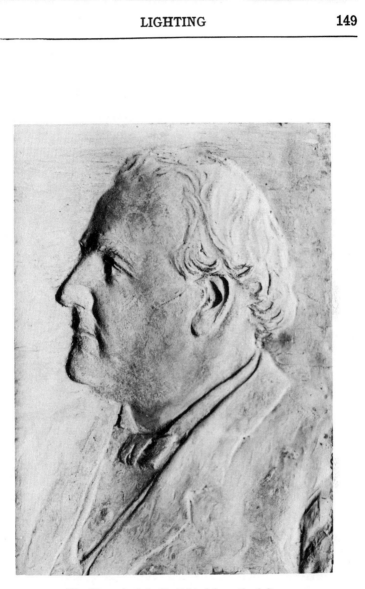

Fig. 73. — An intaglio lighted from the left.

to a source of light of rather small physical dimensions directly above the objects. The same objects illuminated by means of highly diffused light (that is, light from many directions and of uniform intensity) appear as in *b*. Both objects now appear as disks. It is obvious that under appropriate lighting a disk might be taken for a sphere and vice versa, depend-

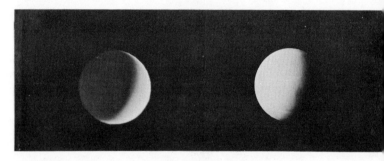

Fig. 75. — A concave hemispherical cup on the left and a convex hemisphere on the right lighted by a light-source of large angle such as a window.

ing upon which dominates the judgment or upon the formulation of the attendant assumptions. Incidentally an appearance quite similar to that of *a*, Fig. 74 is obtained when the light-source is near the observer; that is, when it lies near the line of sight.

Somewhat similar to the confusion of intaglio with bas-relief is the confusion of the two hemispherical objects illustrated in Fig. 75. The one on the left is concave toward the observer. In other words, both could be hemispherical shells — one a mold for the other. Under the lighting which existed when the original photographs were made they could both be taken for hemispheres. The lighting was due to a large light-source at the left, but if the object

on the left is assumed (incorrectly) to be a hemisphere convex toward the observer or a sphere, it must be considered to be lighted from the right, which is also an incorrect assumption. Obviously, if the direction of the dominant light is clear to the observer, he is not likely to make the error in judgment. Incidentally the object on the right might be assumed to be a

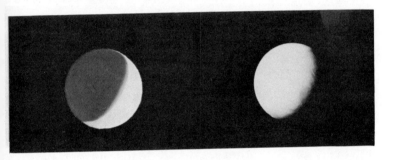

Fig. 76. — The same as Fig. 75, but lighted by a very small light-source.

sphere because a sphere is more commonly encountered than a hemisphere.

The same objects are represented in Fig. 76 lighted from the left by means of a light-source of relatively small dimensions; that is, a source subtending a relatively small solid-angle at the objects. In this case the sharp shadow due to the edge of the hemispherical cup (on the left) is likely to cause the observer to inquire further before submitting his judgment. The more gradual modulation of light and shade as in the case of a sphere or a hemisphere convex toward the observer is not present in the case of the cup. This should be sufficient information for the careful observer to guide him, or at least to prevent

him from arriving at the definite conclusion that the left-hand object is a hemisphere with its convex side toward him. Furthermore it should be noted that we often jump at the conclusion that an object is a sphere even though we see with one eye practically only a hemisphere and with two eyes hardly enough more to justify such a conclusion. However, spheres are more commonly encountered than hemispheres, so we take a chance without really admitting or even recognizing that we do.

The foregoing figures illustrate several phases which influence our judgments and the wonder is that we do not make more errors than we do. Of course, experience plays a large part and fortunately experience can be depended upon in most cases; however, in the other cases it leads us astray to a greater extent than if we had less of it.

The photographer, perhaps, recognizes more than anyone else the pitfalls of lighting but it is unfortunate that he is not better acquainted with the fundamentals underlying the control of light. Improper lighting does produce apparent incongruous effects but adequately controlled it is a powerful medium whose potentiality has not been fully realized. The photographer aims to illuminate and to pose the subject with respect to the source or sources of light so that undesirable features are suppressed and desirable results are obtained.

Finally his work must be accepted by others and the latter, being human, possess (unadmittedly of course) a desire to be " good looking." Lighting may be a powerful flatterer when well controlled

and may be a base revealer or even a creator of ugliness.

Incidentally, the photographer is always under the handicap of supplying a " likeness " to an individual who perhaps never sees this same " likeness " in a mirror. In other words, the image which a person sees of himself in a mirror is not the same in general that the photographer supplies him in the photographic portrait. The portrait can be a true likeness but the mirrored image in general cannot be. In the mirror there is a reversal of the parts from right to left. For example, a scar on the right cheek of the actual face appears on the left cheek in the mirror. Faces are not usually symmetrical and this reversal causes an individual to be familiar with his own facial characteristics in this reversed form. This influence is very marked in some cases. For example, suppose the left side of a companion's face to be somewhat paralyzed on one side due to illness. We have become more or less oblivious to the altered expression of the left side by seeing it so often. However, if we catch a glimpse of this companion's face in the mirror and the altered expression of the left side now appears upon the right side of the face, the contrast makes the fact very conspicuous. Perhaps this accounts for the difference which exists between the opinions of the photographer (or friends) and of the subject of the portrait.

All the illusions of brightness-contrast may be produced by lighting. Surfaces and details may appear larger or smaller, harsh or almost obliterated, heavy or light; in fact, lighting plays an important

part in influencing the mood or expression of a room. A ceiling may be "lifted" by light or it may hang low and threatening when dark, due to relatively little light reaching it. Columns may appear dark on a light background or vice versa, and these illustrate the effects of irradiation. A given room may be given a variety of moods or expressions by varying the lighting and inasmuch as the room and its physical characteristics have not been altered, the various moods may be considered to be illusions. It should be obvious that lighting is a potent factor.

In connection with lighting it should be noted that contrasts play a prominent rôle as they always do. These have been discussed in other chapters, but it appears advantageous to recall some of the chief features. The effect of contrast is always in the direction of still greater contrast. That is, black tends to make its surroundings white; red tends to make its surroundings blue-green (complementary), etc. The contrast-effect is greatest when the two surfaces are juxtaposed and the elimination of boundary lines of other colors (including black or white) increases its magnitude. The contrast-effect of colors is most conspicuous when there is no brightness-contrast, that is, when the two surfaces are of equal brightness and therefore differ chiefly in hue. This effect is also greatest for saturated colors. It has been stated that cold colors produce stronger contrast-effects than warm colors, but experimental evidence is not sufficiently plentiful and dependable to verify this statement.

As the intensity of illumination increases, colors

appear to become less saturated. For example, a pure red object under the noonday sun is likely to be painted an orange red by the artist because it does not appear as saturated as it would under a much lower intensity of illumination. In general, black and white are the final appearances of colors for respectively very low and very high brightness. As the intensity of illumination decreases, hue finally disappears and with continued decrease the color approaches black. Conversely, as the intensity of illumination increases, a color becomes apparently less and less saturated and tends toward white. For example, on viewing the sun through a colored glass the sun appears of a much less saturated color than the haze near the sun or a white object illuminated by sunlight.

Visual adaptation also plays a prominent part, and it may be stated that all sensations of light tend toward a middle gray and all sensations of color tend toward neutrality or a complete disappearance of hue. The tendency of sensations of light toward a middle gray is not as easily recognized as changes in color but various facts support this conclusion. In lighting it is important to recognize the tendency of color toward neutrality. For example, a warm yellow light soon disappears as a hue and only its subtle influence is left; however, a yellow vase still appears yellow because it is contrasted with objects of other colors. In the case of colored light the light falls upon everything visible, and if there is no other light-source of another color with which to contrast it, its color appears gradually to fade. This is an excellent example

of the tremendous power and importance of contrast. It is the life of color and it must be fully appreciated if the potentiality of lighting is to be drawn upon as it should be.

Physical measurements are as essential in lighting as in other phases of human endeavor for forming a solid foundation, but in all these activities where visual perception plays an important part judgment is finally the means for appraisal. Wherever the psychological aspect is prominent physical measurements are likely to be misleading if they do not agree with mental appraisals. Of course the physical measurements should be made and accumulated but they should be considered not alone but in connection with psychological effects.

The photometer may show a very adequate intensity of illumination; nevertheless seeing may be unsatisfactory or even impossible. An illumination of a few foot-candles under proper conditions at a given surface is quite adequate for reading; however, this surface may appear quite dark if the surroundings are bright enough. In such a case the photometer yielded results quite likely to be misinterpreted as satisfactory. It should be obvious that many illusions discussed in preceding chapters are of interest in this connection.

An interesting example of the illusion of color may be easily demonstrated by means of a yellow filter. For this purpose a canary glass is quite satisfactory. When such a filter is placed before the eyes a daytime scene outdoors, for example, is likely to appear to be illuminated to a greater intensity than

when the eyes are not looking through the filter. This is true for a glass used by the author notwithstanding the fact that the filter transmits only about one-half as much light as a perfectly clear colorless glass. In other words, the brightnesses of objects in the scene are reduced on the average about fifty per cent, still the subject is impressed with an apparent *increase* in the intensity of illumination (and in brightness) when the filter is placed before the eyes. Of course, the actual reduction in brightness depends upon the color of the object.

In such a case as the foregoing, true explanations are likely to involve many factors. For this reason explanations are usually tedious if they are to be sufficiently qualified to be reasonably near completeness. In this case it appears that the yellow filter may cause one to appraise the intensity of illumination as having increased, by associating such an influence as the sun coming out from behind a cloud. If we look into the depths where light and color accumulated their psychological powers, we are confronted on every hand by associations many of which are more or less obscure, and therefore are subtly influential.

The psychological powers of colors could have been discussed more generally in the preceding chapter, but inasmuch as they can be demonstrated more effectively by lighting (and after all the effect is one of light in any case) they will be discussed briefly here. They have been presented more at length elsewhere.

It is well known that the artist, decorator, and

others speak of warm and cold colors, and these effects have a firm psychological foundation. For example, if a certain room be illuminated by means of blue light, it does seem colder. A theater illuminated by means of bluish light seems considerably cooler to the audience than is indicated by the thermometer. If this lighting is resorted to in the summer time the theater will be more inviting and, after all, in such a case it makes little difference what the thermometer indicates. The " cold " light has produced an illusion of coolness. Similarly " warm " light, such as yellow or orange, is responsible for the opposite feeling and it is easily demonstrated that an illusion of higher temperature may be produced by its use. As already stated, color-schemes in the decorations and furnishings produce similar effects but in general they are more powerful when the primary light is colored. In the latter case no object is overlooked for even the hands and faces of the beings in the room are colored by the light. In the case of color-schemes not all objects are tinged with the desired " warm " or " cold " color.

In the foregoing, associations play a prominent rôle. The sky has been blue throughout the numberless centuries during which the human organism evolved. The blue-sky during all these centuries has tinged the shadows outdoors a bluish color. That shade is relatively cool we know by experience and perhaps we associate coolness or cold with the aerial realm. These are glimpses of influences which have coöperated toward creating the psychological effect of coldness in the case of bluish light. By contrast

with skylight, sunlight is yellowish, and a place in the sun is relatively warm. South rooms are usually warmer than north rooms in this hemisphere when artificial heat is absent and the psychological effect of warmth has naturally grown out of these and similar influences.

We could go further into the psychology of light and color and conjecture regarding effects directly attributable to color, such as excitement, depression, and tranquillity. In so doing we would be led far astray from illusions in the sense of the term as used here. Although this term as used here is still somewhat restricted, it is broader in scope than in its usual applications. However, it is not broad enough to lead far into the many devious highways and byways of light and color. If we did make these excursions we would find associations almost universally answering the questions. The question would arise as to innate powers of colors and we would find ourselves wondering if all these powers were acquired (through associations) and whether or not some were innate. And after many interesting views of the intricate subject we would likely conclude that the question of the innateness of some of the powers of color must be left unanswered.

As an example let us take the case of the restfulness or depression due to blue. We note that the blue sky is quite serene or tranquil and we find that the delicate sensibilities of poets verify this impression. This association could account for the impression or feeling of tranquillity associated with blue. On proceeding further, we would find nature's soli-

tudes often tinged with the blue skylight, for these solitudes are usually in the shade. Thus their restfulness or even depressiveness may be accounted for — partially at least. These brief glimpses are presented in order that they may suggest to the reader another trend of thought when certain illusions of light and color are held up for analysis. Besides these our individual experiences which have molded our likes and dislikes must be taken into account. This phase of light and color has been treated elsewhere.[6]

A very unusual kind of optical illusion is illustrated by the phenomenon of the apparent ending of a searchlight beam which has attracted much attention in connection with the powerful searchlights used for locating aeroplanes (Fig.77). For years the apparent ending has more or less carelessly been attributed to the diminution of the density of atmospheric fog or haze, but recently Karrer [13] has suggested what appears to be the correct explanation.

When the beam of light from a powerful searchlight is directed into space, its path is visible owing to the scattering of some of the light by dust and moisture particles and the molecules of the air itself. While obviously the beam itself must go on indefinitely, its luminous path appears to end abruptly at no very great distance from the source. This is true whether the beam is photographed or viewed with the naked eye.

The fact that the appearance of the beam is no different when it is directed horizontally than when directed vertically proved that the common assump-

tion pertaining to the ending of the haze or fog is untenable. Furthermore, photometric measurements on the different portions of the beam as seen from a

Fig. 77. — Apparent ending of a searchlight beam.

position near the searchlight show that the beam is actually brighter at its outer termination than near its origin. Again, the apparent length of the beam

varies with the position of the observer, and bears a direct ratio to his distance from the searchlight.

The fact is, that the luminous path of the beam has no definite ending, and extends to a very great distance — practically to infinity. It appears to be sharply cut off for the same reason that the boundary between earth and sky in a flat landscape is a sharp line. Just as the horizon recedes when the landscape is viewed from an elevation, so the beam appears longer when one's distance from it is increased. The outer portion appears brighter, because here the line of sight pierces it to great depth.

That the ending of the beam appears *close at hand* is no doubt partly due to the brightness distribution, but is also a matter of perspective arising from the manner in which the beam is adjusted. Searchlight operators in the army were instructed to adjust the light to throw a parallel beam. Accordingly, the adjustments were so made that the beam appeared the same width at its outer extremity as at its base. The result seems to be a short parallel shaft of light, but is really a divergent cone of infinite extent, its angle of divergence being such as exactly to offset the effects of perspective.

If the beam were a truly parallel one it would seem to come to a point, just as the edges of a long straight stretch of country road seem to meet at the horizon. If the sides of the road were not parallel, but diverged from the observer's eye at exactly the rate at which they ordinarily would appear to converge, then the road would seem to be as wide where it passed out at the horizon as at the observer's feet. If there were

no other means in the landscape of judging the distance of the horizon than by the perspective afforded by the road, it would likely be inferred that the road only extended a short distance on the level, and then went down a hill, that is, passed abruptly from the observer's view.

These conditions obtain ideally in the case of the searchlight beam. There is no other means of judging the position in space of the " end " of an unobstructed searchlight beam than by the perspective of the beam itself, and the operator in adjusting it to appear parallel eliminates the perspective.

The angle at which the beam must diverge to appear parallel to an observer depends upon the distance of the observer from the searchlight. A beam which seems parallel to a person close to it will not appear so at a distance. This fact probably accounts for the difficulties encountered during " searchlight drill " in the army in getting a beam which satisfied both the private operating the lamp and the officer down the field as to its parallelity.

To summarize, the apparent abrupt ending of a searchlight beam is purely an optical illusion. It really has no ending; it extends to infinity.

XI

NATURE

VISUAL illusions abound everywhere, and there are a number of special interest in nature. Inasmuch as these are representative of a wide range of conditions and are usually within the possible experience of nearly everyone daily, they appear worthy of special consideration. Some of these have been casually mentioned in other chapters but further data may be of interest. No agreement has been reached in some cases in the many suggested explanations and little or no attempt of this character will be made in the following paragraphs. Many illusions which may be seen in nature will be passed by because their existence should be obvious after reading the preceding chapters. For example, a tree appears longer when standing than after it has been felled for the same reason that we overestimate vertical lines in comparison with horizontal ones. The apparent movement of the sun, moon, and stars, when clouds are floating past, is a powerful, though commonplace, illusion but we are more specifically interested in static illusions. However, it is of interest to recall the effect of involuntary eye-movements or of fluctuation in fixation because this factor in vision is important in many illusions. It is demonstrated by lying face upward on a starlit night and

fixing the gaze upon a star. The latter appears to move more or less jerkily over its dark background. The magnitude and involuntary nature of these eye-movements is demonstrated in this manner very effectively.

The effect sometimes known as aerial perspective has been mentioned heretofore. The atmosphere is not perfectly transparent or colorless and is not homogeneous from an optical standpoint. It scatters rays of the shorter wave-lengths more than those of the longer wave-lengths. Hence it appears of a bluish tint and anything seen through great distances of it tends toward a reddish color. The blue sky and the redness of the setting sun are results of this cause. Distant signal-lights are reddened, due to the decrease in the rays of shorter wave-length by scattering. Apparently we have come to estimate distance to some extent through the amount of blurring and tinting superposed upon the distant scene.

In the high Rockies where the atmosphere is unusually clear, stretches of fifty miles of atmosphere lying between the observer and the distant peaks will show very little haze. A person inexperienced in the region is likely to construe this absence of haze as a shorter distance than the reality and many amusing incidents and ludicrous mistakes are charged against the tenderfoot in the Rockies. After misjudging distance so often to his own discomfiture a tourist is said to have been found disrobing preparatory to swimming across an irrigation ditch. He had lost confidence in his judgment of distance and was going to assume the risk of jumping across what appeared to be a ditch but what might be a broad

river. Of course, this story might not be true but it serves as well as any to emphasize the illusion which arises when the familiar haze is not present in strange territory.

It is a common experience that things "loom in a fog," that is, that they appear larger than they really are. An explanation which has been offered is that of an "excess of aerial perspective" which causes us to overestimate distance and therefore to overestimate size. If this explanation is correct, it is quite in the same manner that in clear atmosphere in the mountains we underestimate distance and, consequently, size. However, another factor may enter in the latter case, for the illusion is confined chiefly to newcomers; that is, in time one learns to judge correctly. On entering a region of real mountains the first time, the newcomer's previous experience with these formations is confined to hills relatively much smaller. Even allowing considerably for a greater size when viewing the majestic peaks for the first time, he cannot be expected to think in terms of peaks many times larger than his familiar hills. Thus underestimating the size of the great peaks, he underestimates the distance. The rarity of the atmospheric haze aids him in making this mistake. This is not offered as a substitute for aerial perspective as the primary cause of the illusion but it appears to the author that it is a cause which must be taken into account.

The apparent form of the sky has attracted the attention of many scientific investigators for centuries. There are many conflicting opinions as to the causes

of this appearance of form, but there is general agreement that the sky appears usually as a flattened vault. The sky is bright, due to scattering of light by actual particles of solid matter and moisture and possibly by molecules of gas. Lack of optical homogeneity due to varying refractive index is likely to be partially responsible. Usually a prominent layer of haze about a mile in thickness (although this varies considerably) lies next to the earth's surface. The top of this haze is fairly well defined as aerial travelers know, but the sky above is still far from black, indicating scattered light and illuminated particles still higher. As one continues to ascend, thereby leaving more and more of the luminous haze behind, the sky becomes darker and darker. Often at altitudes of four or five miles the sky is very dark and the sun is piercingly bright. Usually there is little or no bright haze adjacent to the sun at these high altitudes as is commonly seen from the earth's surface. At these high altitudes the author is not conscious of a flattened vault as at the earth's surface but the illusion of a hemispherical dome still persists.

There is some agreement that the dome of the sky appears less depressed at the zenith by night than by day. This is in accord with the author's observation at very high altitudes on occasions when the sky was much darker than when viewed from the earth's surface. Dember and Uibe assumed the apparent shape as a part of a sphere (justifying this assumption to their satisfaction) and obtained estimates of the apparent depression at the zenith. They estimated the middle point of the arc from the zenith

to the horizon and then measured the angular altitude of that point. They found that the degree of clearness of the sky has considerable influence upon the apparent height and they state that the sky appears higher in the sub-tropics than in Germany. On very clear moonless nights they found that the shape of the sky-dome differs little from that of a hemisphere. They concluded that the phenomenon is apparently due to optical conditions of the atmosphere which have not been determined.

It is of interest to note the appearance of the sky when cumulus clouds are present. The bases of these vary in height, but are found at altitudes from three to five thousand feet. They appear to form a flat roof of clouds bending downward at the horizon, thus giving the appearance of a vaulted but flattened dome. This apparent shape does not differ much in clear weather, perhaps due largely to the accustomedness of the eye and to the degradation of color from blue to gray toward the horizon. Furthermore the lower sky is usually much brighter than the zenith and the latter being darker appears to hang lower. It is of interest to note how persistent is the illusion of a flattened dome, for when one rises rapidly in the air and, within a few minutes, is on the level with the clouds or the dense low-lying haze, he is mildly surprised to find these are levels and not vaulted roofs. Despite the fact that by many previous experiences he has learned what to expect, the feeling of mild surprise is born each time on ascending rapidly.

The appearance of the flattened vault of the sky is held by some to account for the apparent enlarge-

ment of the sun, moon, and the constellations at the horizon. That is, they appear more distant at the horizon and we instinctively appraise them as being larger than when they are at higher altitudes. It is certain that these heavenly bodies do appear much larger when they are rising or setting than when they are nearer the zenith. In fact, this is one of the most remarkable and surprising illusions which exist. Furthermore this apparent enlargement has been noted universally, still many persons have attributed it to an actual optical magnification. Although we are more familiar with this enlargement in connection with the sun and moon, it still persists with the constellations. For example, Orion is apparently very large; in fact, this is the origin of the name. That this enlargement is an illusion can be shown in several ways but that it is solely due to the influence of the apparent flattened form of the sky may be doubted. Certainly the moon appears greatly enlarged while near the horizon, even when there is doubt as to an appreciable appearance of flattening of the sky-dome.

Many peculiar conditions and prejudices must be taken into account. For example, if various persons are asked to give an idea of how large is the disk of the sun or moon, their answers would vary usually with the head of a barrel as the maximum. However, the size of a tree at a distant sky-line might unhesitatingly be given as thirty feet. At the horizon we instinctively compare the size of the sun, moon, and constellations with hills, trees, houses, and other objects, but when the former are high toward the

zenith in the empty sky we may judge them in their isolated position to be nearer, hence smaller.

Normally the retinal image grows larger as the object approaches, but this same sensation also arises when an object grows in size without altering its distance. If the moon be viewed through field-glasses the image is larger than in the case of the unaided eyes, but it is quite common for observers to state that it appears smaller. The enlargement may be interpreted as approach and inasmuch as we, through habit, allow for enlargement as an object approaches, we also must reduce it in our imagination to its natural size. Perhaps in this case we overdo this reduction.

James states that the increased apparent size of the moon near the horizon " is a result of association and probability. It is seen through vaporous air and looks dimmer and duskier than when it rides on high; and it is seen over fields, trees, hedges, streams, and the like, which break up the intervening space and makes us the better realize the latter's extent." Both these causes may make the moon seem more distant when it is at low altitudes and as its visual angle grows less, we may think that it must be a larger body and we so perceive it. Certainly it looks particularly large when a well-known object is silhouetted against its disk.

Before proceeding further with explanations, it may be of interest to turn to Fig. 78 which is an accurate tracing of the path of the moon's image across a photographic plate. The camera was placed in a fixed position and the image of the moon's disk on rising was accurately focused on a panchromatic plate.

A dense red filter was maintained over the lens throughout in order to eliminate the effect of selective absorption of the atmosphere. But the slightest enlargement was detected in the width of the path near the horizon as compared with that at the highest

Fig. 78. — An accurate tracing from a photograph (continual exposure) of the moon rising.

altitude. This copy was made because it was thought better for reproduction than the photograph which would require a half-tone. This is positive evidence that the phenomenon is an illusion.

Similarly Fig. 79 is a copy of a negative of several exposures of the sun. Owing to the greater brightness, continuous exposure was not considered feasible. A panchromatic plate and red filter was used as in the case of the moon. The various exposures were

made without otherwise adjusting the camera. Again no enlargement at the horizon was found.

Although the foregoing is conclusive evidence of the illusory character of the enlargement there are other ways of making measurements. On viewing

Fig. 79. — Accurate tracings from a photograph (short exposures at intervals) of the sun setting.

the sun at the horizon a bright after-image is obtained. This may now be projected upon the sky as a background at any desired altitude. It will appear much smaller at the zenith than the sun appears at the horizon. Certainly this is a simple and conclusive demonstration of the illusion. In this case the after-image of the sun or the sun itself will usually appear at least twice as large as the after-image at the zenith.

If the variation in the position of the eyes is held to account for the illusion, this explanation may be supported by using a horizontal telescope with adjustable cross-hairs, and a mirror. By varying the position of the latter the disk of the sun may be measured at any altitude without varying the position of the eye. When everything is eliminated from the field but the moon's disk, it is found to be constant in size. However, this is not conclusive evidence that the variation in the position of the line of sight accounts for the illusion.

As a demonstration of the absence of enlargement of the size of the moon near the horizon some have brought forward measurements of the lunar circles and similar phenomena. These are said to be unaffected by the altitude of the moon except for refraction. But even this does not change the horizontal diameter and actually diminishes the vertical one. The moon is further away when near the horizon than when at the zenith, the maximum increase in distance being one-half the diameter of the earth. This would make the moon appear about one-sixtieth, or one-half minute of arc smaller at the horizon than at the zenith. This is not only in the wrong direction to aid in accounting for the apparent enlargement, but it is so slight as to be imperceptible to the unaided eye.

Nearly two centuries ago Robert Smith and his colleagues concluded that the sky appears about three times as far away at the horizon as at the zenith. They found that the relative apparent diameters of the sun and of the moon varied with altitude as follows:

Altitude	Relative apparent diameter
0 deg. (horizon)	100
15 "	68
30 "	50
45 "	40
60 "	34
75 "	31
90 " (zenith)	30

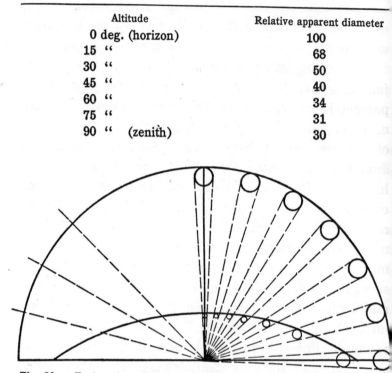

Fig. 80. — Explanation offered by Smith of the apparent enlargement of heavenly bodies near the horizon.

They also found a similar relation between the altitude and the apparent size of constellations. Fig. 80 is a reproduction of a diagram which Smith submitted as illustrating the cause of the illusion of apparent enlargement of heavenly bodies near the horizon. If the sky seems to be a flattened vault, the reason for the apparent decrease in the size of the sun, the moon, or the constellations, as they approach the zenith, is suggested by the diagram.

It has also been suggested that such illusions as those shown in Figs. 10 and 19 are associated with that of apparent enlargement of heavenly bodies near

the horizon. It will be left to the reader to decide whether or not there is any similarity or relation.

Zoth appears to have proved, to his own satisfaction at least, that the chief factors are not aerial perspective, the apparent curvature or form of the sky, and the comparison of the sun or moon with objects of known size. He maintained that the illusion of apparent decrease in size as these bodies increase in altitude is due to the necessary elevation of the eye. No available experimental evidence seems to refute his statement. In fact, Guttman's experiments seem to confirm it to some extent. The latter found that there was an apparent diminution in the size of objects of several per cent, in objects slightly more than a foot distant from the eyes, as they were raised so that the line of vision changed from horizontal to an angle of forty degrees. The magnitude of this diminution is not sufficient to promote the acceptance of elevation of the eyes as a primary cause of the illusion in respect to the heavenly bodies.

Notwithstanding arguments to the contrary, it is difficult to eliminate aerial perspective and the apparent form of the sky as important factors. That no explanation of this illusion has been generally accepted indicates the complexity of the causes. Certainly the reddish coloration of the sun and moon near the horizon and the contrast with the misty atmosphere combined with the general vague aspect of the atmosphere contribute something if no more than a deepening of the mystery. Variations in the transparency and brightness of the air must play some part.

In discussing the great illusions of nature, it appears appropriate to introduce the mirage. This is not due to an error of sense of judgment. The eye sees what is presented but the inversions and other peculiar effects are due to variations in the refractive index of the atmosphere. These variations account for the appearance of "lakes" in arid deserts, of the inverted images of ships and icebergs on the sea and of "pools of water" on pave-

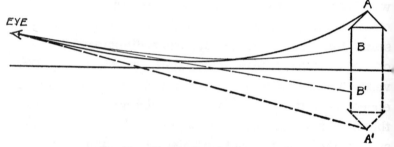

Fig. 81. — Explanation of a common mirage.

ments. The refractive index of the atmosphere is continually changing, but the changes are chiefly of two types: (1) those due to irregular heating and (2) those due to normal variation with altitude. The former type are particularly responsible for mirages.

A common type of mirage is illustrated in Fig. 81. This is often visible on deserts where the hot sand causes the adjacent layer of air to expand and therefore, the refractive index to increase. This layer of air then may be considered to operate like an inverted prism. The rays of light close to the earth are bent convex to the earth and the curvature of those higher up may be reversed. The reason that an object may

appear double, or as if mirrored by the surface of a nearby pond, is clearly shown in the illustration.

Similar atmospheric conditions are found sometimes over pavements and over bodies of water. As one rides along in an automobile ascending an incline, if he closely observes at the moment the line of sight is just on the level of the pavement, he will often be rewarded by the sight of a mirage. An approaching pedestrian may have no feet (they are replaced by a bit of sky) and the distant pavement will appear to contain pools of water on its surface.

Sometimes on deserts, over ice fields, or on northern seas, mirages are of the inverted type. A horseman or ship may appear suspended in the air in an inverted position. When the density of the air is great enough so that only the upper rays reach the eye, the object will be seen inverted and far bove the surface upon which nothing is seen. Many modifications of these types are possible through variations in the refractive indices of various strata of air. Sometimes the air is stratified horizontally and even vertically, which results in magnification as well as other peculiar effects.

As one rides over the desert in a rapidly moving train or automobile these vagaries of nature are sometimes very striking, because the speed of motion will make the effects of the varying refractive indices more marked. A distant foothill may appear to float in the air or to change its shape very rapidly. An island surrounded by quiet air and water may appear like a huge mushroom barely supported by a stem.

Arctic mirages are no less wonderful than those of the hot barren deserts. While traveling along over the ice and snow distant white peaks may assume the most fantastic shapes. At first they may appear flattened like a table-land and then suddenly they may stretch upward like spires. They may shrink then spread like huge mushrooms supported by the stalk-like bases and stretching out laterally. Suddenly they may shoot upward into another series of pinnacles as if another range had suddenly arisen. Such antics may go on for hours as one travels along a frozen valley. Even a change of position of the eyes accompanying a change from erect to lying down may cause remarkable contortions of the distant mountains and one is reminded of the psalmist's query, "Why hop ye so, ye hills?"

Although not an illusion but a physical reality, it is of interest in passing to note the colored halo or aureole surrounding the shadows of objects cast by the sun against a cloud, fog, or jet of steam. The most wonderful effects are seen by the aerial traveler over a bank of clouds when the upper sky is clear. For example, the shadow of the aircraft cast by the sun upon a dense layer of clouds is surrounded by a halo or aureole of the colors of the rainbow. The phenomenon is purely optical, involving diffraction of light. A well-known example of this is the "Spectre of the Brocken."

PAINTING AND DECORATION

IN the arts where colors, brightnesses, contrasts, lines, forms, and perspectives mean so much, it is obvious that visual illusions are important. Sometimes they are evils which must be suppressed; in some cases they are boons to the artist if he is equal to the task of harnessing them. Ofttimes they appear unheralded and unexpected. The existence of visual illusions is sufficient to justify the artist's pride in his " eye " and his dependence upon his visual judgment rather than upon what he knows to be true. However true this may be, knowledge is as useful to the artist as to anyone else. The artist, if he is to produce art, is confronted with the tremendous task of perfecting an imperfect nature and he is handicapped with tools inferior to those which nature has at her disposal. He must deal with reflected lights from earthly materials. Nature has these besides the great primary light-sources — the sun, the moon, the stars, and, we might say, the sky. She also has the advantage of overwhelming magnitudes.

These are only a few of the disadvantages under which the artist works, but they indicate that he must grasp any advantage here and there which he may. Knowledge cannot fail him; still, if he fears that it will take him out of his " dream world " and taint

him with earthliness, let him ponder over da Vinci,
Rembrandt, and such men. These men *knew* many
things. They possessed much knowledge and, after
all, the latter is nothing more nor less than science
when its facts are arranged in an orderly manner.
If the arts are to speak "a noble and expressive
language" despite the handicaps of the artist, knowl-
edge cannot be drawn upon too deeply.

Perhaps in no other art are the workmen as little
acquainted with their handicaps and with the scientific
facts which would aid them as in painting. Painters,
of course, may not agree as to this statement, but if
they wish to see how much of the science of light,
color, lighting, and vision they are unacquainted
with, let them invade the book-shelves. If they think
they know the facts of nature let them paint a given
scene and then inquire of the scientist regarding
the relative values (brightnesses) in the actual scene.
They will usually be amazed to learn that they cannot
paint the lights and shadows of nature excepting in
the feeblest manner. The range of contrast repre-
sented by their entire palette is many thousand
times less than the range of values in nature. In
fact exclusive of nature's primary light-sources, such
as the sun, she sometimes exhibits a range of bright-
ness in a landscape a million times greater than the
painter can produce with black and white pigments.
This suggests that the artist is justified in using any
available means for overcoming the handicap and
among his tools, visual illusions are perhaps the most
powerful.

A painting in the broadest sense is an illusion,

for it strives to present the three-dimensional world upon plane areas of two dimensions. Through representation or imitation it creates an illusion. If the artist's sensibility has been capable of adequate selection, his art will transmit, by means of and through the truths of science, from the region of perception to the region of emotion. Science consists of knowing; art consists of doing. If the artist is familiar with the facts of light, color, lighting, and vision, he will possess knowledge that can aid him in overcoming the great obstacles which are ever-present. A glimpse of visual illusions should strengthen him in his resolution to depend upon visual perception, but he can utilize these very illusions. He can find a use for facts as well as anyone. Facts as well as experience will prepare him to do his work best.

The artist may suggest brilliant sunlight by means of deep shadow. The old painters gained color at the expense of light and therefore lowered the scale of color in their representations of nature. It is interesting to see how increasing knowledge, as centuries passed, directed painters as it did others onward toward the truth. Turner was one of the first to abandon the older methods in an attempt to raise the scale of his paintings toward a brilliance more resembling nature. By doing this he was able to put color in shadows as well as in lights. Gradually paintings became more brilliant. Monet, Claude, and others worked toward this goal until the brightnesses of paintings reached the limits of pigments. The impressionists, in their desire to paint nature's

light, introduced something which was nothing more nor less than science. All this time the true creative artist was introducing science — in fact, illusions — to produce the perfect illusion which was his goal. A survey of any representative paintings' gallery shows the result of the application of more and more knowledge, as the art of painting progressed through the centuries. Surely we cannot go back to the brown shadows and sombre landscapes of the past.

In the earliest art, in the efforts of children, in the wall-paintings of the Egyptians, and in Japanese representation of nature, the process is selective and not imitative. Certain things are chosen and everything else is discarded. In such art selection is carried to the extreme. Much of this simplicity was due to a lack of knowledge. Light and shade, or shading, was not introduced until science discovered and organized its facts. Quite in the same manner linear and aerial perspective made their appearances until in our present art the process of selection is complex. In our paintings of today objects are modeled by light and shade; they are related by perspective; backgrounds and surroundings are carefully considered; the proper emphasis of light, shade and color are given to certain details. The present complexity provides unprecedented opportunities for the application of knowledge pertaining to illusions but it should be understood that this application tends only toward realism of external things. Idealism in art and realism of character and expression are accomplished by the same tools — pigments and brushes — as realism of objective details is attained and

there is nothing mysterious in the masterpieces of this kind. Mystery in art as in other activities is merely lack of understanding due to inadequate knowledge. Mysteries of today become facts tomorrow. Science moves with certainty into the unknown, reaping and binding the facts and dropping them behind where they may be utilized by those who will.

The painter can imitate aerial perspective although many centuries elapsed before mankind was keen enough to note its presence in nature. The atmospheric haze diminishes the brightness of very bright objects and increases that of dark objects. It blurs the distant details and adds a tinge of blue or violet to the distance. In painting it is a powerful illusion which the painter has learned to employ.

The painter can accurately imitate mathematical or linear perspective but the art of early centuries does not exhibit this feature. In a painting a tremendously powerful illusion of the third dimension is obtained by diminishing the size of objects as they are represented in the distance. Converging lines and the other manifold details of perspective are aiding the artist in his efforts toward the production of the great illusion of painting.

The painter cannot imitate focal perspective or binocular perspective. He can try to imitate the definition in the central portion of the visual field and the increased blurring toward the periphery. Focal perspective is not of much importance in painting, because it is scarcely perceptible at the distances at which paintings are usually viewed. However

the absence of binocular perspective in painting does decrease the effectiveness of the illusion very markedly. For this reason a painting is a more successful illusion when viewed with one eye than with two eyes. Of course, in one of nature's scenes the converse is true because when viewing it with both eyes all the forms of perspective coöperate to the final end — the true impression of three dimensions.

The painter may imitate the light and shade of solid forms and thereby apparently model them. In this respect a remarkable illusion of solid form or of depth may be obtained. For example, a painted column may be made to appear circular in cross-section or a circle when properly shaded will appear to be a sphere. Both of these, of course, are pure illusions. Some stage paintings are remarkable illusions of depth, and their success depends chiefly upon linear perspective and shadows. However, the illusion which was so complete at a distance quite disappears at close range.

The inadequate range of brightnesses or values obtainable by means of pigments has already been discussed. The sky in a landscape may be thousands of times brighter than a deep shadow or a hole in the ground. A cumulus cloud in the sky may be a hundred thousand times brighter than the deepest shadow. However, the artist must represent a landscape by means of a palette whose white is only about thirty times brighter than its black. If the sun is considered we may have in a landscape a range of brightness represented by millions.

This illustrates the pitiable weakness of pigments

alone as representative media. Will not light *transmitted* through media some day be utilized to overcome this inherent handicap of reflecting media? To what extent is the success of stained glass windows due to a lessening of this handicap? The range of brightness in this case may be represented by a black (non-transmitting) portion to the brightness of the background (artificial or sky) as seen through an area of clear glass. Transparencies have an inherent advantage over ordinary paintings in this respect and many effective results may be obtained with them even in photography.

It is interesting to study the effect of greatly increasing the range of values or brightnesses in paintings by utilizing non-uniform distributions of light. Let us take a given landscape painting. If a light-source be so placed that it is close to the brighter areas (perhaps clouds and sky near the sun) it will illuminate this brighter portion several times more intensely than the more distant darker portions of the picture (foreground of trees, underbrush, deep shadows, etc.). The addition to the effectiveness of the illusion is quite perceptible. This effect of non-uniform lighting may be carried to the extreme for a painting by making a positive lantern-slide (rather contrasty) of the painting and projecting this slide upon the painting in accurate superposition. Now if the painting is illuminated solely by the "lantern-slide" the range of contrast or brightness will be enormously increased. The lightest portions of the picture will now be illuminated by light passing through the almost totally transparent portions of the slide

and the darkest portions by light greatly reduced by passing through the nearly opaque portions of the slide. The original range of contrast in the painting, perhaps twenty to one, is now increased perhaps to more than a thousand to one. This demonstration will be surprising to anyone and will emphasize a very important point to the painter.

The painter has at his disposal all the scientific facts of light, color, and vision. Many of these have been presented elsewhere,[9] and those pertaining to illusions have been discussed in preceding chapters. These need not be repeated here excepting a few for the purpose of reminding the reader of the wealth of material available to the painter and decorator. Many tricks may be interjected into the foreground for their effect upon the background and vice versa. For example, a branch of a tree drooping in the foreground apparently close to the observer, if done well, will give a remarkable depth to a painting. Modeling of form may be effected to some extent by a judicious use of the " retiring " and " advancing " colors. This is one way to obtain the illusion of depth.

After-images play many subtle parts in painting. For example, in a painting where a gray-blue sky meets the horizon of a blue-green body of water, the involuntary eye-movements may produce a pinkish line just above the horizon. This is the after-image of the blue-green water creeping upward by eye-movements. Many vivid illusions of this character may be deliberately obtained by the artist. Some of the peculiar restless effects obtained in impressionistic painting (stippling of small areas with rela-

tively pure hues) are due to contrasts and after-images.

A painting came to the author's notice in which several after-images of the sun, besides the image of the sun itself, were disposed in various positions. Their colors varied in the same manner as the after-image of the sun. Doubtless the painter strove to give the impression which one has on gazing at the sun. Whether or not this attempt was successful does not matter but it was gratifying to see the attempt made.

There are many interesting effects obtainable by judicious experimentation. For example, if a gray medium be sprayed upon a landscape in such a manner that the material dries in a very rough or diffusing surface some remarkable effects of fog and haze may be produced. While experimenting in this manner a very finely etched clear glass was placed over a landscape and the combined effect of diffusely reflected light and of the slight blurring was remarkable. By separating the etched glass from the painting a slight distance, a very good imitation "porcelain" was produced. The optical properties of varnishes vary and their effect varies considerably, depending upon the mode of application. These and many other details are available to the painter and decorator. An interesting example among many is a cellulose lacquer dyed with an ordinary yellow dye. The solution appears yellow by transmitted light or it will color a surface yellow. By spraying this solution on a metallic object such as a nickel-plated piece, in a manner that leaves the medium rough

or diffusing, the effect is no longer merely a yellow but a remarkable lustre resembling gilt. Quite in the same manner many effects of richness, depth of color, haziness, etc., are obtainable by the artist who is striving to produce a great illusion.

All the means for success which the painter possesses are also available to the decorator; however, the latter may utilize some of the illusions of line, form, irradiation, etc., which the architect encounters. The decorator's field may be considered to include almost all of the painter's and much of the architect's. This being the case, little space will be given to this phase of the subject because painting and architecture are separately treated. The decorator should begin to realize more fully the great potentiality of lighting in creating moods or in giving expression to an interior. The psychology of light and the use of lighting as a mode of expression have barely been drawn upon by the decorator. Lighting has already been discussed so it will be passed by at this point.

The practice of hanging pictures on walls which are brilliantly colored is open to criticism. There are galleries in existence where paintings are hung on brilliant green or rose walls. The changes in the appearance of the object due to these highly colored environments are easily demonstrated by viewing a piece of white paper pinned upon the wall. On the green wall, the white paper appears pinkish; on the rose wall, it appears bluish or greenish. A portrait or a picture in which there are areas of white or delicate tints is subject to considerable distortions in the appearance of its colors. Similarly, if a woman must

have a colored background, it is well to choose one which will induce the more desirable tints in her appearance. The designer of gowns certainly must recognize these illusions of color which may be desirable or undesirable.

The lighting of a picture has already been mentioned, but the discussion was confined solely to distribution of light. The quality of the light (its spectral character) may have an enormous influence upon the painting. In fact with the same painting many illusions may be produced by lighting. In general, paintings are painted in daylight and they are not the same in appearance under ordinary artificial light. For this reason the artist is usually entitled to the preservation of the illusion as he completed it. By using artificial daylight which has been available for some years, the painting appears as the artist gave it his last touch. Of course, it is quite legitimate to vary the quality of light in case the owner desires to do so, but the purpose here is to emphasize the fact that the quality of light is a powerful influence upon the appearance of the painting. The influence is not generally enough recognized and its magnitude is appreciated by relatively few persons.

All other considerations aside, a painting is best hung upon a colorless background and black velvet for this purpose yields remarkable results. Gray velvet is better, when the appearance of the room is taken into consideration, as it must be. However, the influence of dark surroundings toward enhancing the illusion is well worth recognizing. In the case of a special picture or a special occasion, a painting may

be exhibited in a booth — a huge shadow-box not unlike a show-window in which the light-sources are concealed. Such experiments yield many interesting data pertaining to the illusions which the painter strives to obtain.

Incidentally on viewing some picture frames in which the grain of the wood was noticeable, the frames

Fig. 82. — Illustrating the apparent distortion of a picture frame in which the grain of the wood is visible.

did not appear to be strictly rectangular. The illusions were so strong that only by measuring the frames could one be convinced that they were truly rectangular and possessed straight sides. Two of these are represented in Figs. 82 and 83. In the former, the horizontal sides appear bent upward in the middle and the two vertical sides appear bowed toward the right. In Fig. 83, the frame appears considerably narrower at the left end than at the right. Both these frames were represented in the original drawings by true rectangles.

Many illusions are to be seen in furniture and in other woodwork in which the grain is conspicuous. This appears to the author to be an objection in general to this kind of finish. In Fig. 84 there is reproduced a photograph of the end of a board which was plane or straight notwithstanding its warped, or bowed, appearance. The original photographs were placed

Fig. 83. — Another example similar to Fig. 82.

so as to be related as shown in the figure. Various degrees of the illusion are evident. The reader will perhaps find it necessary to convince himself of the straightness of the horizontal edges by applying a straight edge. These are examples of the same illusion as shown in Figs. 37 to 40.

Perhaps a brief statement regarding the modern *isms* in art may be of interest. In considering some of the extreme examples, we must revise our idea that art is or should be always beautiful. The many definitions of art would lead us too far afield to discuss them here but in its most extended and popular

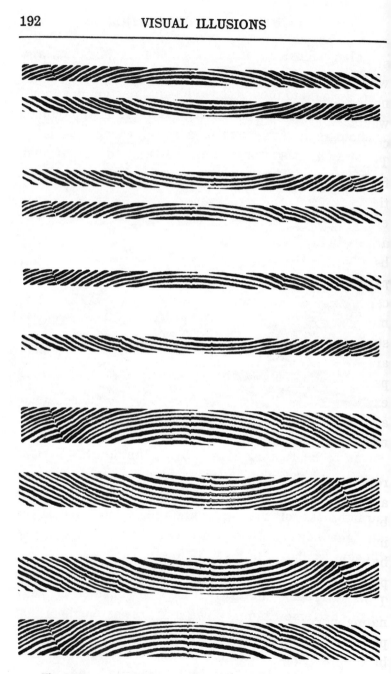

Fig. 84. — From actual photographs of the end-grain of a board.

sense, art may be considered to mean everything which we distinguish from nature. Certainly art need not be beautiful, although it does seem that the world would welcome the beautiful and would get along contentedly without art that is ugly or repulsive. The modern *isms* must be viewed with consideration, for there are many impostors concealing their inabilities by flocking to these less understood fields. However, there are many sincere workers — research artists — in the modern *isms* and their works may best be described at present as experiments in the psychology of light, shade, and color. They have cast aside or reduced in importance some of the more familiar components such as realism and are striving more deeply to utilize the psychology of light and color. Some of them admit that they strive to paint through child's eyes and mind — free from experience, prejudice, and imitation. These need all the scientific knowledge which is available — and maybe more.

In closing this chapter, it appears necessary to remind the artist and others that it is far from the author's intention to subordinate the artist's sensibility to the scientific facts or tools. Art cannot be manufactured by means of formulae. This would be true even if we knew a great deal more than we do pertaining to the science of light, color, and vision. The artist's fine sensibility will always be the dominating necessity in the production of art. He must possess the ability to compose exquisitely; he must be able to look at nature through a special temperament; he must be gifted in eye and in hand; he

must be master of unusual visual and intellectual processes. But knowledge will aid him as well as those in other activities. A superior acquaintance with scientific facts lifted past masters above their fellows and what helped Leonardo da Vinci, Rembrandt, Velasquez, Turner, Claude, Monet, and other masters will help artists of today. What would not those past masters have accomplished if they had available in their time the greater knowledge of the present!

XIII

ARCHITECTURE

MANY illusions are found in architecture and, strangely enough, many of these were recognized long before painting developed beyond its primitive stages. The architecture of classic Greece displays a highly developed knowledge of many geometrical illusions and the architects of those far-off centuries carefully worked out details for counteracting them. Drawings reveal many illusions to the architect, but many are not predicted by them. The ever-changing relations of lines and forms in architecture as we vary our viewpoint introduce many illusions which may appear and disappear. No view of a group of buildings or of the components of a single structure can be free from optical illusions. We never see in the reality the same relations of lines, forms, colors, and brightnesses as indicated by the drawings or blue-prints. Perhaps this is one of the best reasons for justifying the construction of expensive models of our more pretentious structures.

No detailed account of the many architectural illusions will be attempted, for it is easy for the reader to see many of the possibilities suggested by preceding chapters. However, a few will be touched upon to reveal the magnitude of the illusory effect and to

aid the observer in looking for or recognizing them, or purely for historical interest. In architecture the eye cannot be wholly satisfied by such tools as the level, the square, and the plumb-line. The eye is satisfied only when the *appearance* is satisfactory. For the purpose of showing the extent of certain architectural illusions, the compensatory measures applied by the Greeks are excellent examples. These also reveal the remarkable application of science to architecture as compared with the scanty application in painting of the same period.

During the best period of Grecian art many refinements were applied in order to correct optical illusions. It would be interesting to know to what extent the magnitude of the illusions as they appeared to many persons were actually studied. The Parthenon of Athens affords an excellent example of the magnitude of the corrections which the designer thought necessary in order to satisfy the eye. The long lines of the architrave — the beam which surmounts the columns or extends from column to column — would appear to sag if it were actually straight. This is also true of the stylobate, or substructure of a colonnade, and of pediments and other features. These lines were often convex instead of being straight as the eye desires to see them.

In the Parthenon, the stylobate has an upward curvature of more than four inches on the sides of the edifice and of more than two and a half inches on the east and west fronts. Vertical features were made to incline inward in order to correct the common appearance of leaning outward at the top. In

the Parthenon, the axes of the columns are not vertical, but they are inclined inward nearly three inches. They are said also to be inclined toward each other to such a degree that they would meet at an altitude of one mile above the ground. The eleven-foot frieze and architrave is inclined inward about one and one-half inches.

In Fig. 85, *a* represents the front of a temple as it should appear; *b* represents its appearance (exaggerated) if it were actually built like *a* without compensations for optical illusions; *c* represents it as built and showing the physical corrections (exaggerated) in order that it may appear to the eye as *a* does.

Tall columns if they are actually straight are likely to appear somewhat shrunken in the middle; therefore they are sometimes made slightly swollen in order to appear straight. This outward curvature of the profile is termed an entasis and in the Parthenon column, which is thirty-four feet in height, amounted to about three-fourths of an inch. In some early Grecian works, it is said that this correction was overdone but that its omission entirely is quite unsatisfactory. Some authorities appear to believe that an excellent compromise is found in the Parthenon columns.

One of the conditions which is responsible for certain illusions and has been compensated for on occasions is represented in Fig. 86. On the left are a series of squares of equal size placed in a vertical row. If these are large so that they might represent stories in a building they will appear to decrease in size from the bottom upward, because of the decreas-

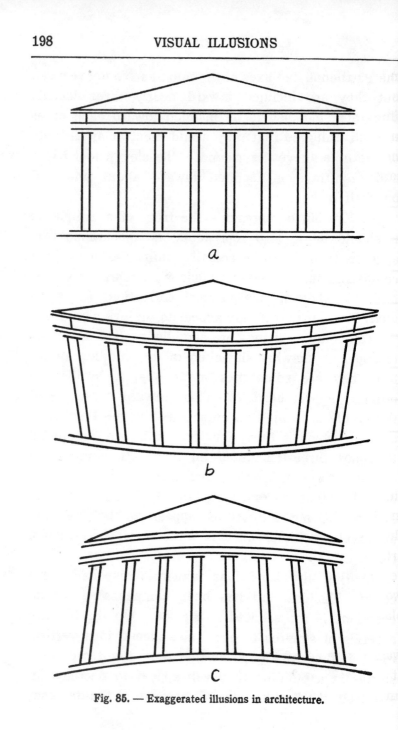

Fig. 85. — Exaggerated illusions in architecture.

ing projection at the eye. This is obvious if the eye
is considered to be at the point where the inclined
lines meet. In order to compensate for the variation
in visual angle, there must be a series of rectangles
increasing considerably in height toward the top. The
correction is shown in the illustration. It is stated

Fig. 86. — Illustrating the influence of visual angle upon apparent
vertical height.

that an inscription on an ancient temple was written
in letters arranged vertically, and in order to make
them appear of equal size they were actually in-
creased in size toward the top according to the law
represented in Fig. 86. Obviously a given correction
would be correct only for one distance in a given
plane.

In Chapter VIII the phenomenon of irradiation
was discussed and various examples were presented.
It exerts its influence in the arts as elsewhere. Col-
umns viewed against a background of white sky

appear of smaller diameter than when they are viewed against a dark background. This is illustrated in Fig. 87 where the white and the black columns are supposed to be equal in diameter.

The careful observer will find numberless optical illusions and occasionally he will recognize an attempt on the part of the architect to apply an illusory effect to his advantage. In Fig. 88 some commonplace illusions are presented, not for what they are worth,

Fig. 87. — Irradiation in architecture.

but to suggest how prevalent they may be. Where the pole or column intersects the arches or circle, there is an apparent change in the direction of the curved lines. The different types of arches show different degrees of the illusion. It may be of interest for the reader to refer to preceding chapters and to ascertain what types of illusions are involved.

If a high wall ends in a series of long horizontal steps at a slightly inclined sidewalk, the steps are not likely to appear horizontal.

Some remarkable illusions of depth or of solid form are given to flat surfaces when snow is driven against them so as to adhere in decreasing amounts similar to shading.

A suggestion of augmented height may be given

o a low tower by decreasing the size of its successive
ortions more rapidly than demanded by perspective
lone. The same principal can be applied in many
vays. For example, in Fig. 89 the roof appears quite
xtensive when viewed so that the end-walls of the
tructure are not seen. Such illusions find applications

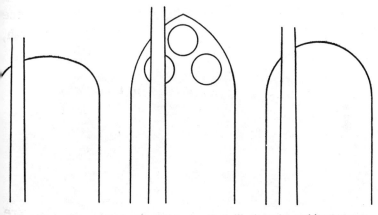

Fig. 88. — Some simple geometrical-optical illusions in architecture.

n the moving-picture studio where extensive interiors,
reat fortresses, and even villages must be erected
vithin small areas. Incidentally the camera aids to
reate the illusion of magnitude in photographs
ecause it usually magnifies perspective, thereby
ausing scenes to appear more extensive in the photo-
raphs than in the reality.

Balance in architecture is subject to illusions and
might be considered an illusion itself. For example,
our judgment of balance is based largely upon mechan-
ical laws. A composition must appear to be stable;
that is, a large component such as a tower must not
be situated too far from what we take as a center of

gravity, to appear capable of tipping the remainder of the structure. In physics we would apply the term "moment." Each mass may be multiplied by its distance from the center of gravity, thus determining its moment. For a building or other composition to appear stable the sum of these moments must be

Fig. 89. — By decreasing the exposed length of shingles toward the top a greater apparent expanse is obtained.

zero; that is, those tending to turn the figure in one direction must be counterbalanced by those tending to turn it in another direction. In appraising a composition, our intellect summates the effects of different parts somewhat in this manner and if satisfactory, balance is considered to have been attained. The colors of the various components exert an influence in this respect, so it is seen that illusions may have much to do with the satisfactoriness of architectural compositions.

Various illusions of height, of ceiling, composed-ness, etc., may be obtained by the color of the ceiling. A dark cornice in an interior may appear to be unsupported if the walls below are light in color, without any apparent vertical supports for the cornice. We are then subjected to the illusion of instability or incongruity. Dark beams of ceilings are not so obtrusive because our intellect tells us that they are supports passing over the top of the walls and are therefore able to support themselves. Color and brightness in such cases are very important.

The architectural details on exteriors evolved under daylighting outdoors so that their form has been determined by the shadows desired. The architect leads his lights and shadows around the building modeling it as he desires. An offset here and a depression there models the exterior in light and shade. The forms must be powerful enough to resist the obliterating effect of overcast skies but notwithstanding all precautions the expression of an exterior varies considerably with nature's lighting. Indoors the architect has a powerful controllable medium in artificial light which he may draw upon for producing various expressions or moods in rooms. The effect of shadows is interesting when viewing some structures flood-lighted at night. In those cases where the light is directed upward there is a reversal of shadows which is sometimes very unsatisfactory.

It is interesting to experiment with various ornamental objects lighted from various directions. For example, a Corinthian capital lighted from below

may produce an unpleasant impression upon the observer. We do not like to have the dominant light from below, perhaps because it is annoying to the eyes. Possibly this is an instinct acquired by experience in snow-fields or on the desert, or it may be a heritage of ancestral experience gained under these glaring conditions. This dislike manifests itself when we appraise shadow-effects and therefore our final impression is tempered by it.

All sculptured objects depend for their appearance upon the lighting, and they are greatly influenced by it. In sculpture, in a strict sense, illusions play a lesser part than in other arts. Perhaps in those of very large proportions various corrections have been applied. A minor detail of interest is the small cavity in the eye, corresponding to a reversed cornea. This depression catches a shadow which gives considerable expression to the eye.

XIV

MIRROR MAGIC

STRICTLY speaking there are fewer illusions found in the practice of the magician than is generally supposed; that is, the eye usually delivers correctly to the intellect, but the judgment errs for various reasons. The " illusion " is due to false assumptions, to the distracting words, to unduly accented superfluous movements of the magician; or in general to downright trickery. Much of the magician's success is due to glibness of tongue and deftness of fingers, but many of the more notable " tricks " were those involving the use of mirrors and the control of light. Black curtains, blackened assistants, and controlled light have played prominent parts in the older magic, but the principles of these are easily understood. However, the mirror perhaps has done more to astound the audience than any other device employed by the magician. For this reason, and because its effects are commonly termed illusions, some representative examples will be presented.

In a previous chapter attention was called to the simple but usually overlooked fact that, for example, the image of a face in a mirror is reversed as to right and left. When this fact is overlooked we may be astonished at the changed expression of an intimate friend as we view the face (reversed) in the mirror.

Similarly our own features are reversed as to right and left and we are acquainted with this reversed image rather than the appearance of our face as it is. Inasmuch as faces are not accurately symmetrical and many are quite unsymmetrical the effects of the mirror are sometimes startling. It might be of interest for the reader to study his face in the mirror and note that the right ear is the left ear of the image which he sees. He will also find it of interest to compare the face of a friend as viewed directly with the appearance of its image in the mirror. If he desires to see himself as others see him, he can arrange two mirrors vertically almost at a right-angle. By a little research he will find an image of his own face, which is not reversed; that is, an image whose right ear is really his right ear.

A famous " illusion " which astounded audiences was the sphinx illustrated in Fig. 90. The box was placed upon a table and when opened there was revealed a Sphinxian head, but why it was called a Sphinx is clothed in mystery because upon some occasions it talked. As a matter of fact it belonged to a body which extended downward from the table-top and this kneeling human being was concealed from the audience by two very clean plate-glass mirrors *M* shown in the accompanying diagram. The table actually appeared to have three legs but the audience if it noticed this at all assumed the fourth leg was obscured by the foremost leg. The walls, floor, and ceiling of the box-like recess in which the table was placed were covered with the same material. It is seen by the diagram that the mirrors *M* reflected

images of the side walls *W* and these images were taken by the audience to be portions of the rear wall *W*. Thus the table appeared to be open underneath and the possibilities of the apparatus are evident.

The magician with a fine flow of language could

Fig. 90. — An example of a "mirror" illusion.

dwell at length upon the coming to life of the head of an ancient statue which he had in the box in his hand. Walking to the table he could place the box over a trap-door and by the time he had unlatched the door of the box, the assistant kneeling under the table could have his head thrust upward through the trap-door of the table-top into the box. After a few impressive words, supposed to be Hindoo but in reality were Hoodoo, presto! and the Sphinx was revealed.

It conversed after a period of silence extending back to the days of Rameses when a wrathful god condemned an unfortunate king to imprisonment in the stone statue. The original trick awed audiences for many nights and defied explanation until one night a keen observer noted finger-prints on what proved to be a mirror. Doubtless a careless accomplice lost

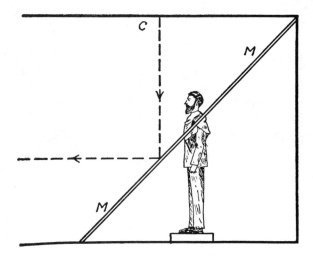

Fig. 91. — Another example of "mirror magic."

his job, but the damage had been done, for the trick was revealed. This " illusion " is so effective that it, or variations of it, are still in use.

Another simple case is illustrated in Fig. 91. A large plate-glass mirror *M* was placed at an angle of approximately 45 degrees from the floor. Through a hole in it an assistant's head and shoulders projected and the edge of the opening was covered with a draped cloth. The audience saw the image of the ceiling *C* of the alcove reflected by the mirror but being ig-

norant of the presence of the mirror, assumed this image to be the rear wall. This trick was effective for many years. Obviously the mirrors must be spotlessly clean and the illuminations of the walls, ceiling, and in some cases, the floor must be very uniform. Furthermore, no large conspicuous pattern could be used for lining the box-like recess.

The foregoing examples illustrate the principles involved in the appearance of ghosts on the stage and of a skeleton or other gruesome object in place of a human being. The possibilities of mirrors in such fields are endless and they can be studied on a small scale by anyone interested. The pseudoscope which produces effects opposite to those of the stereoscope is an interesting device.

The foregoing is the faintest glimpse of the use of the mirror, but it does not appear advisable to dwell further upon its use, for after all the results are not visual illusions in the sense of the term as usually employed throughout this book.

CAMOUFLAGE

ILLUSIONS played many roles in the science and art of deception during the World War, but they served most prominently in the later stages of the war upon the sea. Inasmuch as the story of the science of camouflage is not generally available, it appears worth while to present it briefly. Besides being of interest, it will reveal to the reader the part that the science of light, color, lighting, and vision played in deception. Furthermore, the reader will sense the numberless illusions which are woven into camouflage as developed in nature, and in human activities. The word *camouflage* by origin does not include all kinds of deception; however, by extension it may and will here signify almost the entire art and science of deception as found in nature and as practiced in the World War.

Terrestrial Camouflage. — Camouflage is an art which is the natural outgrowth of our instinct for concealment and deception when pitting our wits against those of a crafty prey or enemy. It is an art older than the human race, for its beginnings may be traced back to the obscurity of the early ages of the evolution of animal life. The name was coined by the French to apply to a definite art which developed during the Great War to a high state, as many other arts developed by drawing deeply upon the resources of scientific

knowledge. With the introduction of this specific word to cover a vast field of activity in scientifically concealing and deceiving, many are led to believe that this is a new art, but such is not the case. However, like many other arts, such as that of flying, the exigencies of modern warfare have provided an impetus which has resulted in a highly developed art.

Scientists have recognized for many years, and perhaps more or less vaguely for centuries, that Nature exhibits wonderful examples of concealment and deception. The survival of the fittest, as Darwin expressed his doctrine, included those individuals of a species who were best fitted by their markings and perhaps by peculiar habits to survive in the environment in which they lived. Naturally, markings, habits, and environment became more and more adapted to each other until the species became in equilibrium with Nature sufficiently to insure its perpetuity. If we look about us upon animal life we see on every hand examples of concealing coloration and attitudes designed to deceive the prey or enemy. The rabbit is mottled because Nature's infinite variety of highlights, shadows, and hues demand variety in the markings of an animal if the latter is to be securely hidden. Solid color does not exist in Nature's landscapes in large areas. The rabbit is lighter underneath to compensate for the lower intensity of illumination received on these portions. As winter approaches, animals in rigorous climates need warmer coats, and the hairs grow longer. In many cases the color of the hairs changes to gray or white, providing a better coating for the winter environment.

Animals are known to mimic inanimate objects for the sake of safety. For example, the bittern will stand rigid with its bill pointed skyward for many minutes if it suspects an enemy. Non-poisonous snakes resemble poisonous ones in general characteristics and get along in the world on the reputation of their harmful relatives. The drone-bee has no sting, but to the casual observer it is a bee and bees generally sting. Some animals have very contrasting patterns which are conspicuous in shape, yet these very features disguise the fact that they are animals. Close observation of fishes in their natural environment provides striking examples of concealing coloration. Vast works have been written on this subject by scientists, so it will only be touched upon here.

There are many examples of " mobile " camouflage to be found in Nature. Seasonal changes have been cited in a foregoing paragraph. The chameleon changes its color from moment to moment. The flounder changes its color and *pattern* to suit its environment. It will even strive to imitate a black and white checkerboard.

In looking at a bird, animal, insect, or other living thing it is necessary to place it in its natural environment at least in the imagination, before analyzing its coloration. For example, a male mallard duck hanging in the market is a very gaudy object, but place it in the pond among the weeds, the green leaves, the highlights, and the shadows, and it is surprisingly inconspicuous. The zebra in the zoo appears to be marked for the purpose of heralding its presence anywhere in the range of vision, but in its reedy, bushy,

grassy environment it is sufficiently inconspicuous for the species to survive in Nature's continuous warfare.

Thus studies of Nature reveal the importance of general hue, the necessity for broken color or pattern, the fact that black spots simulate shadows or voids, the compensation for lower illumination by counter-shading, and many other facts. The artist has aided in the development of camouflage, but the definite and working basis of all branches of camouflage are the laws and facts of light, color, and vision as the scientist knows them.

Just as lower animal life has unconsciously survived or evolved by being fitted to do so, mankind has consciously, or at least instinctively, applied camouflage of various kinds to fool his prey or his enemy. Many of us in hunting ducks have concealed the bow of our sneak-boat with mud and weeds, or in the season of floating ice, with a white cloth. In our quest of water fowl we use decoys and grass suits. The Esquimau stalks his game behind a piece of ice. In fact, on every hand we find evidences of this natural instinct. The Indian painted his face and body in a variety of colors and patterns. Did he do this merely to be hideous? It seems very possible that the same instinct which made him the supreme master of woodcraft caused him to reap some of the advantages of concealment due to the painting of his face and body.

In past wars there is plenty of evidence that concealment and deception were practiced to the full extent justifiable by the advantages or necessity. In the World War the advent of the airplane placed the

third dimension in reconnaissance and called for the application of science in the greatly extended necessity for concealment and deception. With the advent of the airplane, aerial photography became a more important factor than visual observation in much of the reconnaissance. This necessitated that camouflage in order to be successful had to meet the requirements of the photographic eye, as well as that of the human eye. In other words, the special characteristics of the colors used had to be similar to those of Nature's colors. For example, chlorophyl, the green coloring matter of vegetation, is a peculiar green as compared with green pigments. When examined with a spectroscope it is seen to reflect a band of deep red light not reflected by ordinary pigments. In considering this aspect it is well to bear in mind that the eye is a synthetic apparatus; that is does not analyze color in a spectral sense. An artist who views color subjectively and is rarely familiar with the spectral basis may match a green leaf perfectly with a mixture of pigments. A photographic plate, a visual filter, or a spectroscope will reveal a difference which the unaided eye does not.

Some time before the Great War began, it occurred to the writer that colored filters could be utilized in aiding vision by increasing the contrast of the object to be viewed against its surroundings.[9] Studies were made of various filters, made with the object of the experiment in mind, in viewing the uniforms of various armies. Further developments were made by applying the same principles to colored lights and painted pictures. Many of these have been

described elsewhere. With the development of the science of camouflage, filters came into use for the detection of camouflage. As a result of the demand for avoiding detection by photographic plates and by various colored filters, some paints provided for the camoufleur were developed according to the spectral requirements. Many other applications of science were developed so that camouflage can now be called an art based upon sound scientific principles.

Natural lighting is so variable that it is often impossible to provide camouflage which will remain satisfactory from day to day; therefore, a broad knowledge of Nature's lighting is necessary in order to provide the best compromise. There are two sources of light in the daytime, namely, the sun and the sky. The relative amounts of light contributed by these two sources is continually changing. The sky on cloudless days contributes from one-tenth to one-third of the total light received by a horizontal surface at noon. Light from the sky and light reflected from the surroundings illuminate the shadows. These shadows are different in color than highlights, although these finer distinctions may be ignored in most camouflage because color becomes less conspicuous as the distance of observation increases. In general, the distribution of brightness or light and shade is the most important aspect to be considered.

The camoufleur worries over shadows more than any other aspect generally. On overcast days camouflage is generally much more successful than on sunny days. Obviously, counter-shading is resorted to in

order to eliminate shadows, and where this is unsuccessful confusion is resorted to by making more shadows. The shape and orientation of a building is very important to those charged with the problem of rendering it inconspicuous to the enemy, but little attention has been paid to these aspects. For example, a hangar painted a very satisfactory dull green will be distinguishable by its shape as indicated by its shadow and shaded sides. In this zone a hangar, for example, would be more readily concealed if its length lay north and south. Its sides could be brought with a gradual curve to the ground and its rear, which is during most of the day in shadow, could be effectively treated to conceal the shadow. A little thought will convince the reader of the importance of shape and orientation.

Broken color or pattern is another fundamental of camouflage which, of course, must be adapted to its environment. For our trucks, cannon, and many other implements of war, dark green, yellow, dark blue, light gray, and other colors have been used in a jumble of large patterns. A final refinement is that of the blending of these colors at a distance, where the eye no longer resolves the individual patches, to a color which simulates the general hue of the surroundings. For example, red and green patches at a distance blend to yellow; yellow and blue patches blend to a neutral gray if suitably balanced, but if not, to a yellow-gray or a blue-gray; red, green, and blue if properly balanced will blend to a gray; black, white and green patches will blend to a green shade, and so on. These facts are simple to those who are

familiar with the science of light and color, but the artist, whose knowledge is based upon the mixture of pigments, sometimes errs in considering this aspect of color-blending by distance. For example, it is not uncommon for him to state that at a distance yellow and blue patches blend to make green, but the addition of lights or of juxtaposed colors is quite different in result from the addition of pigments by intimately mixing them.

In constructing such a pattern of various colors it is also desirable to have the final mean brightness approximate that of the general surroundings. This problem can be solved by means of the photometer and a formula provided, which states, for example, that a certain percentage of the total area be painted in gray, another percentage in green, and so on. The photometer has played an important rôle in establishing the scientific basis of camouflage. The size of the pattern must be governed by the distance at which it is to be viewed, for obviously if too small the effect is that of solid color, and if too large it will render the object conspicuous, which is a disadvantage ranking next to recognizable.

Where the artist is concerned with a background which does not include the sky, that is, where he deals only with *illuminated* objects on the earth, his trained eye is valuable provided the colors used meet the demands made by photographic plates and visual color-filters. In other words, the sky as a background gives trouble to all who are unfamiliar with scientific measurements. The brightnesses of sky and clouds are outside the scale of brightnesses ordi-

narily encountered in a landscape. Many interesting instances of the artist's mistakes in dealing with these backgrounds could be presented; however, the artist's trained eye has been a great aid in constructing patterns and various other types of camouflage. One of the most conspicuous aspects of the earth's surface is its texture. From great heights it appears flat, that is, rolling land is ironed out and the general contour of the ground is flattened. However, the element of texture always remains. This is the chief reason for the extensive use of netting on which dyed raffia, foliage, pieces of colored cloth, etc., are tied. Such network has concealed many guns, headquarters, ammunition dumps, communication trenches, road-ways, etc. When this has been well done the con-cealment is perfect.

One of the greatest annoyances to the camoufleur is the lack of dullness or "flatness" of the paints, fabrics, and some of the other media used. When viewed at some angles the glint of highlights due to specular reflection renders the work very conspicu-ous. For this reason natural foliage or such material as dyed raffia has been very successful.

Systems of network and vertical screens have been extensively employed on roadways near the front, not for the purpose of concealing from the enemy the fact that the roadways exist, but to make it neces-sary to shell the entire roadway continually if it is hoped to prevent its use.

Although the camoufleur is provided with a vast amount of material for his work, many of his require-ments are met by the material at hand. Obviously,

the most convenient method of providing concealment for a given environment is to use the materials of the environment. Hence, rubbish from ruined buildings or villages supplies camouflage for guns, huts, etc., in that environment. In woods the material to simulate the woods is at hand. Many of these aspects are so obvious to the reader that space will not be given to their consideration. The color of the soil is important, for if it is conspicuous the camoufleur must provide screens of natural turf.

In this great game of hocus-pocus many deceptions are resorted to. Replicas of large guns and trenches are made; dummy soldiers are used to foil the sniper and to make him reveal his location, and papier-maché horses, trees, and other objects conceal snipers and observers and afford listening posts. Gunners have been dressed in summer in green flowing robes. In winter white robes have been utilized. How far away from modern warriors are all the usual glitter and glamour of military impedimenta in the past parades of peace time! The armies now dig in for concealment. The artillery is no longer invisible behind yonder hill, for the eyes of the aerial observer of the camera reveal its position unless camouflaged for the third dimension.

In the foregoing only the highlights of a vast art have been viewed, but the art is still vaster, for it extends into other fields. Sound must sometimes be camouflaged and this can only be done by using the same medium — sound. In these days of scientific warfare it is to be expected that the positions of enemy guns would be detected by other means than em-

ployed in the past. A notable method is the use of velocity of sound. Records are made at various stations of the firing of a gun and the explosion of the shell. By trigonometric laws the position of the gun is ascertained. It is said that the Germans fired a number of guns simultaneously with the " 75-mile " gun in order to camouflage its location. The airplane and submarine would gladly employ sound camouflage in order to foil the sound detector if practicable solutions were proposed.

The foregoing is a brief statement of some of the fundamental principles of land camouflage. Let us now briefly consider the eyes of the enemy. Of course, much concealment and deception is devised to foil the observer who is on the ground and fairly close. The procedure is obvious to the average imagination; however, the reader may not be acquainted with the aerial eyes from which concealment is very important. As one ascends in an airplane to view a landscape he is impressed with the inadequacy of the eyes to observe the vast number of details and of the mind to retain them. Field glasses cannot be used as satisfactorily in an airplane as on solid ground, owing to vibration and other movements. The difference is not as great in the huge flying boats as it is in the ordinary airplane. The camera can record many details with higher accuracy than the eye. At an altitude of one mile the lens can be used at full aperture and thus very short exposures are possible. This tends to avoid the difficulty due to vibration. When the plates are developed for detail and enlargements are made, many

minute details are distinguishable. Furthermore, owing to the fact that the spectral sensibilities of photographic emulsions differ from that of the eye, contrasts are brought out which the eye would not see. This applies also to camouflage which is devised merely to suit the eye. Individual footprints have been distinguished on prints made from negatives exposed at an altitude of 6000 feet. By means of photography, daily records can be made if desired and these can be compared. A slight change is readily noted by such comparison by skilled interpreters of aerial photographs. The disappearance of a tree from a clump of trees may arouse suspicion. Sometimes a wilted tree has been noted on a photograph which naturally attracts attention to this position. It has been said that the belligerents resorted to transplanting trees a short distance at a time from day to day in order to provide clearance for newly placed guns. By paths converging toward a certain point, it may be concluded from the photographs that an ammunition dump or headquarters is located there even though the position itself was well camouflaged. Continuous photographic records may reveal disturbances of turf and lead to a more careful inspection of the region for sapping operations, etc. By these few details it is obvious that the airplane is responsible for much of the development of camouflage on land, owing to the necessity which it created for a much more extensive concealment. The entire story of land camouflage would overflow the confines of a volume, but it is hoped that the foregoing will aid the reader in visualizing the magnitude of the art and

the scientific basis upon which terrestial camouflage is founded.

Marine Camouflage. — At the time of the Spanish-American war, our battleships were painted white, apparently with little thought of attaining low visibility. Later the so-called " battleship gray " was adopted, but it has been apparent to close observers that this gray is in general too dark. Apparently it is a mixture of black and white. The ships of the British navy were at one time painted black, but preceding the Great War their coats were of a warm dark gray. Germany adopted dark gray before the close of the last century and Austria adopted the German gray at the outbreak of the war. The French and Italian fleets were also painted a warm gray. This development toward gray was the result of an aim toward attaining low visibility. Other changes were necessitated by submarine warfare which will be discussed later.

In the early days of unrestricted submarine warfare many schemes for modifying the appearance of vessels were submitted. Many of these were merely wild fancies with no established reasoning behind them. Here again science came to the rescue and through research and consultation, finally straightened out matters. The question of low visibility for vessels could be thoroughly studied on a laboratory scale, because the seascape and natural lighting conditions could be reproduced very closely. Even the general weather conditions could be simulated, although, of course, the experiments could be prosecuted outdoors with small models, as indeed they

were. Mr. L. A. Jones [10] carried out an investigation on the shore of Lake Ontario, and laboratory experiments were conducted by others with the result that much light was shed on the questions of marine camouflage. This work confirmed the conclusion of the author and others that our battleship gray was too dark. Of course, the color best adapted is that which is the best compromise for the extreme variety in lighting and weather conditions. These vary in different parts of the world, so naturally those in the war zone were of primary importance. All camouflage generally must aim to be a compromise best suited for average or dominating conditions. For example, in foggy weather a certain paint may render a ship of low visibility, but on a sunny day the ship might be plainly visible. However, if ships are rendered of low visibility for even a portion of the time it is obvious that an advantage has been gained. Cloudiness increases generally from the equator northward, as indicated by meteorological annals.

In order to study low visibility a scale of visibility must be established, and it is essential to begin with the fundamentals of vision. We distinguish objects by contrasts in brightness and in color and we recognize objects by these contrasts which mold their forms. In researches in vision it is customary to devise methods by which these contrasts can be varied. This is done by increasing or decreasing a veil of luminosity over the object and its surroundings and by other means. Much work has been done in past years in studying the minimum perceptible contrast, and it has been found to vary with hue, with the magnitude

of brightness, and with the size of the image, that is, with the distance of an object of given size. In such problems as this one much scientific work can be drawn upon. A simple, though rough, scale of visibility may be made by using a series of photographic screens of different densities. A photographic screen is slightly diffusing, still the object can be viewed through it very well. Such methods have been employed by various investigators in the study of visibility.

Owing to the curvature of the earth, the distance at which a vessel can be seen on a clear day is limited by the height of the observer and of the ship's superstructure. For an observer in a certain position the visibility range varies as the square root of the distance of the object from him. Such data are easily available, so they will not be given here. So far we have considered the ship itself when, as a matter of fact, on clear days the smoke cloud emitted by the ship is usually visible long before a ship's superstructure appears on the horizon. This led to the prevention of smoke by better combustion, by using smokeless fuels, etc.

The irregular skyline of a ship is perhaps one of the most influential factors which tend to increase its visibility. Many suggestions pertaining to the modification of the superstructure have been made, but these are generally impracticable. False work suffers in heavy seas and high winds.

After adopting a suitable gray as a " low-visibility " paint for ships, perhaps the next refinement was counter shading; that is, shadows were painted

a lighter color, or even white. The superstructure was painted in some cases a light blue, with the hope that it would fade into the distant horizon. However, the effectiveness of the submarine demanded new expedients because within its range of effectiveness no ingenuity could render its intended prey invisible. The effective gun-fire from submarines is several miles and torpedoes can be effective at these distances. However, the submarine prefers to discharge the torpedo at ranges within a mile. It is obvious that, in average weather, low visibility ceases to be very effective against the submarine. The movement of a target is of much less importance in the case of gun-fire than in the case of the torpedo with its relatively low velocity. The submarine gunner must have the range, speed, and course of the target in order to fire a torpedo with any hope of a hit. Therefore, any uncertainties that could be introduced pertaining to these factors would be to the advantage of the submarine's prey. For example, low visibility gave way to confusibility in the discussions of defence against the submarine and the slogan, " A miss is as good as a mile " was adopted. The foregoing factors cannot be determined ordinarily with high accuracy, so that it appeared possible to add somewhat to the difficulties of the submarine commander.

Many optical illusions have been devised and studied by scientists. In fact, some of these tricks are well known to the general reader. Straight lines may appear broken, convergent, or divergent by providing certain patterns or lines intermingled with

them. Many of these were applied to models in laboratory experiments and it has been shown that confusion results as to the course of the vessel. The application of these on vessels has resulted in the grotesque patterns to be seen on ships during the latter stage of the war. It is well known that these illusions are most effective when the greatest contrasts are used, hence black and white patterns are common. Color has not been utilized as definitely

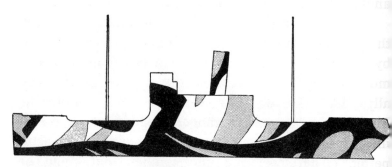

Fig. 92. — A primary stage in the evolution of the use of geometrical-optical illusions on ships.

as pattern in confusibility, although there is a secondary aim of obtaining low visibility at a great distance by properly balancing the black, white, and other colors so that a blue-gray results at distances too great for the individual patterns to be resolved by the eye. Color could be used for the purpose of increasing the conclusion by apparently altering the perspective. For example, blue and red patterns on the same surface do not usually appear at the same distance, the red appearing closer than the blue.

Such apparently grotesque patterns aimed to distort the lines of the ship and to warp the perspective

by which the course is estimated. This was the final type of marine camouflage at the close of the war. Besides relying upon these illusions, ships zigzagged on being attacked and aimed in other ways to confuse the enemy. No general attempt was made to disguise the bow, because the bow-wave was generally visible. However, attempts have been made to increase it apparently and even to provide one at the stern. In fact, ingenuity was heavily drawn upon and many expedients were tried.

After low-visibility was abandoned in favor of the optical illusion for frustrating the torpedo-attack by the submarine, there was a period during which merely a mottled pattern was used for vessels. Gradually this evolved toward such patterns as shown in Fig. 92. In this illustration it is seen that the optical-illusion idea has taken definite form. During the period of uncertainty as to the course the pattern should take, a regularity of pattern was tried, such as illustrated in Figs. 93 and 94. Finally, when it dawned more or less simultaneously upon various scientific men, who were studying the problems of protecting vessels upon the seas, that the geometrical-optical illusion in its well-known forms was directly adaptable, renewed impetus was given to investigation. The scientific literature yielded many facts but the problems were also studied directly by means of models. The latter study is illustrated by Figs. 95 and 96, the originals having been furnished by Mr. E. L. Warner,[11] who among others prosecuted a study of the application of illusions to vessels. The final results were gratifying, as shown to some extent

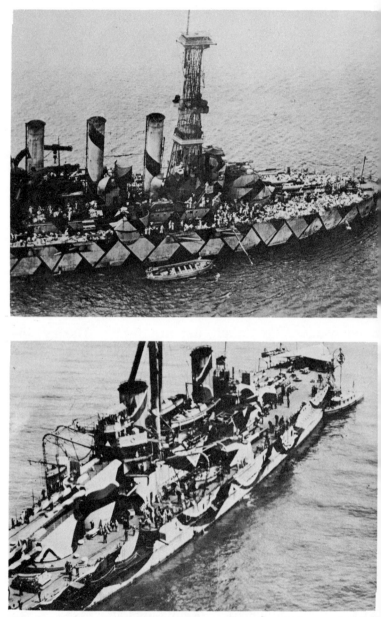

Figs. 93 and 94. — Attempts at distortion of outline which preceded the adoption of geometrical-optical illusions for ships.

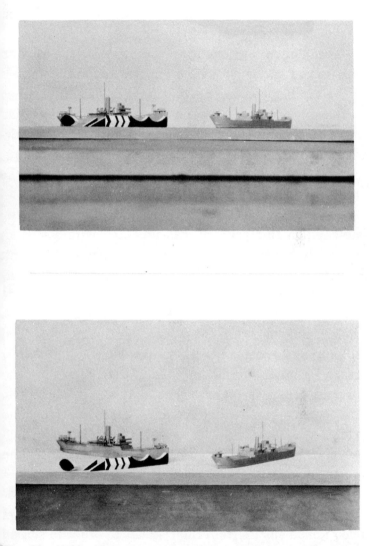

Figs. 95 and 96. Illustrating the use of models by the Navy Department in developing the geometrical-illusion for ships.

in Figs. 97 and 98, also kindly furnished by Mr. Warner It is seen that these patterns are really deceiving as to the course of the vessel.

The convoy system is well known to the reader This saved many vessels from destruction. Vessels of the same speed were grouped together and steamed in flocks across the Atlantic. Anyone who has had the extreme pleasure of looking down from an airplane upon these convoys led by destroyers and attended by chasers is strongly impressed with the old adage, "In unity there is strength."

Before the war began, a Brazilian battleship launched in this country was provided with a system of blue lights for use when near the enemy at night. Blue was adopted doubtless for its low range compared with light of other colors. We know that the setting sun is red because the atmospheric dust, smoke, and moisture have scattered and absorbed the blue and green rays more than the red and yellow rays. In other words the penetrating power of the red and yellow is greater than that of the blue rays. This country made use of this expedient to some extent. Of course, all other lights were extinguished and portholes were closed in ocean travel during the submarine menace.

Naturally smoke-screens were adopted as a defensive measure on sea as well as on land. Destroyers belch dense smoke from their stacks in order to screen battleships. Many types of smoke-boxes have been devised or suggested. The smoke from these is produced chemically and the apparatus must be simple and safe. If a merchantman were attacked

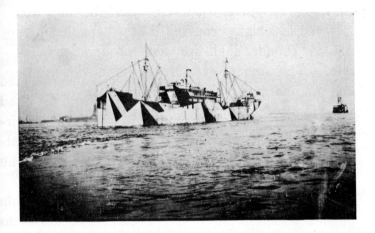

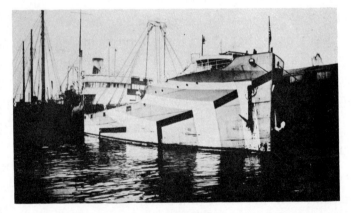

Figs. 97 and 98. — Examples of the geometrical-optical illusion as finally applied.

by a submarine immediately smoke-boxes would be dumped overboard or some which were installed on deck would be put into operation and the ship would be steered in a zigzag course. These expedients were likely to render shell-fire and observations inaccurate. This mode of defense is obviously best suited to unarmed vessels. In the use of smoke-boxes the direction and velocity of the wind must be considered. The writer is unacquainted with any attempts made to camouflage submarines under water, but that this can be done is evident from aerial observations. When looking over the water from a point not far above it, as on a pier, we are unable to see into the water except at points near us where our direction of vision is not very oblique to the surface of the water. The brightness of the surface of water is due to mirrored sky and clouds ordinarily. For a perfectly smooth surface of water, the reflection factor is 2 per cent for perpendicular incidence. This increases only slightly as the obliquity increases to an angle of about 60 degrees. From this point the reflection-factor of the surface rapidly increases, becoming 100 per cent at 90 degrees incidence. This accounts for the ease with which we can see into the water from a position directly overhead and hence the airplane has been an effective hunter of submerged submarines. The depth at which an object can be seen in water depends, of course, upon its clarity. It may be surprising to many to learn that the brightness of water, such as rivers, bays, and oceans, as viewed perpendicularly to its surface, is largely due to light diffused within it. This point

became strikingly evident during the progress of work in aerial photometry.

A submerged submarine may be invisible for two reasons: (1) It may be deep enough to be effectively veiled by the luminosity of the mass of water above it (including the surface brightness) or, (2) It may be of the proper brightness and color to simulate the brightness and color of the water. It is obvious that if it were white it would have to attain concealment by submerging deeply. If it were a fairly dark greenish-blue it would be invisible at very small depths. In fact, it would be of very low visibility just below the surface of the water. By the use of the writer's data on hues and reflection-factors of earth and water areas it would be easy to camouflage submarines effectively from enemies overhead. The visibility of submarines is well exemplified by viewing large fish such as sharks from airships at low altitudes. They appear as miniature submarines dark gray or almost black amid greenish-blue surroundings. Incidentally, the color of water varies considerably from the dirty yellowish-green of shallow inland waters containing much suspended matter to the greenish-blue of deep clear ocean waters. The latter as viewed vertically are about one-half the brightness of the former under the same conditions and are decidedly bluer.

The Visibility of Airplanes. — In the Great War the airplane made its début in warfare and in a short time made a wonderful record, yet when hostilities ceased aerial camouflage had not been put on a scientific basis. No nation had developed this general

aspect of camouflage systematically or to an extent comparable with the developments on land and sea. One of the chief difficulties was that scientific data which were applicable were lacking. During the author's activities as Chairman of the Committee on Camouflage of the National Research Council he completed an extensive investigation [12] of the fundamentals upon which the attainment of low visibility for airplanes must be based. Solutions of the problems encountered in rendering airplanes of low visibility resulted and various recommendations were made, but the experiences and data will be drawn upon here only in a general way. In this general review details would consume too much space, for the intention has been to present a broad view of the subject of camouflage.

The visibility of airplanes presents some of the most interesting problems to be found in the development of the scientific basis for camouflage. The general problem may be subdivided according to the type of airplane, its field of operation, and its activity. For example, patrol craft which fly low over our own lines would primarily be camouflaged for low visibility as viewed by enemies above. (See Fig. 99.) High-flying craft would be rendered of low visibility as viewed primarily by the enemy below. Airplanes for night use present other problems and the visibility of seaplanes is a distinct problem, owing to the fact that the important background is the water, because seaplanes are not ordinarily high-flying craft. In all these considerations it will be noted that the activity of the airplanes is of primary importance,

because it determines the lines of procedure in rendering the craft of low visibility. This aspect is too complicated to discuss thoroughly in a brief résumé.

The same fundamentals of light, color, and vision apply in this field as in other fields of camouflage,

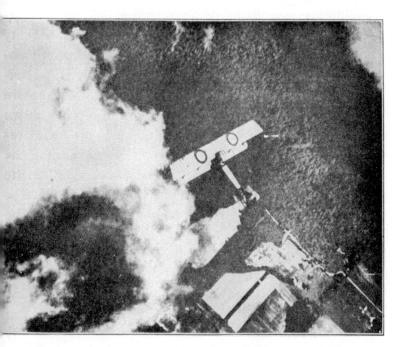

Fig. 99. — Representative earth backgrounds for an airplane (uncamouflaged) as viewed from above.

but different data are required. When viewing aircraft from above, the earth is the background of most importance. Cumulus clouds on sunny days are generally at altitudes of 4000 to 7000 feet. Clouds are not always present and besides they are of such a different order of brightness from that of the earth that they cannot be considered in camouflage designed

for low visibility from above. In other words, the compromise in this case is to accept the earth as a background and to work on this basis. We are confronted with seasonal changes of landscape, but inasmuch as the summer landscape was of greatest importance generally, it was the dominating factor in considering low visibility from above.

On looking down upon the earth one is impressed with the definite types of areas such as cultivated fields, woods, barren ground and water. Different landscapes contain these areas in various proportions, which fact must be considered. Many thousand determinations of reflection-factor and of approximate hue were made for these types of areas, and upon the mean values camouflage for low visibility as viewed from above was developed. A few values are given in the accompanying table, but a more comprehensive presentation will be found elsewhere.[12]

Mean Reflection-Factors

(From thousands of measurements made by viewing vertically downward during summer and fall from various altitudes.)

	Per Cent
Woods	4.3
Barren ground	13.0
Fields (grazing land and growing crops)	6.8
Inland water (rivers and bays)	6.8
Deep ocean water	3.5
Dense clouds	78.0

Wooded areas are the darkest general areas in a landscape and possess a very low reflection-factor. From above one sees the deep shadows interspersed among the highlights. These shadows and the trap-

ping of light are largely responsible for the low brightness or apparent reflection-factor. This is best illustrated by means of black velvet. If a piece of cardboard is dyed with the same black dye as that used to dye the velvet, it will diffusely reflect 2 or 3 per cent of the incident light, but the black velvet will reflect no more than 0.5 per cent. The velvet fibers provide many light traps and cast many shadows which reduce the relative brightness or reflection-factor far below that of the flat cardboard. Cultivated fields on which there are growing crops are nearly twice as bright as wooded areas, depending, of course, upon the denseness of the vegetation. Barren sunbaked lands are generally the brightest large areas in a landscape, the brightness depending upon the character of the soil. Wet soil is darker than dry soil, owing to the fact that the pores are filled with water, thus reducing the reflection-factor of the small particles of soil. A dry white blotting paper which reflects 75 per cent of the incident light will reflect only about 55 per cent when wet.

Inland waters which contain much suspended matter are about as bright as grazing land and cultivated fields. Shallow water partakes somewhat of the color and brightness of the bed, and deep ocean water is somewhat darker than wooded areas. Quiet stagnant pools or small lakes are sometimes exceedingly dark; in fact, they appear like pools of ink, owing to the fact that their brightness as viewed vertically is almost entirely due to surface reflection. If it is due entirely to reflection at the surface, the brightness will be about 2 per cent of the brightness of the

zenith sky. That is, when viewing such a body of water vertically one sees an image of the zenith sky reduced in brightness to about 2 per cent.

The earth patterns were extensively studied with the result that definite conclusions were formulated pertaining to the best patterns to be used. Although it is out of the question to present a detailed discussion of this important phase in this résumé, attention will be called to the manner in which the earth patterns diminish with increasing altitude. The insert in Fig. 100 shows the actual size of an image of a 50-foot airplane from 0 to 16,000 feet below the observer as compared with corresponding images (to the same scale) of objects and areas on the earth's surface 10,000 feet below the observer.

For simplicity assume a camera lens to have a focal length equal to 10 inches, then the length x of the image of an object 100 feet long will be related to the altitude h in this manner:

$$\frac{x}{10} = \frac{100}{h} \text{ or } xh = 1000$$

By substituting the values of altitude h in the equation the values of the length x of the image are found. The following values illustrate the change in size of the image with altitude:

Altitude h in feet	Size of image x in inches
1,000	1.00
2,000	0.50
3,000	0.33
4,000	0.25
10,000	0.10
20,000	0.05

It is seen that the image diminishes less rapidly in size as the altitude increases. For example, going from 1000 feet to 2000 feet the image is reduced to one-half. The same reduction takes place in as-

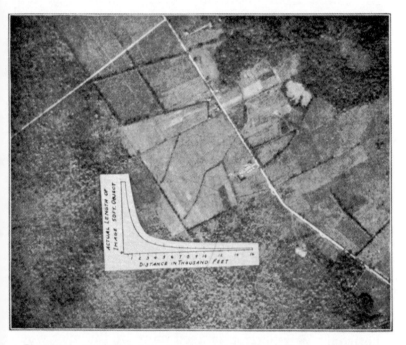

Fig. 100. — Illustrating the study of pattern for airplanes. The photograph was taken from an altitude of 10,000 feet. The insert shows the relative lengths (verticle scale) of an airplane of 50-foot spread at various distances below the observer.

cending from 10,000 to 20,000 feet. By taking a series of photographs and knowing the reduction-factor of the lens it is a simple matter to study pattern. An airplane of known dimensions can be placed in the imagination at any altitude on a photograph taken at a known altitude and the futility of certain patterns and the advantages of others are at once evident.

It is impracticable to present colored illustrations in this résumé and values expressed in numbers are meaningless to most persons, so a few general remarks will be made in closing the discussion of low visibility as viewed from above in spring, summer and fall. A black craft is of much lower visibility than a white one. White should not be used. The paints should be very dark shades. The hues are approximately the same for the earth areas as seen at the earth's surface. Inland waters are a dirty blue-green or bluish-green, and deep ocean water is a greenish-blue when viewed vertically, or nearly so. Mean hues of these were determined approximately.

Before considering other aspects of camouflage it is well to consider such features as haze, clouds and sky. There appear to be two kinds of haze which the writer will arbitrarily call earth and high haze, respectively. The former consists chiefly of dust and smoke and usually extends to an altitude of about one mile, although it occasionally extends much higher. Its upper limit is very distinct, as seen by the "false" horizon. This horizon is used more by the pilot when flying at certain altitudes than the true horizon. At the top of this haze cumulus clouds are commonly seen to be poking out like nearly submerged icebergs. The upper haze appears somewhat whiter in color and appears to extend sometimes to altitudes of several or even many miles. The fact that the "earth" haze may be seen to end usually at about 5000 to 6000 feet and the upper haze to persist even beyond 20,000 feet has led the author to apply different names for convenience. The upper limit of the "earth"

haze is determined by the height of diurnal atmospheric convection. Haze aids in lowering the visibility of airplanes by providing a luminous veil, but it also operates at some altitudes to increase the brightness of the sky, which is the background in this case.

The sky generally decreases considerably in brightness as the observer ascends. The brightness of the sky is due to scattered light, that is, to light being reflected by particles of dust, smoke, thinly diffused clouds, etc. By making a series of measurements of the brightness of the zenith sky for various altitudes, the altitude where the earth haze ends is usually plainly distinguishable. Many observations of this character were accumulated. In some extreme cases the sky was found to be only one-tenth as bright when observed at high altitudes of 15,000 to 20,000 feet as seen from the earth's surface. This accounts partly for the decrease in the visibility of an airplane as it ascends. At 20,000 feet the sky was found to contribute as little as 4 per cent of the total light on a horizontal plane and the extreme harshness of the lighting is very noticeable when the upper sky is cloudless and clear.

Doubtless, it has been commonly noted that airplanes are generally very dark objects as viewed from below against the sky. Even when painted white they are usually much darker than the sky. As they ascend the sky above them becomes darker, although to the observer on the ground the sky remains constant in brightness. However, in ascending, the airplane is leaving below it more and more luminous haze which acts as a veil in aiding to screen it until,

when it reaches a high altitude, the combination of dark sky behind it and luminous haze between it and the observer on the ground, it becomes of much lower visibility. Another factor which contributes somewhat is its diminishing size as viewed from a fixed position at the earth. The minimum perceptible contrast becomes larger as the size of the contrasting patch diminishes.

Inasmuch as there is not enough light reflected upward from the earth to illuminate the lower side of an opaque surface sufficiently to make it as bright as the sky ordinarily, excepting at very high altitudes for very clear skies, it is necessary, in order to attain low visibility for airplanes as viewed from below, to supply some additional illumination to the lower surfaces. Computations have shown that artificial lighting is impracticable, but measurements on un-doped airplane fabrics indicate that on sunny days a sufficient brightness can be obtained from direct sunlight diffused by the fabric to increase the brightness to the order of magnitude of the brightness of the sky. On overcast days an airplane will nearly always appear very much darker than the sky. That is, the brightness of the lower sides can in no other manner be made equal to that of the sky. However, low visibility can be obtained on sunny days which is an advantage over high visibility at all times, as is the case with airplanes now in use. Many observations and computations of these and other factors have been made, so that it is possible to predict results. Transparent media have obvious advantages, but no satisfactory ones are available at present.

Having considered low visibility of aircraft as viewed from above and from below, respectively, it is of interest to discuss briefly the possibility of attaining both of these simultaneously with a given airplane. Frankly, it is not practicable to do this. An airplane to be of low visibility against the earth background must be painted or dyed very dark shades of appropriate color and pattern. This renders it almost opaque and it will be a very dark object when viewed against the sky. If the lower surfaces of the airplane are painted as white as possible the airplane still remains a dark object against the blue sky and a very dark object against an overcast sky, except at high altitudes. In the latter cases the contrast is not as great as already explained. A practicable method of decreasing the visibility of airplanes at present as viewed from below is to increase the brightness by the diffuse transmission of direct sun-light on clear days. On overcast days clouds and haze must be depended upon to screen the craft.

In considering these aspects it is well to recall that the two sources of light are the sun and the sky. Assuming the sun to contribute 80 per cent of the total light which reaches the upper side of an opaque horizontal diffusing surface at midday at the earth and assuming the sky to be cloudless and uniform in brightness, then the brightness of the horizontal upper surface will equal $5\ RB$, where R is the reflection-factor of the surface and B is the brightness (different in the two cases) of the sky. On a uniformly overcast day the brightness of the surface would be equal to RB. Now assuming R_e to be the mean reflection-

factor of the earth, then the lower side of a horizontal opaque surface suspended in the air would receive light in proportion to R_eB. If this lower surface were a perfect mirror or a perfectly reflecting and diffusing surface its brightness would equal $5\,R_eB$ on the sunny day and R_eB on the overcast day where B is the value (different in the two cases) of the brightness of the uniform sky. The surface can never be a perfect reflector, so on an overcast day its brightness will be a fraction (RR_e) of the brightness B of the uniform sky. Inasmuch as R_e is a very small value it is seen that low visibility of airplanes as viewed from below generally cannot be attained on an overcast day. It can be approached on a sunny day and even realized by adopting the expedient already mentioned. Further computations are to be found elsewhere.[12]

Seasonable changes present no difficulties, for from a practical standpoint only summer and winter need be generally considered. If the earth is covered with snow an airplane covered completely with white or gray paint would be fairly satisfactory as viewed from above, and if a certain shade of a blue tint be applied to the lower surfaces, low visibility as viewed from below would result. The white paint would possess a reflection-factor about equal to that of snow, thus providing low visibility from above. Inasmuch as the reflection-factor of snow is very high, the white lower sides of an airplane would receive a great deal more light in winter than they would in summer. Obviously, a blue tint is necessary for low visibility against the sky, but color has not been primarily considered in the preceding paragraphs because the chief difficulty

in achieving low visibility from below lies in obtaining brightness of the proper order of magnitude. In winter the barren ground would be approximately of the same color and reflection-factor as in summer, so it would not be difficult to take this into consideration.

Seaplanes whose backgrounds generally consist of water would be painted of the color and brightness of water with perhaps a slight mottling. The color would generally be a very dark shade, approximating blue-green in hue.

Aircraft for night use would be treated in the same manner as aircraft for day use, if the moonlight is to be considered a dominant factor. This is one of the cases where the judgment must be based on actual experience. It appears that the great enemy of night raiders is the searchlight. If this is true the obvious expedient is to paint the craft a dull jet black. Experiments indicate that it is more difficult to pick up a black craft than a gray or white one and also it is more difficult to hold it in the beam of the searchlight. This can be readily proved by the use of black, gray, and white cards in the beam of an automobile headlight. The white card can be seen in the outskirts of the beam where the gray or black cannot be seen, and the gray can be picked up where the black one is invisible. The science of vision accounts for this as it does for many other questions which arise in the consideration of camouflage or low visibility.

Some attempts have been made to apply the principle of confusibility to airplanes as finally developed for vessels to circumvent the submarine, but the

folly of this appears to be evident. Air battles are conducted at terrific speeds and with skillful maneuvering. Triggers are pulled without computations and the whole activity is almost lightning-like. To expect to confuse an opponent as to the course and position of the airplane is folly.

The camouflage of observation balloons has not been developed, though experiments were being considered in this direction as the war closed. Inasmuch as they are low-altitude crafts it appears that they would be best camouflaged for the earth as a background. Their enemies pounce down upon them from the sky so that low visibility from above seems to be the better choice.

In the foregoing it has been aimed to give the reader the general underlying principles of camouflage and low visibility, but at best this is only a résumé. In the following references will be found more extensive discussions of various phases of the subject.

REFERENCES

1. A Study of Zöllner's Figures and Other Related Figures, J. Jastrow, Amer. Jour. of Psych. 1891, 4, p. 381.
2. A Study of Geometrical Illusions, C. H. Judd, Psych. Rev. 1899, 6, p. 241.
3. Visual Illusions of Depth, H. A. Carr, Psych. Rev. 1909, 16, p. 219.
4. Irradiation of Light, F. P. Boswell, Psych. Bul. 1905, 2, p. 200.
5. Retiring and Advancing Colors, M. Luckiesh, Amer. Jour. Psych. 1918, 29, p. 182.
6. The Language of Color, 1918, M. Luckiesh.
7. Apparent Form of the Dome of the Sky, Ann. d. Physik, 1918, 55, p. 387; Sci. Abs. 1918, No. 1147.

8. Course on Optics, 1738, Robert Smith.
9. Color and Its Applications, 1915 and 1921; Light and Shade and Their Applications, 1916, M. Luckiesh.
10. Report of The Submarine Defense Association, L. T. Bates and L. A. Jones.
11. Marine Camouflage Design, E. L. Warner, Trans. I. E. S. 1919, 14, p. 215.
12. The Visibility of Airplanes, M. Luckiesh, Jour. Frank. Inst. March and April, 1919; also Aerial Photometry, Astrophys. Jour. 1919, 49, p. 108.
13. Jour. Amer. Opt. Soc., E. Karrer, 1921.

The foregoing are only a few references indicated in the text. Hundreds of references are available and obviously it is impracticable to include such a list. The most fruitful sources of references are the general works on psychology. E. B. Titchener's Experimental Psychology (vol. 1) contains an excellent list. A chapter on Space in William James' Principles of Psychology (vol. II) will be found of interest to those who wish to delve deeper into visual perception. Other general references are Elements of Physiological Psychology by Ladd and Woodworth; the works of Helmholtz; a contribution by Hering in Hermann's Handb. d. Phys. Bk. III, part 1; Physiological Psychology by Wundt; E. B. Delabarre, Amer. Jour. Psych. 1898, 9, p. 573; W. Wundt, Täuschungen, p. 157 and Philos. Stud. 1898, 14, p. 1; T. Lipps, Raumaesthetik and Zeit. f. Psych. 1896, 12, 39.

INDEX

CATALOGUE OF DOVER BOOKS

The more difficult books are indicated by an asterisk (*

Books Explaining Science and Mathematics

WHAT IS SCIENCE?, N. Campbell. The role of experiment and measurement, the function of mathematics, the nature of scientific laws, the difference between laws and theories the limitations of science, and many similarly provocative topics are treated clearly and without technicalities by an eminent scientist. "Still an excellent introduction to scientific philosophy," H. Margenau in PHYSICS TODAY. "A first-rate primer . . . deserves a wide audience," SCIENTIFIC AMERICAN. 192pp. 5⅜ x 8. S43 Paperbound **$1.25**

THE NATURE OF PHYSICAL THEORY, P. W. Bridgman. A Nobel Laureate's clear, non-technical lectures on difficulties and paradoxes connected with frontier research on the physical sciences. Concerned with such central concepts as thought, logic, mathematics, relativity probability, wave mechanics, etc. he analyzes the contributions of such men as Newton Einstein, Bohr, Heisenberg, and many others. "Lucid and entertaining . . . recommended to anyone who wants to get some insight into current philosophies of science," THE NEW PHILOSOPHY. Index. xi + 138pp. 5⅜ x 8. S33 Paperbound **$1.25**

EXPERIMENT AND THEORY IN PHYSICS, Max Born. A Nobel Laureate examines the nature of experiment and theory in theoretical physics and analyzes the advances made by the great physicists of our day: Heisenberg, Einstein, Bohr, Planck, Dirac, and others. The actual process of creation is detailed step-by-step by one who participated. A fine examination of the scientific method at work. 44pp. 5⅜ x 8. S308 Paperbound **75¢**

THE PSYCHOLOGY OF INVENTION IN THE MATHEMATICAL FIELD, J. Hadamard. The reports of such men as Descartes, Pascal, Einstein, Poincaré, and others are considered in this investigation of the method of idea-creation in mathematics and other sciences and the thinking process in general. How do ideas originate? What is the role of the unconscious? What is Poincaré's forgetting hypothesis? are some of the fascinating questions treated. A penetrating analysis of Einstein's thought processes concludes the book. xiii + 145pp. 5⅜ x 8. T107 Paperbound **$1.25**

THE NATURE OF LIGHT AND COLOUR IN THE OPEN AIR, M. Minnaert. Why are shadows sometimes blue, sometimes green, or other colors depending on the light and surroundings? What causes mirages? Why do multiple suns and moons appear in the sky? Professor Minnaert explains these unusual phenomena and hundreds of others in simple, easy-to-understand terms based on optical laws and the properties of light and color. No mathematics is required but artists, scientists, students, and everyone fascinated by these "tricks" of nature will find thousands of useful and amazing pieces of information. Hundreds of observational experiments are suggested which require no special equipment. 200 illustrations; 42 photos. xvi + 362pp. 5⅜ x 8. T196 Paperbound **$2.00**

THE UNIVERSE OF LIGHT, W. Bragg. Sir William Bragg, Nobel Laureate and great modern physicist, is also well known for his powers of clear exposition. Here he analyzes all aspects of light for the layman: lenses, reflection, refraction, the optics of vision, x-rays, the photoelectric effect, etc. He tells you what causes the color of spectra, rainbows, and soap bubbles how magic mirrors work, and much more. Dozens of simple experiments are described. Preface Index. 199 line drawings and photographs, including 2 full-page color plates. x + 283pp. 5⅜ x 8. T538 Paperbound **$1.85**

SOAP-BUBBLES: THEIR COLOURS AND THE FORCES THAT MOULD THEM, C. V. Boys. For continuing popularity and validity as scientific primer, few books can match this volume of easily-followed experiments, explanations. Lucid exposition of complexities of liquid films, surface tension and related phenomena, bubbles' reaction to heat, motion, music, magnetic fields Experiments with capillary attraction, soap bubbles on frames, composite bubbles, liquid cylinders and jets, bubbles other than soap, etc. Wonderful introduction to scientific method, natural laws that have many ramifications in areas of modern physics. Only complete edition in print. New Introduction by S. Z. Lewin, New York University. 83 illustrations; 1 full-page color plate. xii + 190pp. 5⅜ x 8½. T542 Paperbound **95¢**

CATALOGUE OF DOVER BOOKS

THE STORY OF X-RAYS FROM RONTGEN TO ISOTOPES, A. R. Bleich, M.D. This book, by a member of the American College of Radiology, gives the scientific explanation of x-rays, their applications in medicine, industry and art, and their danger (and that of atmospheric radiation) to the individual and the species. You learn how radiation therapy is applied against cancer, how x-rays diagnose heart disease and other ailments, how they are used to examine mummies for information on diseases of early societies, and industrial materials for hidden weaknesses. 54 illustrations show x-rays of flowers, bones, stomach, gears with flaws, etc. 1st publication. Index. xix + 186pp. 5⅜ x 8. T622 Paperbound **$1.35**

SPINNING TOPS AND GYROSCOPIC MOTION, John Perry. A classic elementary text of the dynamics of rotation — the behavior and use of rotating bodies such as gyroscopes and tops. In simple, everyday English you are shown how quasi-rigidity is induced in discs of paper, smoke rings, chains, etc., by rapid motions; why a gyrostat falls and why a top rises; precession; how the earth's motion affects climate; and many other phenomena. Appendix on practical use of gyroscopes. 62 figures. 128pp. 5⅜ x 8. T416 Paperbound **$1.00**

SNOW CRYSTALS, W. A. Bentley, M. J. Humphreys. For almost 50 years W. A. Bentley photographed snow flakes in his laboratory in Jericho, Vermont; in 1931 the American Meteorological Society gathered together the best of his work, some 2400 photographs of snow flakes, plus a few ice flowers, windowpane frosts, dew, frozen rain, and other ice formations. Pictures were selected for beauty and scientific value. A very valuable work to anyone in meteorology, cryology; most interesting to layman; extremely useful for artist who wants beautiful, crystalline designs. All copyright free. Unabridged reprint of 1931 edition. 2453 illustrations. 227pp. 8 x 10½. T287 Paperbound **$3.00**

DOVER SCIENCE SAMPLER, edited by George Barkin. A collection of brief, non-technical passages from 44 Dover Books Explaining Science for the enjoyment of the science-minded browser. Includes work of Bertrand Russell, Poincaré, Laplace, Max Born, Galileo, Newton; material on physics, mathematics, metallurgy, anatomy, astronomy, chemistry, etc. You will be fascinated by Martin Gardner's analysis of the sincere pseudo-scientist, Moritz's account of Newton's absentmindedness, Bernard's examples of human vivisection, etc. Illustrations from the Diderot Pictorial Encyclopedia and De Re Metallica. 64 pages. **FREE**

THE STORY OF ATOMIC THEORY AND ATOMIC ENERGY, J. G. Feinberg. A broader approach to subject of nuclear energy and its cultural implications than any other similar source. Very readable, informal, completely non-technical text. Begins with first atomic theory, 600 B.C. and carries you through the work of Mendelejeff, Röntgen, Madame Curie, to Einstein's equation and the A-bomb. New chapter goes through thermonuclear fission, binding energy, other events up to 1959. Radioactive decay and radiation hazards, future benefits, work of Bohr, moderns, hundreds more topics. "Deserves special mention . . . not only authoritative but thoroughly popular in the best sense of the word," Saturday Review. Formerly, "The Atom Story." Expanded with new chapter. Three appendixes. Index. 34 illustrations. vii + 243pp. 5⅜ x 8. T625 Paperbound **$1.45**

THE STRANGE STORY OF THE QUANTUM, AN ACCOUNT FOR THE GENERAL READER OF THE GROWTH OF IDEAS UNDERLYING OUR PRESENT ATOMIC KNOWLEDGE, B. Hoffmann. Presents lucidly and expertly, with barest amount of mathematics, the problems and theories which led to modern quantum physics. Dr. Hoffmann begins with the closing years of the 19th century, when certain trifling discrepancies were noticed, and with illuminating analogies and examples takes you through the brilliant concepts of Planck, Einstein, Pauli, Broglie, Bohr, Schroedinger, Heisenberg, Dirac, Sommerfeld, Feynman, etc. This edition includes a new, long postscript carrying the story through 1958. "Of the books attempting an account of the history and contents of our modern atomic physics which have come to my attention, this is the best," H. Margenau, Yale University, in "American Journal of Physics." 32 tables and line illustrations. Index. 275pp. 5⅜ x 8. T518 Paperbound **$1.50**

SPACE AND TIME, E. Borel. Written by a versatile mathematician of world renown with his customary lucidity and precision, this introduction to relativity for the layman presents scores of examples, analogies, and illustrations that open up new ways of thinking about space and time. It covers abstract geometry and geographical maps, continuity and topology, the propagation of light, the special theory of relativity, the general theory of relativity, theoretical researches, and much more. Mathematical notes. 2 Indexes. 4 Appendices. 15 figures. xvi + 243pp. 5⅜ x 8. T592 Paperbound **$1.45**

FROM EUCLID TO EDDINGTON: A STUDY OF THE CONCEPTIONS OF THE EXTERNAL WORLD, Sir Edmund Whittaker. A foremost British scientist traces the development of theories of natural philosophy from the western rediscovery of Euclid to Eddington, Einstein, Dirac, etc. The inadequacy of classical physics is contrasted with present day attempts to understand the physical world through relativity, non-Euclidean geometry, space curvature, wave mechanics, etc. 5 major divisions of examination: Space; Time and Movement; the Concepts of Classical Physics; the Concepts of Quantum Mechanics; the Eddington Universe. 212pp. 5⅜ x 8. T491 Paperbound **$1.35**

CATALOGUE OF DOVER BOOKS

***THE EVOLUTION OF SCIENTIFIC THOUGHT FROM NEWTON TO EINSTEIN, A. d'Abro.** A detailed account of the evolution of classical physics into modern relativistic theory and the concommitant changes in scientific methodology. The breakdown of classical physics in the face of non-Euclidean geometry and the electromagnetic equations is carefully discussed and then a exhaustive analysis of Einstein's special and general theories of relativity and their implications is given. Newton, Riemann, Weyl, Lorentz, Planck, Maxwell, and many others are considered. A non-technical explanation of space, time, electromagnetic waves, etc. as understood today. "Model of semi-popular exposition," NEW REPUBLIC. 21 diagrams. 482pp. 5⅜ x 8.
T2 Paperbound **$2.0**

EINSTEIN'S THEORY OF RELATIVITY, Max Born. Nobel Laureate explains Einstein's special and general theories of relativity, beginning with a thorough review of classical physics in simple, non-technical language. Exposition of Einstein's work discusses concept of simultaneity, kinematics, relativity of arbitrary motions, the space-time continuum, geometry of curved surfaces, etc., steering middle course between vague popularizations and complex scientific presentations. 1962 edition revised by author takes into account latest findings, predictions of theory and implications for cosmology, indicates what is being sought in unified field theory. Mathematics very elementary, illustrative diagrams and experiment informative but simple. Revised 1962 edition. Revised by Max Born, assisted by Gunther Leibfried and Walter Biem. Index. 143 illustrations. vii + 376pp. 5⅜ x 8.
S769 Paperbound **$2.0**

PHILOSOPHY AND THE PHYSICISTS, L. Susan Stebbing. A philosopher examines the philosophical aspects of modern science, in terms of a lively critical attack on the ideas of Jeans and Eddington. Such basic questions are treated as the task of science, causality, determinism, probability, consciousness, the relation of the world of physics to the world of everyday experience. The author probes the concepts of man's smallness before an inscrutable universe, the tendency to idealize mathematical construction, unpredictability theorems and human freedom, the supposed opposition between 19th century determinism and modern science, and many others. Introduces many thought-stimulating ideas about the implications of modern physical concepts. xvi + 295pp. 5⅜ x 8.
T480 Paperbound **$1.6**

THE RESTLESS UNIVERSE, Max Born. A remarkably lucid account by a Nobel Laureate of recent theories of wave mechanics, behavior of gases, electrons and ions, waves and particles, electronic structure of the atom, nuclear physics, and similar topics. "Much more thorough and deeper than most attempts . . . easy and delightful," CHEMICAL AND ENGINEERING NEWS. Special feature: 7 animated sequences of 60 figures each showing such phenomena as gas molecules in motion, the scattering of alpha particles, etc. 11 full-page plates of photographs. Total of nearly 600 illustrations. 351pp. 6⅛ x 9¼. T412 Paperbound **$2.0**

THE COMMON SENSE OF THE EXACT SCIENCES, W. K. Clifford. For 70 years a guide to the basic concepts of scientific and mathematical thought. Acclaimed by scientists and laymen alike, it offers a wonderful insight into concepts such as the extension of meaning of symbols, characteristics of surface boundaries, properties of plane figures, measurement of quantities, vectors, the nature of position, bending of space, motion, mass and force, and many others. Prefaces by Bertrand Russell and Karl Pearson. Critical introduction by James Newman. 130 figures. 249pp. 5⅜ x 8. T61 Paperbound **$1.60**

MATTER AND LIGHT, THE NEW PHYSICS, Louis de Broglie. Non-technical explanations by a Nobel Laureate of electro-magnetic theory, relativity, matter, light and radiation, wave mechanics, quantum physics, philosophy of science, and similar topics. This is one of the simplest yet most accurate introductions to the work of men like Planck, Einstein, Bohr, and others. Only 2 of the 21 chapters require a knowledge of mathematics. 300pp. 5⅜ x 8.
T35 Paperbound **$1.75**

SCIENCE, THEORY AND MAN, Erwin Schrödinger. This is a complete and unabridged reissue of SCIENCE AND THE HUMAN TEMPERAMENT plus an additional essay: "What Is an Elementary Particle?" Nobel Laureate Schrödinger discusses such topics as nature of scientific method, the nature of science, chance and determinism, science and society, conceptual models for physical entities, elementary particles and wave mechanics. Presentation is popular and may be followed by most people with little or no scientific training. "Fine practical preparation for a time when laws of nature, human institutions . . . are undergoing a critical examination without parallel," Waldemar Kaempffert, N. Y. TIMES. 192pp. 5⅜ x 8.
T428 Paperbound **$1.35**

CONCERNING THE NATURE OF THINGS, Sir William Bragg. The Nobel Laureate physicist in his Royal Institute Christmas Lectures explains such diverse phenomena as the formation of crystals, how uranium is transmuted to lead, the way X-rays travel, why a spinning ball travels in a curved path, the reason why bubbles bounce from each other, and many other scientific topics that are seldom explained in simple terms. No scientific background needed—book is easy enough that any intelligent adult or youngster can understand it. Unabridged. 32pp. of photos; 57 figures. xii + 232pp. 5⅜ x 8. T31 Paperbound **$1.35**

***THE RISE OF THE NEW PHYSICS (formerly THE DECLINE OF MECHANISM), A. d'Abro.** This authoritative and comprehensive 2 volume exposition is unique in scientific publishing. Written for intelligent readers not familiar with higher mathematics, it is the only thorough explanation in non-technical language of modern mathematical-physical theory. Combining both history and exposition, it ranges from classical Newtonian concepts up through the electronic theories of Dirac and Heisenberg, the statistical mechanics of Fermi, and Einstein's relativity theories. "A must for anyone doing serious study in the physical sciences," J. OF FRANKLIN INST. 97 illustrations. 991pp. 2 volumes. T3 Vol. 1, Paperbound **$2.00**
T4 Vol. 2, Paperbound **$2.00**

CATALOGUE OF DOVER BOOKS

BRIDGES AND THEIR BUILDERS, D. B. Steinman & S. R. Watson. Engineers, historians, and very person who has ever been fascinated by great spans will find this book an endless source of information and interest. Greek and Roman structures, Medieval bridges, modern classics such as the Brooklyn Bridge, and the latest developments in the science are retold by one of the world's leading authorities on bridge design and construction. BRIDGES AND THEIR BUILDERS is the only comprehensive and accurate semi-popular history of these important measures of progress in print. New, greatly revised, enlarged edition. 23 photos; 26 line-drawings. Index. xvii + 401pp. 5⅜ x 8. **T431 Paperbound $2.00**

FAMOUS BRIDGES OF THE WORLD, D. B. Steinman. An up-to-the-minute new edition of a book that explains the fascinating drama of how the world's great bridges came to be built. The author, designer of the famed Mackinac bridge, discusses bridges from all periods and all parts of the world, explaining their various types of construction, and describing the problems their builders faced. Although primarily for youngsters, this cannot fail to interest readers of all ages. 48 illustrations in the text. 23 photographs. 99pp. 6⅛ x 9¼. **T161 Paperbound $1.00**

HOW DO YOU USE A SLIDE RULE? by A. A. Merrill. A step-by-step explanation of the slide rule that presents the fundamental rules clearly enough for the non-mathematician to understand. Unlike most instruction manuals, this work concentrates on the two most important operations: multiplication and division. 10 easy lessons, each with a clear drawing, for the reader who has difficulty following other expositions. 1st publication. Index. 2 Appendices. 10 illustrations. 78 problems, all with answers. vi + 36 pp. 6⅛ x 9¼. **T62 Paperbound 60¢**

HOW TO CALCULATE QUICKLY, H. Sticker. A tried and true method for increasing your "number sense" — the ability to see relationships between numbers and groups of numbers. Addition, subtraction, multiplication, division, fractions, and other topics are treated through techniques not generally taught in schools: left to right multiplication, division by inspection, etc. This is not a collection of tricks which work only on special numbers, but a detailed well-planned course, consisting of over 9,000 problems that you can work in spare moments. It is excellent for anyone who is inconvenienced by slow computational skills. 5 or 10 minutes of this book daily will double or triple your calculation speed. 9,000 problems, answers. 256pp. 5⅜ x 8. **T295 Paperbound $1.00**

MATHEMATICAL FUN, GAMES AND PUZZLES, Jack Frohlichstein. A valuable service for parents of children who have trouble with math, for teachers in need of a supplement to regular upper elementary and junior high math texts (each section is graded—easy, average, difficult —for ready adaptation to different levels of ability), and for just anyone who would like to develop basic skills in an informal and entertaining manner. The author combines ten years of experience as a junior high school math teacher with a method that uses puzzles and games to introduce the basic ideas and operations of arithmetic. Stress on everyday uses of math: banking, stock market, personal budgets, insurance, taxes. Intellectually stimulating and practical, too. 418 problems and diversions with answers. Bibliography. 120 illustrations. ix + 306pp. 5⅝ x 8½. **T789 Paperbound $1.75**

GREAT IDEAS OF MODERN MATHEMATICS: THEIR NATURE AND USE, Jagjit Singh. Reader with only high school math will understand main mathematical ideas of modern physics, astronomy, genetics, psychology, evolution, etc. better than many who use them as tools, but comprehend little of their basic structure. Author uses his wide knowledge of non-mathematical fields in brilliant exposition of differential equations, matrices, group theory, logic, statistics, problems of mathematical foundations, imaginary numbers, vectors, etc. Original publication. 2 appendixes. 2 indexes. 65 illustr. 322pp. 5⅜ x 8. **S587 Paperbound $1.75**

MATHEMATICS IN ACTION, O. G. Sutton. Everyone with a command of high school algebra will find this book one of the finest possible introductions to the application of mathematics to physical theory. Ballistics, numerical analysis, waves and wavelike phenomena, Fourier series, group concepts, fluid flow and aerodynamics, statistical measures, and meteorology are discussed with unusual clarity. Some calculus and differential equations theory is developed by the author for the reader's help in the more difficult sections. 88 figures. Index. viii + 236pp. 5⅜ x 8. **T440 Clothbound $3.50**

INTRODUCTION TO SYMBOLIC LOGIC AND ITS APPLICATIONS, Rudolph Carnap. One of the clearest, most comprehensive, and rigorous introductions to modern symbolic logic, by perhaps its greatest living master. Not merely elementary theory, but demonstrated applications in mathematics, physics, and biology. Symbolic languages of various degrees of complexity are analyzed, and one constructed. "A creation of the rank of a masterpiece," Zentralblatt für Mathematik und Ihre Grenzgebiete. Over 300 exercises. 5 figures. Bibliography. Index. vi + 241pp. 5⅜ x 8. **S453 Paperbound $1.85**

HIGHER MATHEMATICS FOR STUDENTS OF CHEMISTRY AND PHYSICS, J. W. Mellor. Not abstract, but practical, drawing its problems from familiar laboratory material, this book covers theory and application of differential calculus, analytic geometry, functions with singularities, integral calculus, infinite series, solution of numerical equations, differential equations, Fourier's theorem and extensions, probability and the theory of errors, calculus of variations, determinants, etc. "If the reader is not familiar with this book, it will repay him to examine it," CHEM. & ENGINEERING NEWS. 800 problems. 189 figures. 2 appendices; 30 tables of integrals, probability functions, etc. Bibliography. xxi + 641pp. 5⅜ x 8. **S193 Paperbound $2.25**

History of Science and Mathematics

THE STUDY OF THE HISTORY OF MATHEMATICS, THE STUDY OF THE HISTORY OF SCIENCE, G. Sarton. Two books bound as one. Each volume contains a long introduction to the methods and philosophy of each of these historical fields, covering the skills and sympathies of the historian, concepts of history of science, psychology of idea-creation, and the purpose of history of science. Prof. Sarton also provides more than 80 pages of classified bibliography. Complete and unabridged. Indexed. 10 illustrations. 188pp. 5⅜ x 8. T240 Paperbound **$1.25**

A HISTORY OF PHYSICS, Florian Cajori, Ph.D. First written in 1899, thoroughly revised in 1929, this is still best entry into antecedents of modern theories. Precise non-mathematical discussion of ideas, theories, techniques, apparatus of each period from Greeks to 1920's, analyzing within each period basic topics of matter, mechanics, light, electricity and magnetism, sound, atomic theory, etc. Stress on modern developments, from early 19th century to present. Written with critical eye on historical development, significance. Provides most of needed historical background for student of physics. Reprint of second (1929) edition. Index. Bibliography in footnotes. 16 figures. xv + 424pp. 5⅜ x 8. T970 Paperbound **$2.00**

A HISTORY OF ASTRONOMY FROM THALES TO KEPLER, J. L. E. Dreyer. Formerly titled A HISTORY OF PLANETARY SYSTEMS FROM THALES TO KEPLER. This is the only work in English which provides a detailed history of man's cosmological views from prehistoric times up through the Renaissance. It covers Egypt, Babylonia, early Greece, Alexandria, the Middle Ages, Copernicus, Tycho Brahe, Kepler, and many others. Epicycles and other complex theories of positional astronomy are explained in terms nearly everyone will find clear and easy to understand. "Standard reference on Greek astronomy and the Copernican revolution," SKY AND TELESCOPE. Bibliography. 21 diagrams. Index. xvii + 430pp. 5⅜ x 8. S79 Paperbound **$1.98**

A SHORT HISTORY OF ASTRONOMY, A. Berry. A popular standard work for over 50 years, this thorough and accurate volume covers the science from primitive times to the end of the 19th century. After the Greeks and Middle Ages, individual chapters analyze Copernicus, Brahe, Galileo, Kepler, and Newton, and the mixed reception of their startling discoveries. Post-Newtonian achievements are then discussed in unusual detail: Halley, Bradley, Lagrange, Laplace, Herschel, Bessel, etc. 2 indexes. 104 illustrations, 9 portraits. xxxi + 440pp. 5⅜ x 8. T210 Paperbound **$2.00**

PIONEERS OF SCIENCE, Sir Oliver Lodge. An authoritative, yet elementary history of science by a leading scientist and expositor. Concentrating on individuals—Copernicus, Brahe, Kepler, Galileo, Descartes, Newton, Laplace, Herschel, Lord Kelvin, and other scientists—the author presents their discoveries in historical order, adding biographical material on each man and full, specific explanations of their achievements. The full, clear discussions of the accomplishments of post-Newtonian astronomers are features seldom found in other books on the subject. Index. 120 illustrations. xv + 404pp. 5⅜ x 8. T716 Paperbound **$1.68**

THE BIRTH AND DEVELOPMENT OF THE GEOLOGICAL SCIENCES, F. D. Adams. The most complete and thorough history of the earth sciences in print. Geological thought from earliest recorded times to the end of the 19th century—covers over 300 early thinkers and systems: fossils and hypothetical explanations of them, vulcanists vs. neptunists, figured stones and paleontology, generation of stones, and similar topics. 91 illustrations, including medieval, renaissance woodcuts, etc. 632 footnotes and bibliographic notes. Index. 511pp. 5⅜ x 8. T5 Paperbound **$2.25**

THE STORY OF ALCHEMY AND EARLY CHEMISTRY, J. M. Stillman. "Add the blood of a red-haired man"—a recipe typical of the many quoted in this authoritative and readable history of the strange beliefs and practices of the alchemists. Concise studies of every leading figure in alchemy and early chemistry through Lavoisier, in this curious epic of superstition and true science, constructed from scores of rare and difficult Greek, Latin, German, and French texts. Foreword by S. W. Young. 246-item bibliography. Index. xiii + 566pp. 5⅜ x 8. S628 Paperbound **$2.45**

HISTORY OF MATHEMATICS, D. E. Smith. Most comprehensive non-technical history of math in English. Discusses the lives and works of over a thousand major and minor figures, from Euclid to Descartes, Gauss, and Riemann. Vol. I: A chronological examination, from primitive concepts through Egypt, Babylonia, Greece, the Orient, Rome, the Middle Ages, the Renaissance, and up to 1900. Vol. 2: The development of ideas in specific fields and problems, up through elementary calculus. Two volumes, total of 510 illustrations, 1355pp. 5⅜ x 8. Set boxed in attractive container. T429,430 Paperbound the set **$5.00**

CATALOGUE OF DOVER BOOKS

Biological Sciences

AN INTRODUCTION TO GENETICS, A. H. Sturtevant and G. W. Beadle. A very thorough exposition of genetic analysis and the chromosome mechanics of higher organisms by two of the world's most renowned biologists, A. H. Sturtevant, one of the founders of modern genetics, and George Beadle, Nobel laureate in 1958. Does not concentrate on the biochemical approach, but rather more on observed data from experimental evidence and results . . . from Drosophila and other life forms. Some chapter titles: Sex chromosomes; Sex-Linkage; Autosomal Inheritance;; Chromosome Maps; Intra-Chromosomal Rearrangements; Inversions—and Incomplete Chromosomes; Translocations; Lethals; Mutations; Heterogeneous Populations; Genes and Phenotypes; The Determination and Differentiation of Sex; etc. Slightly corrected reprint of 1939 edition. New preface by Drs. Sturtevant and Beadle. 1 color plate. 126 figures. Bibliographies. Index. 391pp. 5⅜ x 8½. S306 Paperbound **$2.00**

THE GENETICAL THEORY OF NATURAL SELECTION, R. A. Fisher. 2nd revised edition of a vital reviewing of Darwin's Selection Theory in terms of particulate inheritance, by one of the great authorities on experimental and theoretical genetics. Theory is stated in mathematical form. Special features of particulate inheritance are examined: evolution of dominance, maintenance of specific variability, mimicry and sexual selection, etc. 5 chapters on man and his special circumstances as a social animal. 16 photographs. Bibliography. Index. x + 310pp. 5⅜ x 8. S466 Paperbound **$2.00**

THE ORIENTATION OF ANIMALS: KINESES, TAXES AND COMPASS REACTIONS, Gottfried S. Fraenkel and Donald L. Gunn. A basic work in the field of animal orientations. Complete, detailed survey of everything known in the subject up to 1940s, enlarged and revised to cover major developments to 1960. Analyses of simpler types of orientation are presented in Part I: kinesis, klinotaxis, tropotaxis, telotaxis, etc. Part II covers more complex reactions originating from temperature changes, gravity, chemical stimulation, etc. The two-light experiment and unilateral blinding are dealt with, as is the problem of determinism or volition in lower animals. The book has become the universally-accepted guide to all who deal with the subject—zoologists, biologists, psychologists, and the like. Second, enlarged edition, revised to 1960. Bibliography of over 500 items. 135 illustrations. Indices. xiii + 376pp. 5⅜ x 8½. T786 Paperbound **$2.25**

THE BEHAVIOUR AND SOCIAL LIFE OF HONEYBEES, C. R. Ribbands. Definitive survey of all aspects of honeybee life and behavior; completely scientific in approach, but written in interesting, everyday language that both professionals and laymen will appreciate. Basic coverage of physiology, anatomy, sensory equipment; thorough account of honeybee behavior in the field (foraging activities, nectar and pollen gathering, how individuals find their way home and back to food areas, mating habits, etc.); details of communication in various field and hive situations. An extensive treatment of activities within the hive community—food sharing, wax production, comb building, swarming, the queen, her life and relationship with the workers, etc. A must for the beekeeper, natural historian, biologist, entomologist, social scientist, et al. "An indispensable reference," J. Hambleton, BₑES. "Recommended in the strongest of terms," AMERICAN SCIENTIST. 9 plates. 66 figures. Indices. 693-item bibliography. 252pp. 5⅜ x 8½. T1137 Paperbound **$2.00**

BIRD DISPLAY: AN INTRODUCTION TO THE STUDY OF BIRD PSYCHOLOGY, E. A. Armstrong. The standard work on bird display, based on extensive observation by the author and reports of other observers. This important contribution to comparative psychology covers the behavior and ceremonial rituals of hundreds of birds from gannet and heron to birds of paradise and king penguins. Chapters discuss such topics as the ceremonial of the gannet, ceremonial gaping, disablement reactions, the expression of emotions, the evolution and function of social ceremonies, social hierarchy in bird life, dances of birds and men, songs, etc. Free of technical terminology, this work will be equally interesting to psychologists and zoologists as well as bird lovers of all backgrounds. 32 photographic plates. New introduction by the author. List of scientific names of birds. Bibliography. 3-part index. 431pp. 5⅜ x 8½. T1128 Paperbound **$2.00**

THE SPECIFICITY OF SEROLOGICAL REACTIONS, Karl Landsteiner. With a Chapter on Molecular Structure and Intermolecular Forces by Linus Pauling. Dr. Landsteiner, winner of the Nobel Prize in 1930 for the discovery of the human blood groups, devoted his life to fundamental research and played a leading role in the development of immunology. This authoritative study is an account of the experiments he and his colleagues carried out on antigens and serological reactions with simple compounds. Comprehensive coverage of the basic concepts of immunolgy includes such topics as: The Serological Specificity of Proteins, Antigens, Antibodies, Artificially Conjugated Antigens, Non-Protein Cell Substances such as polysaccharides, etc., Antigen-Antibody Reactions (Toxin Neutralization, Precipitin Reactions, Agglutination, etc.). Discussions of toxins, bacterial proteins, viruses, hormones, enzymes, etc. in the context of immunological phenomena. New introduction by Dr. Merrill Chase of the Rockefeller Institute. Extensive bibliography and bibliography of author's writings. Index. xviii + 330pp. 5⅜ x 8½. S299 Paperbound **$2.00**

CATALOGUE OF DOVER BOOKS

CULTURE METHODS FOR INVERTEBRATE ANIMALS, P. S. Galtsoff, F. E. Lutz, P. S. Welch, J. Needham, eds. A compendium of practical experience of hundreds of scientists and techni cians, covering invertebrates from protozoa to chordata, in 313 articles on 17 phyla. Explain in great detail food, protection, environment, reproduction conditions, rearing methods embryology, breeding seasons, schedule of development, much more. Includes at least on species of each considerable group. Half the articles are on class insecta. Introduction. illustrations. Bibliography. Index. xxix + 590pp. 5⅜ x 8. S526 Paperbound $2.

THE BIOLOGY OF THE LABORATORY MOUSE, edited by G. D. Snell. 1st prepared in 19 by the staff of the Roscoe B. Jackson Memorial Laboratory, this is still the standard treati on the mouse, assembling an enormous amount of material for which otherwise you spen hours of research. Embryology, reproduction, histology, spontaneous tumor formation, geneti of tumor transplantation, endocrine secretion & tumor formation, milk, influence & tum formation, inbred, hybrid animals, parasites, infectious diseases, care & recording. Classifi bibliography of 1122 items. 172 figures, including 128 photos. ix + 497pp. 6⅛ x 9¼. S248 Clothbound $6.

MATHEMATICAL BIOPHYSICS: PHYSICO-MATHEMATICAL FOUNDATIONS OF BIOLOGY, N. Rashevsk One of most important books in modern biology, now revised, expanded with new chapter to include most significant recent contributions. Vol. 1: Diffusion phenomena, particular diffusion drag forces, their effects. Old theory of cell division based on diffusion dra forces, other theoretical approaches, more exhaustively treated than ever. Theories of e citation, conduction in nerves, with formal theories plus physico-chemical theory. Vol. Mathematical theories of various phenomena in central nervous system. New chapters theory of color vision, of random nets. Principle of optimal design, extended from earli edition. Principle of relational mapping of organisms, numerous applications. Introduc into mathematical biology such branches of math as topology, theory of sets. Index. 2 illustrations. Total of 988pp. 5⅜ x 8. S574 Vol. 1 (Books 1, 2) Paperbound $2. S575 Vol. 2 (Books 3, 4) Paperbound $2. 2 vol. set $5.0

ELEMENTS OF MATHEMATICAL BIOLOGY, A. J. Lotka. A pioneer classic, the first major attem to apply modern mathematical techniques on a large scale to phenomena of biology, bi chemistry, psychology, ecology, similar life sciences. Partial Contents: Statistical meanin of irreversibility; Evolution as redistribution; Equations of kinetics of evolving system Chemical, inter-species equilibrium; parameters of state; Energy transformers of natur etc. Can be read with profit even by those having no advanced math; unsurpassed as stud reference. Formerly titled ELEMENTS OF PHYSICAL BIOLOGY. 72 figures. xxx + 460p 5⅜ x 8. S346 Paperbound $2.

THE BIOLOGY OF THE AMPHIBIA, G. K. Noble, Late Curator of Herpetology at the Am. Mu of Nat. Hist. Probably the most used text on amphibia, unmatched in comprehensivenes clarity, detail. 19 chapters plus 85-page supplement cover development; heredity; life histor speciation; adaptation; sex, integument, respiratory, circulatory, digestive, muscular, nervou systems; instinct, intelligence, habits, environment, economic value, relationships, classific tion, etc. "Nothing comparable to it," C. H. Pope, Curator of Amphibia, Chicago Mus. Nat. Hist. 1047 bibliographic references. 174 illustrations. 600pp. 5⅜ x 8. S206 Paperbound $2.9

STUDIES ON THE STRUCTURE AND DEVELOPMENT OF VERTEBRATES, E. S. Goodrich. A definiti study by the greatest modern comparative anatomist. Exceptional in its accounts of th ossicles of the ear, the separate divisions of the coelom and mammalian diaphragm, ar the 5 chapters devoted to the head region. Also exhaustive morphological and phylogenet expositions of skeleton, fins and limbs, skeletal visceral arches and labial cartilage visceral clefts and gills, vacular, respiratory, excretory, and peripheral nervous systems, etc from fish to the higher mammals. 754 illustrations. 69 page biographical study by C. Hardy. Bibliography of 1186 references. "What an undertaking . . . to write a textbook whic will summarize adequately and succinctly all that has been done in the realm of Vert brate Morphology these recent years," Journal of Anatomy. Index. Two volumes. Total 906p 5⅜ x 8. Two vol. set S449-50 Paperbound $5.0

A TREATISE ON PHYSIOLOGICAL OPTICS, H. von Helmholtz, Ed. by J. P. C. Southall. Unmatche for thoroughness, soundness, and comprehensiveness, this is still the most important wor ever produced in the field of physiological optics. Revised and annotated, it contains ever thing known about the subject up to 1925. Beginning with a careful anatomical descriptio of the eye, the main body of the text is divided into three general categories: The Dioptric of the Eye (covering optical imagery, blur circles on the retina, the mechanism of accommo dation, chromatic aberration, etc.); The Sensations of Vision (including stimulation of th organ of vision, simple and compound colors, the intensity and duration of light, variation of sensitivity, contrast, etc.); and The Perceptions of Vision (containing movements of th eyes, the monocular field of vision, direction, perception of depth, binocular double visio etc.). Appendices cover later findings on optical imagery, refraction, ophthalmoscopy, an many other matters. Unabridged, corrected republication of the original English translatio of the third German edition. 3 volumes bound as 2. Complete bibliography, 1911-192 Indices. 312 illustrations. 6 full-page plates, 3 in color. Total of 1,749pp. 5⅜ x 8. Two-volume set S15, 16 Clothbound $15.0

CATALOGUE OF DOVER BOOKS

INTRODUCTION TO PHYSIOLOGICAL OPTICS, James P. C. Southall, former Professor of Physics, Columbia University. Readable, top-flight introduction, not only for beginning students of optics, but also for other readers—physicists, biochemists, illuminating engineers, optometrists, psychologists, etc. Comprehensive coverage of such matters as the Organ of Vision, structure of the eyeball, the retina, the dioptric system, monocular and binocular vision, adaptation, etc.); The Optical System of the Eye (reflex images in the cornea and crystalline lens, Emmetropia and Ametropia, accommodation, blur circles on retina); Eye-Glasses; Eye defects; Movements of the Eyeball in its Socket; Rod and Cone Vision; Color Vision; and other similar topics. Index. 134 figures. x +426pp. 5⅜ x 8. S924 Paperbound **$2.25**

LIGHT, COLOUR AND VISION, Yves LeGrand. A thorough examination of the eye as a receptor of radiant energy and as a mechanism (the retina) consisting of light-sensitive cells which absorb light of various wave lengths—probably the most complete and authoritative treatment of this subject in print. Originally prepared as a series of lectures given at the Institute of Optics in Paris, subsequently enlarged for book publication. Partial contents: Radiant energy—concept, nature, theories, etc., Sources of Radiation—artificial and natural, the visual Receptor, Photometric Quantities, Units, Calculations, Retinal Illumination, Trivariance of Vision, Colorimetry, Luminance Difference Thresholds, Anatomy of the Retina, Theories of Vision, Photochemistry and Electro-physiology of the Retina, etc. Appendices, Exercises, with solutions. 500-item bibliography. Authorized translation by R. Hunt, J. Walsh, F. Hunt. Index. 173 illustrations. xiii + 512pp. 5⅜ x 8½. S979 Clothbound **$10.00**

FINGER PRINTS, PALMS AND SOLES: AN INTRODUCTION TO DERMATOGLYPHICS, Harold Cummins and Charles Midlo. An introduction in non-technical language designed to acquaint the reader with a long-neglected aspect of human biology. Although a chapter dealing with fingerprint identification and the systems of classification used by the FBI, etc. has been added especially for this edition, the main concern of the book is to show how the intricate pattern of ridges and wrinkles on our fingers have a broader significance, applicable in many areas of science and life. Some topics are: the identification of two types of twins; the resolution of doubtful cases of paternity; racial variation; the relation of fingerprints to body measurements, blood groups, criminality, character, etc. Classification and recognition of fundamental patterns and pattern types discussed fully. 149 figures. 49 tables. 361-item bibliography. Index. xii + 319pp. 5⅝ x 8⅜. T778 Paperbound **$1.95**

classics and histories

ANTONY VAN LEEUWENHOEK AND HIS "LITTLE ANIMALS," edited by Clifford Dobell. First book to treat extensively, accurately, life and works (relating to protozoology, bacteriology) of first microbiologist, bacteriologist, micrologist. Includes founding papers of protozoology, bacteriology; history of Leeuwenhoek's life; discussions of his microscopes, methods, language. His writing conveys sense of an enthusiastic, naive genius, as he looks at rainwater, pepper water, vinegar, frog's skin, rotifers, etc. Extremely readable, even for non-specialists. "One of the most interesting and enlightening books I have ever read," Dr. C. Bass, former Dean, Tulane U. School of Medicine. Only authorized edition. 400-item bibliography. Index. 32 illust. 442pp. 5⅜ x 8. S594 Paperbound **$2.25**

THE GROWTH OF SCIENTIFIC PHYSIOLOGY, G. J. Goodfield. A compact, superbly written account of how certain scientific investigations brought about the emergence of the distinct science of physiology. Centers principally around the mechanist-vitalist controversy prior to the development of physiology as an independent science, using the arguments which raged around the problem of animal heat as its chief illustration. Covers thoroughly the efforts of clinicians and naturalists and workers in chemistry and physics to solve these problems—from which the new discipline arose. Includes the theories and contributions of: Aristotle, Galen, Harvey, Boyle, Bernard, Benjamin Franklin, Palmer, Gay-Lussac, Priestley, Spallanzani, and many others. 1960 publication. Biographical bibliography. 174pp. 5 x 7½. T1066 Clothbound **$3.00**

MICROGRAPHIA, Robert Hooke. Hooke, 17th century British universal scientific genius, was a major pioneer in celestial mechanics, optics, gravity, and many other fields, but his greatest contribution was this book, now reprinted entirely from the original 1665 edition, which gave microscopy its first great impetus. With all the freshness of discovery, he describes fully his microscope, and his observations of cork, the edge of a razor, insects' eyes, fabrics, and dozens of other different objects. 38 plates, full-size or larger, contain all the original illustrations. This book is also a fundamental classic in the fields of combustion and heat theory, light and color theory, botany and zoology, hygrometry, and many other fields. It contains such farsighted predictions as the famous anticipation of artificial silk. The final section is concerned with Hooke's telescopic observations of the moon and stars. 323pp. 5⅜ x 8. T8 Paperbound **$2.00**

Art, History of Art, Antiques, Graphic Arts, Handcrafts

ART STUDENTS' ANATOMY, E. J. Farris. Outstanding art anatomy that uses chiefly living objec for its illustrations. 71 photos of undraped men, women, children are accompanied by car fully labeled matching sketches to illustrate the skeletal system, articulations and movemen bony landmarks, the muscular system, skin, fasciae, fat, etc. 9 x-ray photos show moveme of joints. Undraped models are shown in such actions as serving in tennis, drawing a bo in archery, playing football, dancing, preparing to spring and to dive. Also discussed an illustrated are proportions, age and sex differences, the anatomy of the smile, etc. 8 plat by the great early 18th century anatomic illustrator Siegfried Albinus are also include Glossary. 158 figures, 7 in color. x + 159pp. 5⅝ x 8⅜. T744 Paperbound **$1.**

AN ATLAS OF ANATOMY FOR ARTISTS, F Schider. A new 3rd edition of this standard text e larged by 52 new illustrations of hands, anatomical studies by Cloquet, and expressive li studies of the body by Barcsay. 189 clear, detailed plates offer you precise information impeccable accuracy. 29 plates show all aspects of the skeleton, with closeups of speci areas, while 54 full-page plates, mostly in two colors, give human musculature as seen fro four different points of view, with cutaways for important portions of the body. 14 fu page plates provide photographs of hand forms, eyelids, female breasts, and indicate th location of muscles upon models. 59 additional plates show how great artists of the pa utilized human anatomy. They reproduce sketches and finished work by such artists a Michelangelo, Leonardo da Vinci, Goya, and 15 others. This is a lifetime reference wo which will be one of the most important books in any artist's library. "The standard refe ence tool," AMERICAN LIBRARY ASSOCIATION. "Excellent," AMERICAN ARTIST. Third enlarge edition. 189 plates, 647 illustrations. xxvi + 192pp. 7⅞ x 10⅝. T241 Clothbound **$6.0**

AN ATLAS OF ANIMAL ANATOMY FOR ARTISTS, W. Ellenberger, H. Baum, H. Dittrich. Th largest, richest animal anatomy for artists available in English. 99 detailed anatomical plate of such animals as the horse, dog, cat, lion, deer, seal, kangaroo, flying squirrel, cow, bu goat, monkey, hare, and bat. Surface features are clearly indicated, while progressive b neath-the-skin pictures show musculature, tendons, and bone structure. Rest and action a exhibited in terms of musculature and skeletal structure and detailed cross-sections a given for heads and important features. The animals chosen are representative of specifi families so that a study of these anatomies will provide knowledge of hundreds of relate species. "Highly recommended as one of the very few books on the subject worthy of bein used as an authoritative guide," DESIGN. "Gives a fundamental knowledge," AMERICA ARTIST. Second revised, enlarged edition with new plates from Cuvier, Stubbs, etc. 28 illustrations. 153pp. 11⅜ x 9. T82 Clothbound **$6.0**

THE HUMAN FIGURE IN MOTION, Eadweard Muybridge. The largest selection in print « Muybridge's famous high-speed action photos of the human figure in motion. 4789 photograph illustrate 162 different actions: men, women, children—mostly undraped—are shown walkin running, carrying various objects, sitting, lying down, climbing, throwing, arising, and pe forming over 150 other actions. Some actions are shown in as many as 150 photograph each. All in all there are more than 500 action strips in this enormous volume, series sho taken at shutter speeds of as high as 1/6000th of a second! These are not posed shots, b true stopped motion. They show bone and muscle in situations that the human eye is n fast enough to capture. Earlier, smaller editions of these prints have brought $40 and mo on the out-of-print market. "A must for artists," ART IN FOCUS. "An unparalleled dictiona of action for all artists," AMERICAN ARTIST. 390 full-page plates, with 4789 photograph Printed on heavy glossy stock. Reinforced binding with headbands. xxi + 390pp. 7⅞ x 10.
T204 Clothbound **$10.0**

ANIMALS IN MOTION, Eadweard Muybridge. This is the largest collection of animal actio photos in print. 34 different animals (horses, mules, oxen, goats, camels, pigs, cats, guanaco lions, gnus, deer, monkeys, eagles—and 21 others) in 132 characteristic actions. The hors alone is shown in more than 40 different actions. All 3919 photographs are taken in serie at speeds up to 1/6000th of a second. The secrets of leg motion, spinal patterns, head mov ments, strains and contortions shown nowhere else are captured. You will see exactly ho a lion sets his foot down; how an elephant's knees are like a human's—and how they diffe the position of a kangaroo's legs in mid-leap; how an ostrich's head bobs; details of th flight of birds—and thousands of facets of motion only the fastest cameras can catcl Photographed from domestic animals and animals in the Philadelphia zoo, it contains neithe semiposed artificial shots nor distorted telephoto shots taken under adverse condition Artists, biologists, decorators, cartoonists, will find this book indispensable for understandir animals in motion. "A really marvelous series of plates," NATURE (London). "The dry plate most spectacular early use was by Eadweard Muybridge," LIFE. 3919 photographs; 380 fu pages of plates. 440pp. Printed on heavy glossy paper. Deluxe binding with headband 7⅞ x 10⅝. T203 Clothbound **$10.0**

CATALOGUE OF DOVER BOOKS

SHAKER FURNITURE, E. D. Andrews and F. Andrews. The most illuminating study on what many scholars consider the best examples of functional furniture ever made. Includes the history of the sect and the development of Shaker style. The 48 magnificent plates show tables, chairs, cupboards, chests, boxes, desks, beds, woodenware, and much more, and are accompanied by detailed commentary. For all antique collectors and dealers, designers and decorators, historians and folklorists. "Distinguished in scholarship, in pictorial illumination, and in all the essentials of fine book making," Antiques. 3 Appendixes. Bibliography. Index. 192pp. 7⅞ x 10¾.
T679 Paperbound **$2.00**

JAPANESE HOMES AND THEIR SURROUNDINGS, E. S. Morse. Every aspect of the purely traditional Japanese home, from general plan and major structural features to ceremonial and additional appointments—tatami, hibachi, shoji, tokonoma, etc. The most exhaustive discussion in English, this book is equally honored for its strikingly modern conception of architecture. First published in 1886, before the contamination of the Japanese traditions, it preserves the authentic features of an ideal of construction that is steadily gaining devotees in the Western world. 307 illustrations by the author. Index. Glossary. xxxvi + 372pp. 5⅛ x 8⅜.
T746 Paperbound **$2.00**

COLONIAL LIGHTING, Arthur H. Hayward. The largest selection of antique lamps ever illustrated anywhere, from rush light-holders of earliest settlers to 1880's—with main emphasis on Colonial era. Primitive attempts at illumination ("Betty" lamps, variations of open wick design, candle molds, reflectors, etc.), whale oil lamps, painted and japanned hand lamps, sandwich glass candlesticks, astral lamps, Bennington ware and chandeliers of wood, iron, pewter, brass, crystal, bronze and silver. Hundreds of illustrations, loads of information on colonial life, customs, habits, place of acquisition of lamps illustrated. A unique, thoroughgoing survey of an interesting aspect of Americana. Enlarged (1962) edition. New Introduction by James R. Marsh. Supplement "Colonial Chandeliers," photographs with descriptive notes. 169 illustrations, 647 lamps. xxxi + 312pp. 5⅝ x 8¼.
T975 Paperbound **$2.00**

CHINESE HOUSEHOLD FURNITURE, George N. Kates. The first book-length study of authentic Chinese domestic furniture in Western language. Summarises practically everything known about Chinese furniture in pure state, uninfluenced by West. History of style, unusual woods used, craftsmanship, principles of design, specific forms like wardrobes, chests and boxes, beds, chairs, tables, stools, cupboards and other pieces. Based on author's own investigation into scanty Chinese historical sources and surviving pieces in private collections and museums. Will reveal a new dimension of simple, beautiful work to all interior decorators, furniture designers, craftsmen. 123 illustrations; 112 photographs. Bibliography. xiii + 205pp. 5¼ x 7¾.
T958 Paperbound **$1.50**

ART AND THE SOCIAL ORDER, Professor D. W. Gotshalk, University of Illinois. One of the most profound and most influential studies of aesthetics written in our generation, this work is unusual in considering art from the relational point of view, as a transaction consisting of creation-object-apprehension. Discussing material from the fine arts, literature, music, and related disciplines, it analyzes the aesthetic experience, fine art, the creative process, art materials, form, expression, function, art criticism, art and social life and living. Graceful and fluent in expression, it requires no previous background in aesthetics and will be read with considerable enjoyment by anyone interested in the theory of art. "Clear, interesting, the soundest and most penetrating work in recent years," C. J. Ducasse, Brown University. New preface by Professor Gotshalk. xvi + 248pp. 5⅝ x 8½.
T294 Paperbound **$1.50**

FOUNDATIONS OF MODERN ART, A. Ozenfant. An illuminating discussion by a great artist of the interrelationship of all forms of human creativity, from painting to science, writing to religion. The creative process is explored in all facets of art, from paleolithic cave painting to modern French painting and architecture, and the great universals of art are isolated. Expressing its countless insights in aphorisms accompanied by carefully selected illustrations, this book is itself an embodiment in prose of the creative process. Enlarged by 4 new chapters. 226 illustrations. 368pp. 6⅛ x 9¼.
T215 Paperbound **$2.00**

VITRUVIUS: TEN BOOKS ON ARCHITECTURE. Book by 1st century Roman architect, engineer, is oldest, most influential work on architecture in existence; for hundreds of years his specific instructions were followed all over the world, by such men as Bramante, Michelangelo, Palladio, etc., and are reflected in major buildings. He describes classic principles of symmetry, harmony; design of treasury, prison, etc.; methods of durability; much more. He wrote in a fascinating manner, and often digressed to give interesting sidelights, making this volume appealing reading even to the non-professional. Standard English translation, by Prof. M. H. Morgan, Harvard U. Index. 6 illus. 334pp. 5⅜ x 8.
T645 Paperbound **$2.00**

THE BROWN DECADES, Lewis Mumford. In this now classic study of the arts in America, Lewis Mumford resurrects the "buried renaissance" of the post-Civil War period. He demonstrates that it contained the seeds of a new integrity and power and documents his study with detailed accounts of the founding of modern architecture in the work of Sullivan, Richardson, Root, Roebling; landscape development of Marsh, Olmstead, and Eliot; the graphic arts of Homer, Eakins, and Ryder. 2nd revised enlarged edition. Bibliography. 12 illustrations. Index. xiv + 266pp. 5⅜ x 8.
T200 Paperbound **$1.65**

THE AUTOBIOGRAPHY OF AN IDEA, Louis Sullivan. The pioneer architect whom Frank Lloyd Wright called "the master" reveals an acute sensitivity to social forces and values in this passionately honest account. He records the crystallization of his opinions and theories, the growth of his organic theory of architecture that still influences American designers and architects, contemporary ideas, etc. This volume contains the first appearance of 34 full-page plates of his finest architecture. Unabridged reissue of 1924 edition. New introduction by R. M. Line. Index. xiv + 335pp. 5⅜ x 8. T281 Paperbound **$2.0**

THE DRAWINGS OF HEINRICH KLEY. The first uncut republication of both of Kley's devastating sketchbooks, which first appeared in pre-World War I Germany. One of the greatest cartoonists and social satirists of modern times, his exuberant and iconoclastic fantasy and his extraordinary technique place him in the great tradition of Bosch, Breughel, and Goya, while his subject matter has all the immediacy and tension of our century. 200 drawings. viii + 128pp. 7¾ x 10¾. T24 Paperbound **$1.8**

MORE DRAWINGS BY HEINRICH KLEY. All the sketches from Leut' Und Viecher (1912) and Sammel-Album (1923) not included in the previous Dover edition of Drawings. More of the bizarre, mercilessly iconoclastic sketches that shocked and amused on their original publication. Nothing was too sacred, no one too eminent for satirization by this imaginative, individual and accomplished master cartoonist. A total of 158 illustrations. Iv + 104pp. 7¾ x 10¾. T41 Paperbound **$1.8**

PINE FURNITURE OF EARLY NEW ENGLAND, R. H. Kettell. A rich understanding of one of America's most original folk arts that collectors of antiques, interior decorators, craftsmen woodworkers, and everyone interested in American history and art will find fascinating and immensely useful. 413 illustrations of more than 300 chairs, benches, racks, beds, cupboards, mirrors, shelves, tables, and other furniture will show all the simple beauty and character of early New England furniture. 55 detailed drawings carefully analyze outstanding pieces. "With its rich store of illustrations, this book emphasizes the individuality and varied design of early American pine furniture. It should be welcomed," ANTIQUES. 413 illustrations and 55 working drawings. 475. 8 x 10¾. T145 Clothbound **$10.0**

THE HUMAN FIGURE, J. H. Vanderpoel. Every important artistic element of the human figure is pointed out in minutely detailed word descriptions in this classic text and illustrated as well in 430 pencil and charcoal drawings. Thus the text of this book directs your attention to all the characteristic features and subtle differences of the male and female (adults, children, and aged persons), as though a master artist were telling you what to look for at each stage. 2nd edition, revised and enlarged by George Bridgman. Foreword. 430 illustrations. 143pp. 6⅛ x 9¼. T432 Paperbound **$1.50**

LETTERING AND ALPHABETS, J. A. Cavanagh. This unabridged reissue of LETTERING offers a full discussion, analysis, illustration of 89 basic hand lettering styles — styles derived from Caslons, Bodonis, Garamonds, Gothic, Black Letter, Oriental, and many others. Upper and lower cases, numerals and common signs pictured. Hundreds of technical hints on make-up, construction, artistic validity, strokes, pens, brushes, white areas, etc. May be reproduced without permission! 89 complete alphabets; 72 lettered specimens. 121pp. 9¾ x 8. T53 Paperbound **$1.25**

STICKS AND STONES, Lewis Mumford. A survey of the forces that have conditioned American architecture and altered its forms. The author discusses the medieval tradition in early New England villages; the Renaissance influence which developed with the rise of the merchant class; the classical influence of Jefferson's time; the "Mechanicsvilles" of Poe's generation; the Brown Decades; the philosophy of the Imperial facade; and finally the modern machine age. "A truly remarkable book," SAT. REV. OF LITERATURE. 2nd revised edition. 21 illustrations. xvii + 228pp. 5⅜ x 8. T202 Paperbound **$1.60**

THE STANDARD BOOK OF QUILT MAKING AND COLLECTING, Marguerite Ickis. A complete easy-to-follow guide with all the information you need to make beautiful, useful quilts. How to plan, design, cut, sew, appliqué, avoid sewing problems, use rag bag, make borders, tuft, every other aspect. Over 100 traditional quilts shown, including over 40 full-size patterns. At-home hobby for fun, profit. Index. 483 illus. 1 color plate. 287pp. 6¾ x 9½. T582 Paperbound **$2.00**

THE BOOK OF SIGNS, Rudolf Koch. Formerly $20 to $25 on the out-of-print market, now only $1.00 in this unabridged new edition! 493 symbols from ancient manuscripts, medieval cathedrals, coins, catacombs, pottery, etc. Crosses, monograms of Roman emperors, astrological, chemical, botanical, runes, housemarks, and 7 other categories. Invaluable for handicraft workers, illustrators, scholars, etc., this material may be reproduced without permission. 493 illustrations by Fritz Kredel. 104pp. 6½ x 9¼. T162 Paperbound **$1.00**

PRIMITIVE ART, Franz Boas. This authoritative and exhaustive work by a great American anthropologist covers the entire gamut of primitive art. Pottery, leatherwork, metal work, stone work, wood, basketry, are treated in detail. Theories of primitive art, historical depth in art history, technical virtuosity, unconscious levels of patterning, symbolism, styles, literature, music, dance, etc. A must book for the interested layman, the anthropologist, artist, handicrafter (hundreds of unusual motifs), and the historian. Over 900 illustrations (50 ceramic vessels, 12 totem poles, etc.). 376pp. 5⅜ x 8. T25 Paperbound **$2.00**

History, Political Science

E POLITICAL THOUGHT OF PLATO AND ARISTOTLE, E. Barker. One of the clearest and most curate expositions of the corpus of Greek political thought. This standard source contains haustive analyses of the "Republic" and other Platonic dialogues and Aristotle's "Politics" d "Ethics," and discusses the origin of these ideas in Greece, contributions of other Greek eorists, and modifications of Greek ideas by thinkers from Aquinas to Hegel. "Must" reading r anyone interested in the history of Western thought. Index. Chronological Table of Events. Appendixes. xxiv + 560pp. 5⅜ x 8. **T521 Paperbound $1.85**

IE IDEA OF PROGRESS, J. B. Bury. Practically unknown before the Reformation, the idea of ogress has since become one of the central concepts of western civilization. Prof. Bury alyzes its evolution in the thought of Greece, Rome, the Middle Ages, the Renaissance, to s flowering in all branches of science, religion, philosophy, industry, art, and literature, aring and following the 16th century. Introduction by Charles Beard. Index. xl + 357pp. ⅛ x 8. **T40 Paperbound $2.00**

IE ANCIENT GREEK HISTORIANS, J. B. Bury. This well known, easily read work covers the tire field of classical historians from the early writers to Herodotus, Thucydides, Xenophon, rough Poseidonius and such Romans as Tacitus, Cato, Caesar, Livy. Scores of writers are udied biographically, in style, sources, accuracy, structure, historical concepts, and influ- ces. Recent discoveries such as the Oxyrhinchus papyri are referred to, as well as such eat scholars as Nissen, Gomperz, Cornford, etc. "Totally unblemished by pedantry." Outlook. he best account in English," Dutcher, A Guide to Historical Lit. Bibliography, Index. + 281pp. 5⅜ x 8. **T397 Paperbound $1.65**

STORY OF THE LATER ROMAN EMPIRE, J. B. Bury. This standard work by the leading zantine scholar of our time discusses the later Roman and early Byzantine empires from 5 A.D. through the death of Justinian in 565, in their political, social, cultural, theological, d military aspects. Contemporary documents are quoted in full, making this the most mplete reconstruction of the period and a fit successor to Gibbon's "Decline and Fall." Most unlikely that it will ever be superseded," Glanville Downey, Dumbarton Oaks Research . Geneological tables. 5 maps. Bibliography. Index. 2 volumes total of 965pp. 5⅜ x 8. **T398, 399 Two volume set, Paperbound $4.00**

HISTORY OF ANCIENT GEOGRAPHY, E. H. Bunbury. Standard study, in English, of ancient ography; never equalled for scope, detail. First full account of history of geography from eeks' first world picture based on mariners, through Ptolemy. Discusses every important ap, discovery, figure, travel expedition, war, conjecture, narrative, bearing on subject. apters on Homeric geography, Herodotus, Alexander expedition, Strabo, Pliny, Ptolemy, uld stand alone as exhaustive monographs. Includes minor geographers, men not usually garded in this context: Hecataeus, Pytheas, Hipparchus, Artemidorus, Marinus of Tyre, etc. es information gleaned from military campaigns such as Punic Wars, Hannibal's passage of ps, campaigns of Lucullus, Pompey, Caesar's wars, the Trojan War. New introduction by . H. Stahl, Brooklyn College. Bibliography. Index. 20 maps. 1426pp. 5⅜ x 8. **T570-1, clothbound, 2-volume set $12.50**

LITICAL PARTIES, Robert Michels. Classic of social science, reference point for all later ork, deals with nature of leadership in social organization on government and trade ion levels. Probing tendency of oligarchy to replace democracy, it studies need for leader- ip, desire for organization, psychological motivations, vested interests, hero worship, action of leaders to power, press relations, many other aspects. Trans. by E. & C. Paul. troduction. 447pp. 5⅜ x 8. **T569 Paperbound $2.00**

HISTORY OF HISTORICAL WRITING, Harry Elmer Barnes. Virtually the only adequate survey the whole course of historical writing in a single volume. Surveys developments from e beginnings of historiographies in the ancient Near East and the Classical World, up rough the Cold War. Covers major historians in detail, shows interrelationship with cultural ckground, makes clear individual contributions, evaluates and estimates importance; also ormously rich upon minor authors and thinkers who are usually passed over. Packed with holarship and learning, clear, easily written. Indispensable to every student of history. vised and enlarged up to 1961. Index and bibliography. xv + 442pp. 5⅜ x 8½. **T104 Paperbound $2.25**

rices subject to change without notice.

over publishes books on art, music, philosophy, literature, languages, history, social iences, psychology, handcrafts, orientalia, puzzles and entertainments, chess, pets d gardens, books explaining science, intermediate and higher mathematics, math- natical physics, engineering, biological sciences, earth sciences, classics of science, etc. rite to:

Dept. catrr.
Dover Publications, Inc.
180 Varick Street, N. Y. 14, N. Y.